MEDIEVAL DEATH

Ritual and Representation

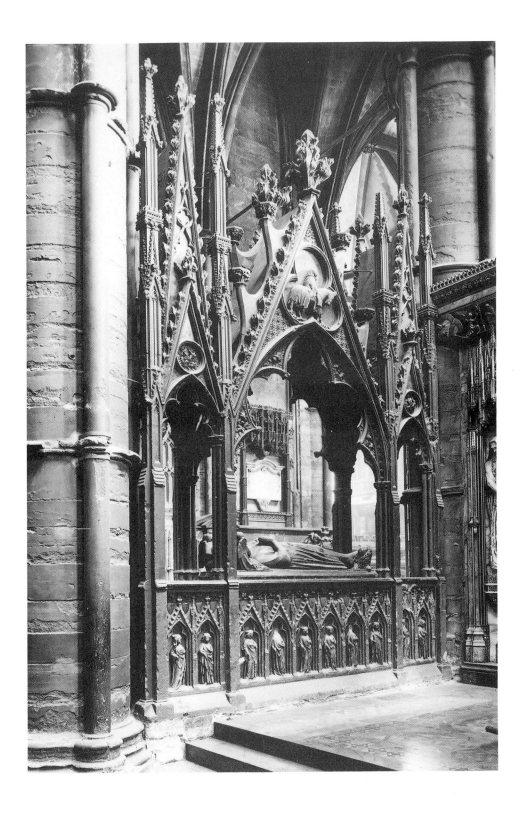

MEDIEVAL DEATH

Ritual and Representation

Paul Binski

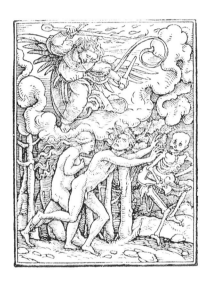

Cornell University Press
Ithaca, New York

For Margaret

'Only one man ever understood me . . .
and he didn't understand me.'

(Hegel's last words, 1831)

Paul Binski has asserted his right to be identified
as the Author of this work.

First published in the United States 1996 by
Cornell University Press.

International Standard Book Number 8014-3315-0

Library of Congress Cataloguing-in-Publication Data
A CIP catalog record for this book is available from
the Library of Congress.

Designed by James Shurmer

Typeset by Wyvern Typesetting Ltd, Bristol

Printed in Great Britain by the Bath Press, Avon

Frontispiece Tomb of Edmund Crouchback, Earl of
Lancaster (d. 1296), Westminster Abbey

Page 3 Adam and Eve expelled from Paradise
(*c.*1526), by Hans Holbein the Younger

CONTENTS

Illustration Credits

Illustrations were supplied by the following on the pages or for the plate nos cited:

Archivi Alinari 9, 73, 98, 112, 117, 129, 178, 193, 203; Antikvarisk-topografiska arkivet, Stockholm (photo: Nils Azelius 1928) 49; James Austin 19; Bayerische Staatsbibliothek, Munich 189 (MS Lat. 835, f.30v); Biblioteca Nazionale Centrale, Florence 192; Bibliothèque Municipale de Toulouse 196 (MS 815, f.58v); Bibliothèque Municipale de Troyes 28 (MS 2273, f.74); Bibliothèque Nationale, Paris 189 (MS Lat. 1023, f.49), 211 (MS Lat. 1186, f.171), PL. IV (MS Lat. 9471, f.159); Bildarchiv Foto Marburg 141; Bodleian Library, Oxford PL. VI (MS Auct. D4.4, f.236v); British Library 41L (IB 18, p.6a), 41R (IB 23, p.23), 81 (MS Cotton Claudius B.IV, f.72v), 145 (MS Add. 37049, f.32v), 151 (MS Egerton 1070, f.53), 171 (MS Arundel 83(II), f.123v), 213 (MS Royal 6E. VI, f.16v), PL. VIII (MS Arundel 83(II), f.127), PL. IX (MS Cotton Nero C.IV, f.39); British Museum 2 & 155 (PD 1895.1–22.79), 23 (GR 1954.12–14.1); CNHMS/DACS 1995 17, 43, 44, 59, 80, 90, 143, 154; Cambridge University Library 79 (MS Ee.3.59, f.30); The Master and Fellows of Corpus Christi College, Cambridge (photo: Conway Library, Courtauld Institute of Art) 48 (MS 16, f.177v); Conway Library, Courtauld Institute of Art 87, 95, 101, 119, 153, 169, 174, 209; Fitzwilliam Museum, Cambridge 146 (MS 330, f.6); Giraudon 176 (Musée des Monuments Français, Paris), 191 (Musée Municipal, Villeneuve-lès-Avignon), 195 (Musée des Monuments Français, Paris); Hirmer Verlag GmbH 68, 92, 204; Istituto Centrale per il Catalogo e la Documentazione, Roma 83; Lauros-Giraudon 100 (Musée des Beaux-Arts, Dijon); Fabio Lensini, Siena 179; Metropolitan Museum of Art, New York 35 (The Cloisters Collection, 1954, 54.1.2 f.165v, 166r); *The Monumental Brass Society Portfolio*, Vol. 1, Pt 1, Pl. 2 107R; © Musée d'Unterlinden, 6800 Colmar, France (photo: O. Zimmermann) 46; Museo del Prado 161; Museu Nacional d'Art de Catalunya, Barcelona 52; National Gallery of Art, Washington, Samuel H. Kress Collection, © 1995 Board of Trustees 20, PL. I; National Gallery of Canada, Ottawa 162; Oeffentliche Kunstsammlung Basel, Kuntsmuseum 159 (photo: Oeffentliche Kunstsammlung Basel, Martin Buhler); Palazzo Ducale, Venice 165; The Pierpont Morgan Library, New York PL. XI (M.677, f.245); Private Collection, Amsterdam PL. VII (photo: Department of Photography, Rijksmuseum, Amsterdam); RCHME © Crown copyright 2 & 108, 38, 82, 85, 89, 109, 144, 197; John Rylands University Library of Manchester, reproduced by courtesy of the Director and University Librarian 31 (MS Lat. 114), 137 (MS Lat. 484, f.5v); Scala 12, 13; Walter Scott (BFD) Ltd 148; Trinity College, Cambridge 168 (MS R. 16.2, f.25v); Victoria and Albert Museum, © The Board of Trustees 69; The Walters Art Gallery, Baltimore 190 (MS W.274, f.118), PL. III (MS W.168, f.166v–167), PL. V (MS W.249, f.119); Westminster Abbey, by courtesy of the Dean and Chapter 62 (MS 38, f.33v), 96, 102; Winchester Cathedral, by courtesy of the Dean and Chapter (photo: Miki Slingsby) PL. X (Winchester Bible, Vol. III, f.218); © photo Woodmansterne PL. II.

PREFACE

It appears to be customary to open a book on the subject of death with some solemn set of generalizations about the universality, ineffability, profundity and so on of the subject. Openings of this type tend to look strikingly similar. Sometimes the same can be said for the books they introduce: it is hard to say anything new about a subject whose literature is immense and whose subject is universal, ineffable and profound.

This book has some novelties in it, but its primary purpose is straightforward: to provide the general reader and students with an overview, broad in character and as wide ranging as is compatible with scholarly responsibility, of the subject of medieval death specifically in relation to medieval representations. This is not a book about art, any more than it is about religion, society, the body or ritual. In fact it started as a book about religion in the period between the late Roman Empire and the Reformation and has ended up as a text about all these things. But it is a book written by someone whose training and interests reflect a preoccupation with images, so in attempting to take account of a variety of perspectives on medieval death, I have wherever possible addressed these ideas to images, knowing full well that no account can adequately embrace the phenomenal richness of the theme. Books about the imagery of death written from this position are relatively rare, and it is in this respect especially that I hope this brief and necessarily brisk text, which is emphatically not to be understood as a textbook, will make some contribution.

The book – or, better, essay – is based upon a series of lectures I delivered to undergraduates at Yale University in 1990. I was struck by their enthusiasm for the subject, by the diverse nature of their interest in it and, at the practical level, by the problem of furnishing them with a coherent body of reading which seriously addressed the visual texts of medieval death culture as more than merely evidence for some prior theory or historical 'context', a favourite tactic of historians of culture and society which can smack of condescension towards images. Though in form it might resemble one, this is not an illustrated social history of death. The reading included at the end of the book, arranged in a fashion I found useful in teaching the subject and writing the book, illustrates the range of concerns a course on this topic might touch on.

I thank all my students for helping me to understand their needs and interests better in approaching this most fascinating of subjects. I am especially indebted to Christopher Wilson for detailed comments on the text, and to Liz Smale for preparing the index. At the British Museum Press Sarah Derry and Colin Grant saw the book through to production with skill and dedication.

INTRODUCTION
THE ROOTS OF MEDIEVAL DEATH CULTURE

We begin with a supreme moment of transgression; and since it is a supreme moment, we may as well view it with a supreme medieval artist and storyteller. The place is Padua in north Italy; the time is at once the first century of the Christian era, the fourteenth century, and now; and the event is the Raising of Lazarus, as depicted in a fresco by Giotto di Bondone on the north wall of the chapel he decorated around 1305 for the Scrovegni family, in order to assist the expiation of their sins.

Giotto is here framing and fleshing out a moment in the most spiritual of Gospels, that of St John 11:1–45. Jesus has heard of the sickness of Lazarus the brother of Mary and Martha; He says that the sickness is not 'unto death' but 'for the Glory of God, that the Son of Man might be glorified thereby'. And so Jesus does not intervene. By the time of His arrival in Bethany, Lazarus has already been dead for four days; Jesus has not cured him from afar, but instead promises that he 'shall rise again'. Martha understands this to mean that Lazarus will rise again on the last day at the Resurrection; but for Jesus the moment is more immediate: 'I am the resurrection and the life: he that believeth in me, though he were dead, yet shall he live: and whosoever liveth and believeth in me shall never die.' Mary pleads with him that, had he come sooner, Lazarus would not have died. Jesus is troubled and groans in the spirit, and weeps. Coming to Lazarus' grave, a cave with a stone rolled in front of it, Jesus asks that the stone should be taken away, even though Lazarus has been dead for four days and stinks. In a loud voice He cries: 'Lazarus, come forth', and Lazarus emerges, still shrouded.

For the medieval Christian, the moment is one of the affirmation of faith; for all its strangeness, it is a moment of absolute normality. Giotto lends the scene the lapidary vividness of which he was uniquely capable: to the left, Jesus commands; to the right a waxen-faced Lazarus appears, exciting horrified gesticulations in the onlookers, some of whom cover their noses at the stench; Mary and Martha are prostrate in faith. This is an art of authority, enforcing truth, and commending to us a way of reacting and seeing. By the same token, it is an art of convention. Traditionally and liturgically, this is the moment when the narrative of Christ's Passion begins. Here is the first great event in the Christian triumph over death, the adumbration in Christ's Ministry of His own greater triumph to follow.

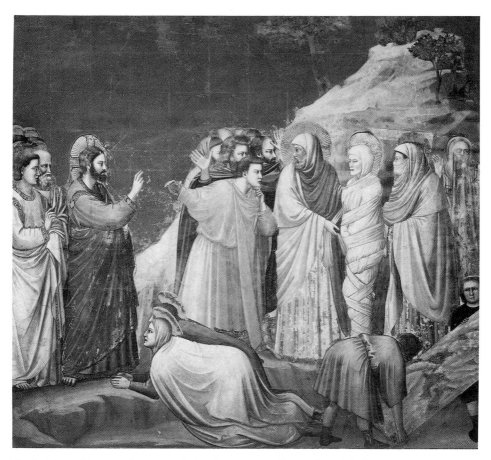

The Raising of Lazarus, by Giotto di Bondone, *c.*1305. Arena Chapel, Padua.

The Impact of Christianity

The facts of medieval death were largely, if not entirely, Christian facts. Christianity, after all, placed a death at the centre of its drama of salvation, that of Christ who redeemed the world on the Cross and subsequently rose from the dead. Its central sign was in effect an implement of lethal torture. But to sophisticated first-century contemporaries of Christ and St John, whether Jew, gentile or Greco-Roman pagan, the raising of the dead was supremely abnormal and absolutely transgressive. Of the colonial, multi-faith and multi-cultural world of the time little can be said by way of intelligent generalization, except perhaps with regard to this monumental interference with the impure, the dead. Here, in a Hellenized pagan world, devoid of systematic dogmatic structures but nevertheless capable of richly imbuing life with meaning, the stunning impact of a new faith is witnessed; a faith rooted deeply in older beliefs about life and death, but

one whose main strength, for the next millenia, lay precisely in its capacity to produce systems. Christianity, for all its initially transgressive character, systematized death in ways (for Christianity was itself heterogeneous) which lent it unique cultural importance, an importance inseparable from the fact that from the fourth century the religion, enjoying official sanction within the Roman Empire, was becoming inextricably bound up with its social and political structures. It was through the universalizing power of the state, and through the drama of its own spiritual claims, that Christianity came to articulate and revolutionize the imaginative world of western Europe.

That so great and, eventually, so universal a system should emerge from a revolutionary moment in attitudes to death and the dead is our first remarkable fact. St John's story of Lazarus plays on many of the contemporary anxieties about death; and in challenging them it inverts and throws aside ways of thinking. Its image of the gravestone rolled away – foreshadowing the narrative of Christ's own void tomb exposed by the rolling of a stone – symbolizes for us a conceptual breach of ancient barriers, ancient taboos. Like all powerful new ideas, it reveals a profound understanding of context. To Judaism the corpse was a site of impurity: Numbers 19:11–16 specifies that 'He who toucheth the dead body of any man shall be unclean seven days'. To pagan Roman world the dead body was an abomination, abhorred by the Gods. The dead were to be honoured, but to the notion of honour was attached that of appeasement, leading to the idea that the dead should be distanced and placated. Romans had accepted anciently that the dead could be buried within the precincts of a house; but intra-mural burial, within the city walls, was eventually prohibited by the Roman imperial Law of the Twelve Tables and was later repeated in the Code of Theodosius, which stated that the dead must be removed from the city of Constantinople. The dead were deliberately kept out of the sanctuaries and were buried *extra muros*, outside the city walls, especially the Aurelian walls. Only *triumphales*, those held in special esteem, were buried within the city wall as a point of honour, like the Emperor Trajan, whose ashes were placed in a golden urn and laid to rest in his triumphal column. Some pagans believed that there was an underworld of the dead ruled by Pluto and Persephone, with gates at various places which were opened periodically to give the dead access to the world of the living. Rome possessed one such gate covered by a stone, the *lapis manalis*, raised three times a year during the infernal 'adits' (i.e. ritual openings of the entrances to the underworld). The dead were widely thought to linger in their souls near their bodies for three days, hoping for joyful access to life; but they were a thing to be kept apart. The modern word 'funeral' is related to the Latin *funestus*, implying profanation by the dead. The story of Lazarus concerns a rolling stone and, in its four-day-old figure of the corpse, stresses the body's absolute deadness, the greater to emphasize the accomplishment of its resurrection. The third day of the Easter story of

Christ's Resurrection reflects this same sense of time's passage, the Gates of Hades converted, as it were, into the Portals of Paradise. The Christian triumph over death is final, absolute, for with it death re-entered the realm of the living.

Pagans regarded the idea of the resurrection of the dead as primitive but powerful. The great fourth-century Christian writer Eusebius tells us that the Romans burned and scattered the charred remains of the early Christian martyrs of the city of Lyons to prevent their resurrection and also, presumably, to prevent the gathering up of anything worth venerating as a sign of martyrdom. In 296 the Emperor Diocletian decreed that the Manichees were to be burned. This exposes for us another truth about Christianity: that it was both a religion of system (or, better, systems) and a religion of the body as much as of the soul. Christians usually did not practice cremation except, of course, in later centuries when the burning of heretics – defined by the clash of systems which Christianity comprised – marked out the periodic crises which identified Christianity as a creed of intolerance of itself, in its various forms. Here burning signified the purification of the soul, and the bursting into the temporal world of the ghastly retributive power of the afterlife.

From the time of St Paul onwards, the great transgression implicit in the Christian attitude to the dead threatened both to reorder the old worlds of nature and divinity and, more importantly, to adjust, or renegotiate, the sensitive boundaries between the dead and the living. Under the new apocalyptic dispensation of the early Church, death and the dead were fundamentally resocialized, and it is to this very basic realignment that we must look to understand the links, and points of difference, between this early world of the Church and the Middle Ages. We can do this by considering two critical topics: attitudes to the body and attitudes to the soul.

The Christian Body and the Cult of Relics

Christianity acted slowly, in effect, to demarginalize the dead, and it was the closeness of Christians to the dead that excited comment. Writing from the perspective of Egypt, Eunapius of Sardis noted of the Christians:

... they collected the bones and skulls of criminals who had been put to death for numerous crimes ... made them out to be gods, and thought that they became better by defiling themselves at their graves. 'Martyrs' the dead men were called, and ministers of a sort, and ambassadors with the gods to carry men's prayers.

At first the bodies of the dead, including the Christian dead, had been concentrated outside cities in burial complexes, or necropoli (cities of the dead), well removed from the living; and it was here, in suburban contexts, that communal devotions to the dead, and the natural expressions of kin and community,

occurred. Then, with the growing importance of the Christian profession of faith through confession and martyrdom, the sainted dead, what Peter Brown called the 'very special dead', were admitted within; especially into the churches of the newly Christianized Latin empire. It was near the Christian altar, the focus of the new mysteries, that the dead were now installed: 'And . . . I saw under the altar the souls of them that were slain for the word of God and for the testimony which they held' (Revelation 6:9). The saints were the first to enjoy this special protection, for in a special, and essentially Christian, sense the saints were not entirely dead. As ministers and ambassadors, the saints owed their peculiar power to their ambivalent identity, on the one hand physically present on earth through their bodies, yet received already into Heaven. The saints were now the main transgressors between the realms of the quick and the dead, and it was they who enjoyed the light of reality and the quick who lived in the shadow of life: a reversal of the tenets of pagan hedonism.

The construction within city walls of basilican churches, where the dead were also buried, effectively helped to urbanize the dead. This accelerated roughly from the time of the Emperor Constantine's Edict of 313 granting freedom of worship to Christians, and obviously had implications for the visual culture of death. Pagan burial typically occurred at the fragrant suburban wayside, as along the Via Appia leading to Rome (though the mighty mausolea of the great like

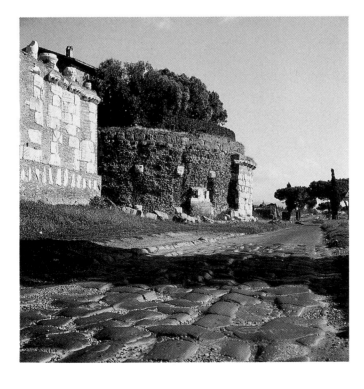

The Via Appia, Rome, showing Roman roadside memorials.

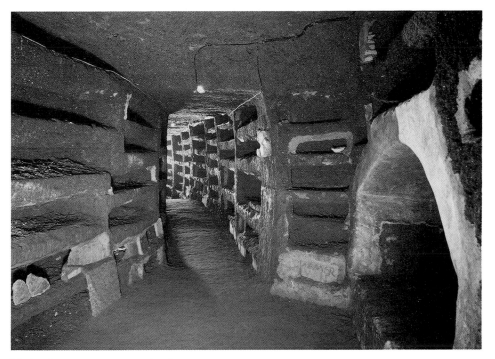

The 2nd-century AD catacomb of Priscilla, Rome.

that of Theodoric at Ravenna were also notable), and it was in such places that sculpted tombs arrested the passer-by with the injunction *Siste viator* ('Halt, traveller!') – a form of address later appropriated by a thousand tombs in the aisles of Latin churches begging for Christian prayer. In contrast, Judeo-Christian discourse of the afterlife, based on the old idea of 'Sheol', had favoured subterranean burial outside the walls in catacombs, effectively apartment buildings for the dead. Catacombs were often in essence private underground graveyards, located thus not because of fear of persecution, but rather, like the high-rise building, as a solution to the economies of space. As, from the fourth century, the dead saints were admitted to the great basilicas of Rome – at first those, like the Lateran and St Peter's and St Paul's, outside the walls of the city, and later those erected within – the culture of the exterior garden tomb was replaced by an interiorized and hierarchical model of burial within. Special burials attracted those of a more humble but spiritually ambitious inclination, and around the shrines grew up burial sites within churches as lavish and various as coral. It was these sites which established the model for the later development of the medieval tomb. From now on the bodies of the saints and those seeking their nurture were held within the Body of Christ, 'upon the very limbs of Christ', as St John Chrysostom (d. 407) said, in objecting to the development. Latin Christianity

departed from the Byzantine East, and eventually Islam, in shedding older taboos about the dead in church.

By the same token, social and religious practices concerning the dead were affected by this new exchange between the city and the places outside: the origins of medieval pilgrimage to the saints lie in the visits made by the faithful to special burial sites of the faithful without the walls in the Early Christian civic world. On such journeys the urban community of the faithful was able to objectify and examine itself in a new 'liminal' context (I shall return to this idea of liminality later – see p. 29); and it was also able to enjoy the 'therapy of distance', much as Chaucer's pilgrims cantering to St Thomas were able to identify and narrate the shortcomings of their own society while on holiday. Shrines both outside the city and within its churches became the principal focus of a new order. Within the shrine was a presence, that of a special dead person. That person was linked, usually, to the place of burial; saints came to symbolize, emblematize, places as effectively as household gods: at first these were the closed spaces of churches and the institutions linked to them, then cities, and finally, with the Middle Ages, nations. Medieval nationhood and kingship identified closely with saints, and thus with special shrines. But it was important to gain proximity to these holy bodies, either for reasons of protection in death or because the bodies were able to transmit the miraculous healing powers of God to the sick. The habit of pilgrims spending a night by a saint's shrine recalled the 'incubation rites' associated with pre-Christian healing cults like that of Asclepius. Shrines and pilgrimages owe their very rationale to the overcoming of distance between the living and the dead; shrines, with their closed surfaces, were to be touched as much as seen, since the power of a saint was itself a form of contagion.

As the Middle Ages progressed, this rationale was affected by other changes in the ways by which medieval people came to know the world. Shrines, for one thing, became important focuses of display for the sense of sight as well as for touch, though eventually entrance to the shrines was thwarted almost entirely. No-one knows for certain if any of Chaucer's fourteenth-century pilgrims actually touched Thomas the Martyr at Canterbury, but they could certainly see him portrayed in the surrounding stained glass emerging from his shrine to heal the sleeping sick nearby. The pilgrim moved in a world of bodies intact and dismembered, because to the medieval Christian the body was above all both a sign and, within itself, a hierarchy: the medieval individual – literally, from the Latin *individuum*, 'undivided one' – was in fact divided metaphysically into a body and a soul. But the body itself could be divided because, so far as a saint was concerned, part represented whole. A fragment of a saintly body represented the saint in his or her entirety, and, as Prudentius, the great early fifth-century Christian author of the *Psychomachia* and the *Crowns of Martyrdom*, said, bodily division manifested triumph over death itself. So when the law of the Church, Canon

Law, required the insertion of a relic of the titular saint into the table of the high altar of every church, echoing the text of Revelation quoted earlier (p. 12), that saint was fully and freely manifest as minister and witness, and ambassador, at that place. The saints could act and feel like the living, and were treated as if they were alive and incorrupt, which technically they were meant to be. Later sources like the *Dialogue on Miracles* of Caesarius of Heisterbach and the English *Speculum laicorum* are full of accounts of saints complaining at the indecorous behaviour of pilgrims at their shrines, scraping their muddy clogs on their steps, spitting, bleeding or even vomiting on their graves.

This sense of the reverence for holy bodies penetrated deep into the medieval mind. On the opening of the tomb of the great East Anglian king and saint, Edmund, at Bury St Edmund's in 1198, the abbot of the monastery went up to the body and asked the saint for forgiveness for his presumption:

he proceeded to touch the eyes and the nose . . . and afterwards he touched the breast and arms and, raising the left hand, he touched the fingers and placed his fingers between the fingers of the saint; and going further . . . touched the toes of the feet and counted them as he touched them.

This devotional lingering over the remains of the dead of course had a practical purpose, almost an inventorial one – to insure against thefts of relics, or *furta sacra*. Relics were a material as well as a spiritual resource, and their acquisition as potential objects of pilgrimage was important to many major ecclesiastical centres. They could be acquired either by gift as a sign of favour or by theft. The circulation or donation of relics was a means of securing loyalty and power; relics were instruments of patronage. For example the monks at Conques in France effectively stole the body of St Foy 'for the health of the area and for the redemption of its inhabitants', but also quite as much out of a sense of competition for status with a neighbouring monastery. Highly-placed men, future saints themselves, could be involved in clerical kleptomania. When visiting the abbey at Fécamp, in Normandy, Hugh, Bishop of Lincoln, exacted booty by biting off two small fragments of the bone of the arm of the most blessed lover of Christ, Mary Magdalen, the sister of Lazarus. This limb had never been seen divested of its wrappings by the abbot or the monks, since it was sewn tightly into cloth. Having been refused permission to see the relic, he took a small knife from one of his notaries, hurriedly cut the thread and undid the wrappings. After reverently examining and kissing the much venerated bone, he tried unsuccessfully to break it with his fingers, and then bit it, first with his incisors, and finally with his molars. When the abbot and monks saw what had happened they were first overcome with horror and then became exceedingly enraged. They cried out: 'What terrible profanity! We thought that the bishop had asked to see this holy and venerable relic for reasons of devotion, and he has stuck his teeth into

it and gnawed it as if he were a dog.' As dog eats dog, so saint eats saint: Hugh was himself canonized in 1220.

The amusing horror of this scene points to the absolute centrality of real or imagined physical contact with objects of Christian devotion in the Middle Ages, partly because such contact enabled the spread of beneficial spiritual contagion, but also because sensory contact was related to the idea of authentication. It was thus linked to the medieval notion of evidence, belief and tradition, systematized in the processes of canonization. To possess a relic was to possess a person and, literally, a body of evidence which substantiated a privilege, and in this sense *furta sacra* were not so much thefts as kidnapping. That this was so reflects the immensely complex and contested belief systems of the Middle Ages about self-hood itself, beliefs which related not just to saints but to Everyman. Debates of this type, essentially practical in their aims if not their character, affected not just the issue of bodily division and how this fitted in with resurrection but also the basic nature of the individual and the relationship within it of the hierarchy of body and soul. Some debates, which stemmed from the greatest Christian thinkers like St Augustine (d. 430) and St Thomas Aquinas (d. 1274), could sustain the view that relics were soulless, and so were not part of the form of the saint and were thus to be revered only as signs, like images on an icon or altarpiece; they were to be regarded as *aides-mémoires* and as devotional focuses. Here the concerns were fundamentally with idolatry, and we have only to turn to Bernard of Anger's critique of the reliquary cult of St Foy at Conques to understand what a delicate and pressing issue this could be. He had a point: the grim, masculine and eerily staring visage of St Foy's reliquary looks decidedly Roman in form. Other concerns, witnessed to by the great Cluniac, Peter the Venerable, stressed the idea that the saints are around the throne of Heaven while their bodies are on earth, the bodies being important because they were already touched by the glory of Paradise.

Not surprisingly, shrines, as the most important tombs in Christian Europe, were meeting points for tensions of various types, and the release of these tensions forms an important part of the sociology of the relic. St Jerome's letters give us one vivid image of the impact of the shrine of a prophet on a Roman pilgrim, Paula:

She shuddered at the sight of so many marvellous happenings. For there she was met by the noise of demons roaring in various torments, and, before the tombs of the saints, she saw men howling like wolves, barking like dogs, roaring like lions, hissing like snakes, bellowing like bulls; some twisted their heads to touch the earth by arching their bodies backwards; women hung upside-down in mid-air, yet their skirts did not fall down over their heads.

The images could almost have been drawn from the ecstatic poses of jongleurs or other marginalia trapped in the coiled foliage in the borders of some Romanesque

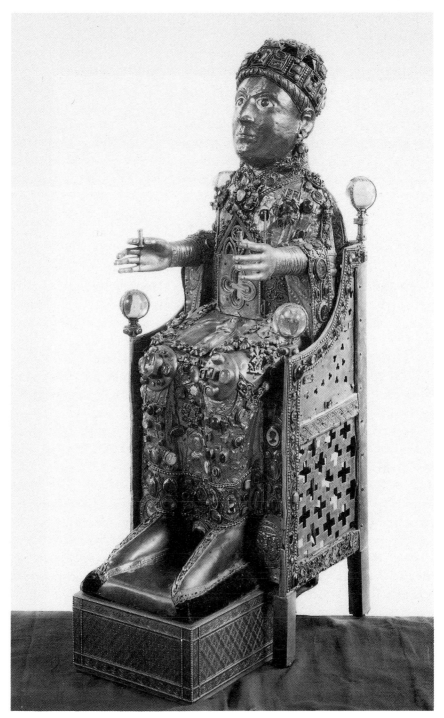

The reliquary of St Foy at Conques. This Romanesque body reliquary was attacked in the 11th century by Bernard of Angers for its resemblance to an idol.

illuminated manuscript. In his treatise *De Consecratione* on the rebuilding and re-equipping of the great Benedictine abbey of Saint-Denis near Paris, the twelfth-century Abbot Suger reports in similar vein on the problems of pilrimage. Such were the crowds coming to see relics at the church that

no one among the countless thousands of people because of their very density could move a foot . . . no one, because of their very congestion, could do anything but stand like a marble statue, stay benumbed or, as a last resort, scream. The distress of the women, however, was so great and so intolerable that you could see with horror how they, squeezed in by the mass of strong men as in a winepress, exhibited bloodless faces as in imagined death; how they cried out horribly as in labour; how several of them, miserably trodden underfoot but then lifted by the pious assistance of men above the heads of the crowd, marched forward as though upon a pavement . . . Moreover the brethren who were showing the tokens of the Passion of Our Lord to the visitors had to yield to their anger and rioting and many a time, having no place to turn, escaped with the relics through the windows.

Accounts of this type reveal several things about the role of shrines and relics to contemporaries. Shrines were in effect popular sites of emotional and spiritual release; pilgrimage provided the detachment necessary to form an objective view of the community, but access to a shrine flushed out the body and soul. St John Chrysostom remarked that 'where the bones of martyrs are buried, devils flee as from fire and unbearable torture'. The triumph of the Church and the saints over evil, following Christ's own example in casting out demons, was to be witnessed by the bodies of the saints and by their victorious images trampling on their satanic oppressors carved on the portals of the great medieval cathedrals. The shrieking vitriol of demons was to be carved on the great Last Judgement portals of Romanesque Burgundy, and Gothic gargoyles, expelled but subjected by the Church as the Body of Christ, lent reality to this notion of purgation and cleansing through their practical function as water spouts. The shrine was a place of exorcism, and as such reminds us of the inextricable logical link between the Christian view of disease and the soul; death and disease were the consequence of sin, and healing was thus the result of the rooting out of spiritual iniquity. The body was a sign, and in its broken glory the saintly body was a sign of triumph; in its twisted fallen nature, the ordinary mortal body was a sign too of the postlapsarian human condition, whose most eloquent theoretical exponent was St Augustine. Death was the consequence of sin since the Fall; but the saints were sources of health under the greatest health-giving banner of all, the Cross. No wonder, then, that medieval representations of miraculous cures like those attributed to St Thomas at Canterbury (PL. II), or to St Nicholas at Bari as depicted by Gentile da Fabriano, are so emotive in character.

By the same token narratives of this type also expose another truth about holy tombs, and about tombs in general: that their development was closely tied in

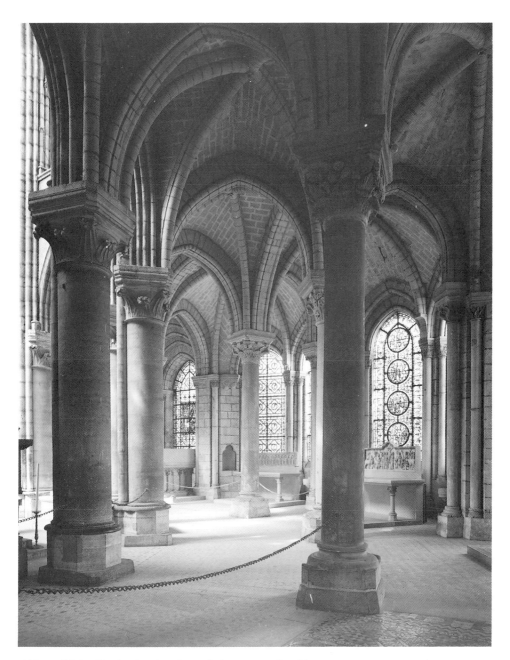

Abbey of Saint-Denis, showing the ambulatory completed in 1144.

with the politics of space in the church. We shall consider this in greater detail in discussing medieval burial. Abbot Suger's dilemma was that he presided over a church that was at once monastic, and so enclosed from the world, yet also the site of mass lay devotion; here were two seemingly irreconcilable but equally important bodies of interest. The period of monastic reform in which Suger lived and wrote, the eleventh and twelfth centuries, was an important one in the emergence of the medieval culture of death, and so too in the redescription of the boundaries between the monastic and lay worlds. The planning of pilgrimage churches (and other great churches) in this period attests to the reconciliation by various spatial strategies of two such incommensurate forces: one, monastic, undergoing constant self-examination, the other, lay, dangerously tainted by pagan practice and by the sheer force of womanhood. Even in the sixth century Caesarius of Arles had been concerned about Christians who danced in or near churches of the saints because it was a relic of pagan practice whose physical character resembled daemonic behaviour too closely. Thus it was that these two worlds had to be rigorously framed and separated, by locating shrines in discrete places like crypts or in spaces accessible to, but spatially separate from, the laity, as in the apses of the great pilgrimage churches of northern Europe. It was in the wake of these sanitizing precautions that the formation of the mausolea of the lay dead developed.

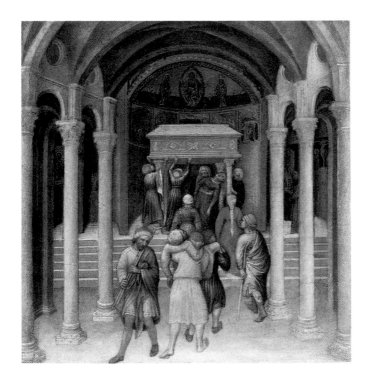

The miracles of St Nicholas of Bari, by Gentile da Fabriano, 1425. Note the stress on the faculty of touch and the emotive responses of the women. By placing the shrine in this accessible way, the painter has sidestepped the real practical problems of public behaviour in shrine churches. Compare PL. 11 and illustration on p. 79.

The dead in whatever form were coming to determine the internal topography of the church as a result of practical necessity; but at a more symbolic level they were directing, if not determining, other and wider topographies. At first it was necessary to identify personally with a saint in death: thus St Ambrose at Milan requested burial with SS Gervasius and Protasius as his protectors. In this he was to be followed by many others in the course of the Middle Ages who wanted burial *ad sanctum*. Gradually this habit was assimilated to mundane power relations; the shrines of the dead, like St Denis, or St Edward, came to lie at the heart of the formation of the medieval idea of statehood and kingship itself. The reception of relics by great cities like Constantinople, and later, after the sack of Constantinople, by thirteenth-century royal Paris, was a sign of the blessing of entire communities of whatever form. When Louis IX gained the Crown of Thorns from the Emperor of Constantinople in the 1230s, the Pope regarded this aquisition as a symbolic gloss on the crown of France itself. The national saint, together with the elevated and often dynastically-related dead that gathered around it, was a sign of collective merit; the impact of the dead was as ever-widening as the rings in water brought about by the casting of a stone.

The Christian Soul: Survival, Purgatory and Suffrages

So far we have seen that between the period of the early Church and the Middle Ages, the dead came profoundly to affect the living. Christianity, by virtue of its doctrines and the works of Christ, changed and strengthened the relationship between the quick and the dead. The Church placed the human body at the centre of its speculations about identity and faith, systematic or otherwise; and the power of the saints was bound up progressively with notions of authority, authenticity, place and, inevitably, power. Intimately tied to these issues was the question of the precise nature of the interaction between the living and dead; and related to this were the issues of selfhood, survival after death and whether the living could actively help the dead.

As we have seen, in a culture committed to a metaphysical view of the person, the individual was a hierarchy of separable elements; the body was arranged hierarchically, and the soul was its finer part. Depending on one's philosophical stance (and there were many stances in the Middle Ages) the soul was either the form of the body or something ontologically above yet within it. As we shall see throughout this book, the temporal body also stood as a natural sign for the condition of the eternal soul. The Christian view of selfhood, though informed by pagan thinking, was subtly different from that of the ancient world. There, the view (put crudely) was that a man, as a social animal, was situated historically and socially in relation to his ancestors and descendants, someone who at death had accomplished certain deeds and who counted reputation and honour above

all. What defined a person was that person's history in the continuum of his own society; the essence of personhood was biography. A person's biography, and hence life, ceased at death; and so it was from a diminished view of the import-ance of an afterlife that Aristotle was able to ask sceptically (*Ethics*, 1, x) whether it meant anything to say that the dead could be affected by the living.

Clearly there was already a body of evidence which could support the idea that the dead could be cared for as persons. Homer pays regard to the idea of remembering the dead, and from a Judaic perspective Ecclesiasticus 44:9 observes that those who are unremembered might as well not have been born. Memory was the sign of a good name. Of course in the heterodox pagan world this remained a complex issue. Some argued that since the dead were insensate they could not mind in what regard they were held in living memory: what was the point of honouring those who cannot appreciate an honour or, for that matter, feel harm? Hellenistic scepticism about the sensate nature of the dead was summed up in the very common epitaph '*Non fui, fui, non sum, non curo*' (I was not, I was, I am not, I don't care), the consequence of which was that death could not be inherently evil. In his *De rerum natura*, Lucretius, a follower of Epicurus, argued that it is as irrational to worry about the state of death as of pre-birth: non-existence is not an evil, and a person fragments at death and so cannot experience fear. For this reason Lucretius attacked the notion of the punishments of Hades and believed in the mortality of the vital animating spirit, since it leaked inconsequentially out of the body at death. There was thus no moral obligation to honour the dead, since they could make no claim upon the living.

Though Lucretius' position was not commonplace – it was after all Plato and Pythagoras who promoted the view of an afterlife with its punishments, Plato's *Phaedo* containing the pathetic image of the impure dead lurking around the tombs of their bodies – it is in a sense congenial to the modern mind. On the other hand modernity has a cruder (and, after Freud, more divided) view of the person than that which pertained, broadly, in the ancient and Renaissance worlds. There, a person was not regarded as a sum total of thoughts and feelings but more as a pattern of life, a process, with consequences in memory, honour and reputation. Human happiness, or *eudaimonia*, was essentially complete in good reputation after death. For Lucretius, fame was a species of triumph over death. Hence Roman tombs bore prominent public inscriptions in the form of *curricula vitae* as well as portrait likenesses of the dead as eulogistic signs.

The Christian view of the person was, and is, for the most part different. The Christian model of the person is inseparable from the idea of salvation; a person is someone who, like Christ, has undergone a series of transformative crises – conversion, baptism and death, for example – and who emerges as a sum total capable of instant assessment, whose qualities are inscribed in the Book of Life

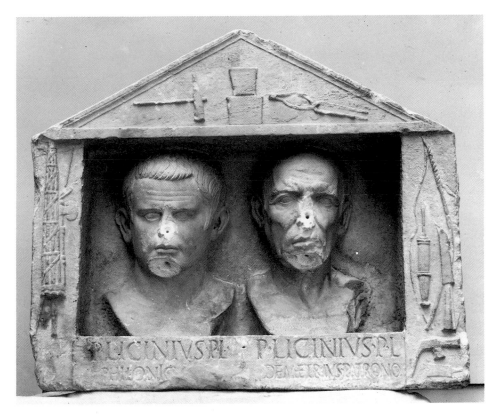

A Roman funerary relief summarizing the *curricula vitae* of the freedmen Publius Licinius Philonicus and P. L. Demetrius, *c.*30–10 BC. The left-hand border shows the rods and axes used in the ceremony of freeing slaves, the pediment shows the tools of a smith or moneyer and the right-hand border shows the tools of a carpenter.

to be judged. The Christian view of the person is thus progressive, and is linked in to the Christian view of time and history as a teleology, moving towards a finite end whose nature is determined by a super-individual, God. This eschatological view of time (time governed by a sense of ultimate destiny and fulfilment) could yield a powerful, cumulative and comprehensive vision of world history as fundamentally one of sin, redemption and salvation; judgement was thus not a matter of mortal reputation, but of instantaneous supernatural discrimination. Happiness lay not in reputation but in salvation. By the same token, the dead continued to exist, but in a new relationship to the world. Heaven was populated ahead of the final judgement by the saints. The dead were not, as in the pagan world, to be appeased and so kept apart. Pagans prayed *to* the dead for this reason: that the living should be protected. Christians, in contrast, for the most part prayed *for* the dead, since the dead were not held in dread. Only the saints were to be prayed to. It was in these terms that Augustine (*City of God*, VIII,

xxvi–xxvii) distinguished the pagan cults of the dead from Christian *pietas*: 'We Christians do not assign to the martyrs temples, priests, ceremonies and sacrifices. They are not gods for us; their God is our God'. The Christian's biography was merely interrupted by death and did not cease; in which case, what was there to fear from the dead?

The fact that the Christian vision of the dead was so confidently prospective had profound consequences for the formation of medieval culture. Shrines and tombs, and so the dead, were merely pivots in a broader history of salvation. The holy dead, in shrines, were in some sense alive, and could care for the quick. Late-medieval sermons still clung on to the idea that those not properly honoured in death or memory could be angry or even dangerous. But the living were also those-to-be-dead, and thus it behoved them to think ahead, both for the sake of those already dead, but also for the sake of themselves. This thinking concerned itself with two things especially: the doctrines of intercession and Purgatory.

The doctrine of the intercession of the saints was based upon the capacity of the saints to break the ancient boundaries between the living and the dead. But the notion of intercession could be widened into a form of two-way traffic, whereby not only the saints but also the living could act, by prayers or other actions, on behalf of the dead. Latin Christianity thus inaugurated a highly organized system of amassing benefits for the afterlife, and a vision of that afterlife more focused than at any time, perhaps, since ancient Egypt. The medieval view of the afterlife became 'transactional', founded upon a covenant between the living and the dead. This meant more than the idea common in the late Roman world, that compensation could be found in the afterlife for injustice in this world; that equity could be attained by redemption. It meant that the character of experience in the afterlife was itself not final but provisional, and that the process of salvation continued, or could continue, after death. What in the pagan world had been a system of honour that guaranteed happiness was transformed into a contractual relationship between the quick and the dead based on the finite, accountable notion of Christian time (which culminated in the general Resurrection of the dead at the Last Judgement), as opposed to the immeasurable, cyclical character of pagan time.

The early Church had not been greatly troubled by the notion of a strictly provisional state or place after death, in which Christians were to be held accountable. Early Christianity was more apocalyptic in tone, and placed greater emphasis, following Christ's own words in Matthew 24:34, on eschatological belief: 'This generation shall not pass, till all these things be fulfilled.' But the expected judgement, the 'parousia', or Second Coming, did not materialize, and the gap between the time of death of the early Christians and the likely period of their judgement widened inexorably. The principle of uncertainty, and the

need for preparedness so stressed in Christ's account of the Last Things in St Matthew's Gospel, were vitiated as the period before the Parousia seemed ever more expansive. Ideas expanded and elaborated to fill the time allotted: the notion of the punishments of Hell was enriched, as in the second-century Apocalypse of Peter. But the issue of the location of the dead after death, especially those who were neither wholly good nor wholly evil, demanded special attention. And it was in response to this that the notion of a place or state (or both) which was neither Heaven nor Hell, but rather a kind of prison, namely Purgatory, evolved. No one (we assume) wished to leave Heaven, and no one could leave Hell: but all wanted to get out of Purgatory, and moreover in time almost everyone could. This distinguished Purgatory from the somewhat less clearly formulated idea prevalent in the early Church that the dead went to what Tertullian called an *interim refrigerium* ('interim refreshment'), a waiting place typically in Abraham's Bosom between Heaven and Hell, until the Last Things.

The doctrine of Purgatory, which evolved slowly in the Latin West from around the time of St Augustine at the turn of the fourth and fifth centuries until the thirteenth century, came to be based upon an impressively simple, entirely calculable, rationale: that of the remission of a prison sentence. Those Christians not in mortal sin – which usually entailed eternal damnation in Hell – but rather in a state of venial (or forgivable) sin which required cleansing in Purgatory, could have their time in Purgatory shortened, and hence their access to Heaven accelerated, by the performance of prayers or other good works such as Masses, collectively known as 'suffrages', on their behalf by the living. It was pointless to pray for the damned. And only the living could assist the dead, since after death the possibility of self-improvement ceased. This decisively shifted responsibility for the dead onto the living, and inherently challenged the older forms of Christian eschatology: whereas the final cleansing of the soul, or catharsis, had been thought of as a final, communal and cataclysmic event, the notion of purgatorial improvement was inherently a process, rather than an event, and individual rather than communal. Moreover the living could build up, as it were, a credit system in advance to shorten their own stay in Purgatory, preferably by living and dying in a state of grace, and by caring for the souls of the departed. One could insure against one's future sentence, and this was most effectively done in life, since merits could not be acquired by the dead for themselves. A religion whose view of the Last Things had been based upon the principle of uncertainty was transformed into one founded upon an absolutely certain calculation; and it was on this basis that much of the religious institutional development of medieval Europe came in turn to be established.

The rejection of the doctrine of Purgatory by the Greek Orthodox Church, which had split from its Latin neighbour in the eleventh century, goes some way to explaining why Byzantine culture developed different notions of the dead and

commemoration. In the West, however, the doctrines and devotional practices of the Church became increasingly influenced by this idea of an advance credit system. Sin and the consequences of sin, as books called 'penitentials' show, were entirely quantifiable, as if in legal terms. This meant above all that the practices of salvation were concerned more with what we might call spiritual cures than with final judgement: this was a system concerned less with final painful retribution (though this remained important) than with healing of the soul. Purgation of the soul was fundamentally a form of further education, driven by the incentive system of Heaven and Hell, in which the living and the dead both participated.

Christianity thus affected a remarkable revolution. Through its notion of canonization of the very special dead, the living were first able to colonize Paradise ahead of time. This idea was then extended by the notion of Purgatory and suffrages in such a way that the charity of the living could morally structure the afterlife. The dead and the living were inextricably linked. This promiscuity between the quick and dead, which was noted early on as a feature of the Christian religion, was thus more profound than a merely physical or topographical relationship; it was at once spiritual and economic, and its interactive character affected the entire hierarchy of the human person. At one level caring for the dead had always been a norm. It had affected the rituals and cultural practices of death. Proper burial of the dead in order to honour and appease them, and ritual feasting at the graveside, were long established not only in the interests of the dead but also of the living. The culture of death is important because it discloses social and ethical relationships between those left behind. Tombs were a focus of familial and, later, communal ties.

St Augustine, who held that death is quite as much about the living as the dead, addressed the issue of Christian caring for the dead in relation to what he regarded as pagan practices (like feasting at the tomb) in his *De cura pro mortuis gerenda* ('On the Care to be Taken for the Dead') of 421. As with many educated Christians working within pagan culture, Augustine's literature is one of refutation: he cites Vergil on death in order to refute him. Christians, unlike the pagan dead in the Aeneid, went on to the other world regardless of the burial of their bodies. So Augustine, like Ambrose, thought elaborate funeral rituals and tombs redundant from the dead's point of view. In a letter of 392 Augustine complained about drunken parties around pagan tombs for the consolation and refreshment (*refrigerium*) of the dead, a practice continued by Christians despite the fact that such acts were anti-communal. His mother, Monica, had attempted such feasting until forbidden to do so by St Ambrose, Bishop of Milan. Above all, Augustine regarded banqueting at memorials as something ill-instructed because tainted with the notion of sacrifice to pagan deities. Thus Masses were offered up to God, but only in commemoration of the saints whose relics lay in

the altars. In this way Christian commentators deflected the charge that the cult of saints rendered their religion as pantheistic as that of the pagans.

In his *Confessions* Augustine held that Monica's memory was appropriately recalled at the celebration of Mass. Herein lay the seeds of a very important association which was to flourish in the Middle Ages. The Romans had funeral societies centred upon *columbaria*, or burial clubs, and their mystery cults had included insurance rituals for the afterlife. But early Christian cemeteries were adapted more for the *refrigerium*, the celebration of anniversaries, than for Mass rituals (though some cemeteries like that at Tebessa in north Africa had altars); and they had no permanent established clergy. With the growing practice of burial in the basilican church, however, it became possible to coordinate the recollection of the dead with the celebration of the divine mystery of Mass, the communal commemorative feast which lay at the centre of Christian practice. There was arising an area of indeterminacy between pagan Bacchic rites – sometimes represented on Christian sarcophagi of the period – and medieval Mass celebration. Rites of 'incorporation' of this type, which we shall consider in the next chapter, can resemble rites of hospitality. What was to happen over the next millenium or so was a further coordination of the practice of saying Masses specifically for the dead, with the calculus of suffrages and other good works for souls in Purgatory, in order that they might be incorporated more rapidly into Heaven. The responsibility for this kind of Mass was initially communal: but Augustine's strictures against the anti-communal nature of feasting the dead were premonitory, since it was in the course of the next millenium that the saying of Masses for the dead became increasingly privatized. It became possible to annex specific spaces for the celebration of Masses for the dead, and to endow those spaces with specialized clergy whose sole task it was to perform such Masses. Thus were the dead literally catered for. In 300 this would have been inconceivable; by 1300 it was big business.

This development could not have occurred without other significant institutional and cultural changes which emerged gradually, and with much discontinuity, between the collapse of the christianized Roman Empire and the Middle Ages. In stressing the points of similarity between early Christian ideas and those of the Middle Ages, we have to bear in mind too the points of fracture and innovation that separated the world of Augustine from that of Aquinas, the world of reaction against paganism, and the later world of systematic assimilation of Christian doctrine and pagan philosophy. Thomas Aquinas, for example, was eventually able to argue against Augustine that care for the dead body was legitimate, in virtue of the bonds of charity that linked the dead to the living. In considering these long-term developments, the rise of Benedictine monasticism is crucial. The monastic movement, which spread throughout western Europe from the fifth century, served both to preserve Latin culture in a time of pro-

found instability, and also to create a model – of which St Benedict's is the first important example – of social organization and religious practice. Monasteries, though set aside from the world, offered a communal counterpart to the family observances and pieties of the lay world. These miniature cities of God eventually became an important, and often aggressively competitive, focus of the medieval cult of relics and of pilgrimage. It became increasingly common for monks to become priests able to administer the sacraments, and as a result the monasteries came to enjoy particular authority as the communal guardians of the spiritual and ritual health of the world: it was they who defined the 'dont's' of religious and social practice from a position of exile. They attracted the protection of self-interested lay patrons who held temporal power; these patrons, usually at first aristocrats, could in turn require their monastic protectors to care for their souls. As monasticism, in both the Greek and Latin worlds, developed highly sophisticated ideas of religious practice and devotion, these ideas could spread throughout lay society, especially from the twelfth century onwards. The communal solidarity, in life and death, of the monastic community had much to teach the outside world, and by the later Middle Ages this served in turn to reinforce patterns of family solidarity and group identity across society, perhaps most notably in the city states of medieval Italy. Above all, the monasteries inaugurated that process whereby the certain and calculable system of insurance for the dead could become a norm. They have justly been called 'strategies for the afterlife'. It remained for them to present to the medieval world the smoothly organized and symbolically resonant rites of passage for the dead, to which we must now turn.

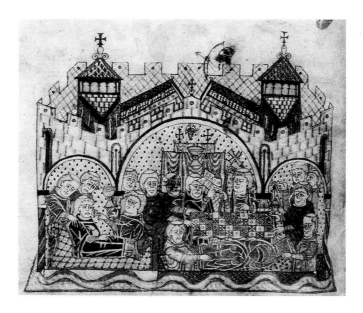

Death of a monk, from the late 11th-century *Life of St Maurus.*

CHAPTER ONE
WAYS OF DYING AND RITUALS
OF DEATH

Medievalists always have to take the long view. The history of dealing with the dead and the dying in our period is one of ancient continuities, breaks, diversification and synthesis, especially in the period up to about the ninth century and the rise of the Carolingian Empire. In the previous chapter, some of the essential themes in this process were sketched out, in order to convey the absolutely peculiar, yet rigorous, attitudes of Christianity to death. But anthropology reminds us too that many death rituals consist of certain basic structural practices, many of which were informed by ordinary biological necessity, but also by cultural relativities. Rites of this type concern processes of individual transformation, whereby social and cultural norms are symbolized and reconfirmed. Typically, such rites, as rites of passage, have a tripartite structure, an insight which we owe to Arnold van Gennep. Van Gennep argued that many rites of transition have, quite simply, a beginning, a middle and an end. In the case of death these transformations were tied in closely with attitudes to impurity, of the type that have been discussed by Mary Douglas; though Christianity oiled the wheels of social intercourse between the quick and the dead, it was historically situated in a world in which views of the dead as ritually impure were deeply rooted. The broadly tripartite rites of passage of the dead reflected these taboos.

At the heart of van Gennep's theory is the idea of transition itself, which centres on the idea of 'liminality' (from the Latin *limen*, 'threshold'). The first rites – threshold, or 'preliminal', rites – were, so far as the dying and dead were concerned, rites of purification and separation: anointing and washing (bodily or spiritual) of the dead, and the cleansing and reconciliation of personal and communal relations amongst the living. In Christian terms this meant the administration of unction and the elements of the Mass to the dead, and ensuring that the dead died in a state of spiritual grace. Anointing was the most final ritual statement: the anointing or unction of the dying (like that of a king at a coronation) was a ritually transformative act from which there was no return. Those who were anointed and yet lived were latter-day Lazaruses, walking corpses. Hence anointing was the most fearful of all the death rituals.

The dead, their neighbours and God having been reconciled, it was possible to inaugurate the liminal rites of the threshold at the actual burial of the body; hence, perhaps, the frequency of doorway and portal motifs on ancient sarcophagi and medieval tombs. By such rites the dead and living were finally separ-

ated, and the bereaved further distinguished from the world, at least for the period of mourning. There followed the 'postliminal' rites of reincorporation, whereby the dead were successfully installed into the afterlife and the mourners resited in temporal society, and so 'normality' was restored. In medieval practice this involved the conventional acts of restoration: proper and elaborate funeral offices and Masses, and the final appeasement of the hierarchy of the body and soul.

Christian death was thus a sacral process. But though it acknowledged the facts of finality, the preliminary rites of separation were always closely bound up with a natural hope: that the dying should not in fact die at all. Death rituals were founded at least in part on the idea of recovery, and hence owed much to other rituals of the sick and suffering. In a double sense, death rituals were about healing – healing the sick and, failing that, healing the soul. The quasi-medical, or 'thaumaturgical', character of medieval death rituals owed much to the heritage of Greco-Roman medicine; Christianity inherited practices and structures from the ancient world, but imposed upon them its own ethical system. Ritualized care for the sick provided the basis of death rituals in the Roman Church, including prayers and feasts for recovery and ritual anointing or healing by oil. These foreshadowed funeral Masses and the anointing of the dying, or extreme unction. As already noted, the Christian perspective saw the body as a sign of the soul; in curing the soul of sin the body too was cured. The early Christian thinker Cassian had developed the idea of the pastor as a spiritual doctor, and as one early Celtic penitential, or rule-book of sin, put it, 'different sins call for different penances, just as doctors prescribe different medicines for different illnesses'. Early Christian catacomb painters frequently depict Christ as a doctor, *Christus Medicus*, bearing a healer's switch at his miracles, like the Raising of Lazarus. In the New Testament, in Acts and in James 5:14–15, the sick were to be healed with oil. The link between sin and death was profound; and it was disclosed as much at the healing shrines of the saints as in the anointing rituals of monarchs who, in the Middle Ages, were possessed of the saints' thaumaturgical powers.

Rituals of the sick and dying thus served to overcome the old anxieties in the Roman and Judaic worlds about the impurity of the dead. They formed the basis of the later *Ordo visitandi*, the service of visiting the sick by the priest. They also served, by ritual reversal, to reinforce the Christian sense of the individual in time. States of transition resemble one another symbolically: we leave the world as we enter it, naked, needy and vulnerable, and so the rites of departure can resemble the rites of entry. Thus as we are washed and cleansed in death, so we are baptized at birth. This reminds us of the dual function of the Early Christian mausoleum-baptistery. The catacombs contain images which stood as types for baptism: Moses and Pharoah crossing the Red Sea, for example. It was also necessary that such rituals should speed passage, and offer protection on the

A medieval notification of death: the Mortuary Roll (1458) of Elizabeth Sconincx, Abbess of Forêt, a Benedictine nunnery in the diocese of Cambrai. Measuring over 42 feet long, the roll is headed with illustrations of Elizabeth's death and presence before the Virgin Mary with St Benedict. After the images comes the 'brief', a document setting out the names of those for whom prayers are asked. It is followed by the titles of the many monastic houses to which the roll was taken for presentation. The itinerary is dated at each stage of its journey, the roll having been taken to 383 institutions by 1459.

journey. The basic death rituals of the medieval Church thus involved confession, extreme unction and communion, the last being known as the *viaticum* (literally, 'one for the road'). The *viaticum* may echo the Greco-Roman practice of giving the dead travelling money for Charon, in order to cross the River Styx. Coins inserted into the mouth of the dying by pagans were thus transmuted into the Flesh and Blood of Christ as nourishment and shield for their journey into the afterlife.

Rites of this type form the earliest coherent Roman Catholic order of the dead, the fourth- or fifth-century *Ordo defunctorum*. Not surprisingly they have, in part, a judicial character: the Mass was regarded as an aid against the Last Judgement, and stood as a form of personal advocacy, a role later assumed by the intercessory power of the saints and especially the Virgin Mary. Though the developments in liturgy and ritual for the dead in early medieval Europe were extremely complex, texts like the *Ordo defunctorum* contain within them the seeds of formal ecclesiastical rituals for the dead in the Middle Ages. These were of two types, conforming to the basic liturgical norms of the medieval Church: the Requiem Mass and the Office of the Dead, a specialized form of vigil which did not include the Mass. We shall return to them shortly. Norms of this type were established in the period 500–900 by a long process of dialogue between the Roman Church and the Churches of north-west Europe, especially the Frankish Church, and they were consolidated under the Carolingian reformers; the formation of liturgy reflected the formation of power. As I have already noted, however, the contribution of monasticism to this process was vital. The death of a monk offered a model of communal solidarity – a monastery was a form of family – and so was an extension of the communal life. It reflected and adapted the monastic rituals of penance and the group vigil, in this case at the bedside of the ailing monk, together with chanting, the administration of unction and the *viaticum*, and the final rituals. Monasteries nurtured the memory of the dead by means of 'obits', or lists of the dead important to them, and anniversaries. When a significant member of a monastic house died, it became the practice to send out an obituary roll relating this fact to other monastic houses and requesting the support of prayers or Masses – perhaps as many as thirty Masses a day – for the dead. Monasteries in effect assumed society's role of caring for the dead and could offer to equally significant lay people, especially those who founded, built and patronized monastic houses, incomparable spiritual benefits. As the Middle Ages developed, the burdens of prayer and, especially, communal and private celebration of Mass for the dead, whether lay or religious, became vast: it is not for nothing that the medieval Church has been called (by G. G. Coulton) a 'Mass machine'.

In essence this clerical domination of the rituals of remembrance amounted to an appropriation of rites by a class of specialized technocrats of death, and

for the remainder of the Middle Ages this renunciation by society of rituals which formerly belonged within the family itself, to an impersonal group, remained normal. The modern lay alienation from death and its rituals stems in part from this development. But it also imposed stresses and strains upon a system premised upon cooperation between this special class of technocrats and the laity; those on the 'supply' side of theology and salvation, and the 'market'. Historically the solution to the burden of the dead carried by the monasteries and great churches was the privatisation of the Mass performance. The communal practices and obligations of death were paralleled, and eventually bypassed, by private practices which annexed the accomplishments of monastic religious culture in the interests of a privileged few. The communal rites of Mass and Office became the standard rites of the medieval Church in all its guises. But the details and habits of monastic devotion, especially as they developed up to the twelfth century, were also annexed by the laity. This meant the spread, from the thirteenth century onwards, of increasingly personal habits of religious thought and deed with specific devotional ends. It meant too that the growing sophistication of communal rituals of a preliminary type – the rituals of separation and purification – also spread to a much wider public. As the theology of sin, and the disciplines of confession and penance, matured in the High Middle Ages, so those rituals which concerned the agony of the dying, and their preparation in death for the afterlife, gained in complexity and system. In short, they became, if not an art, at least a craft: the craft of dying, or *Ars moriendi*. Before considering how the rites of the Mass and Office affected the ritual and visual culture of the Middle Ages, we must look next at the 'good death', how to do it, and how not to do it.

The Good Death

A good death could be the guarantor of the future in two senses: the material and social world of the deceased, their sphere of personal obligation and possessions, could be put in order by the due process of the will – an increasingly important and elaborate form of document – and the soul's future could be cared for. In this sense the good death could ensure satisfactory continuity. The will, as an instance of the growing reliance of medieval society upon written transactions, stands as an important source for ordinary social, as well as devotional, concerns. This is because wills performed two functions: like the ancient Roman will, the medieval will was a legal means of settling an estate; but it was also a religious document, the aim of which was to settle the soul. The will was thus a document of exchange in material and spiritual senses. Late-medieval wills frequently ask for *Diriges* (see below p. 53) and doles, or alms-giving to the poor, by way of good works, and also the saying of Masses.

Medieval wills are often bipartite for this reason, opening with pious clauses before getting on with the nitty-gritty of temporal possessions, whose value was legitimated by pious and charitable intent. The proper distribution of wealth at death defined (in part) what it meant to die well: to abjure the vice of avarice in a pre-capitalistic society in which capital tended to be hoarded rather than invested, and so could be passed on.

By the fifteenth century the form was sufficiently widespread to be aestheticized in the form of the literary testament, of which the most celebrated and gloomy example is associated with the French poet François Villon, namely his *Testament* written in the early 1460s. The will could also concern itself with the future of the deceased's body; many wills are in fact much more concerned with the place of burial than with its form, though wills could specify in detail the form of a funeral, or obsequy, as well as that of a tomb. That of Richard Peke of Wakefield, dated 1516, deals with spiritual property first:

First I commend my soul to God Almighty, to our Lady Saint Mary, and to all the saints in Heaven; my body to be buried in the parish church of All Hallows in Wakefield in the choir of St Nicholas, in the midst of the lowest aisle, when God please to call me to his mercy.

Here was a strategy for the afterlife: the body is to be buried in a position of humility, yet one which was accessible. The protection and intercession of the saints were available to all. The will, aside from enacting a strategy, also served to give the dead a voice, a matter of critical importance in matters of *realpolitik*. In the great late eleventh-century Bayeux Tapestry, executed at a time before the formal will became widespread, the matter of the death in 1066 of King Edward the Confessor and the handing on of the realm of England, altogether bigger property, is treated with some elaboration. Edward's death is shown at two levels. In the Palace of Westminster, the king is shown first on his deathbed in an upper chamber, speaking with his *familia*, including Queen Edith, who weeps at the foot of the bed. Edward appears to stretch forth his left hand to touch that of

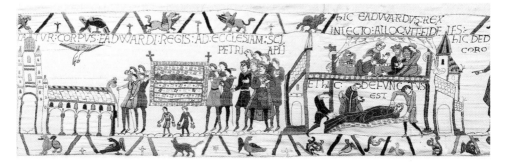

The death and funeral of Edward the Confessor, from the Bayeux Tapestry, *c.*1080. Compare illustration on p. 79.

The good death of St Louis (d. 1270), from the *Hours of Queen Jeanne d'Evreux*, 1325–8.

his interlocutor by the fingers; in all probability this is Harold Godwinson, who is about to assume the crown, the gesture signifying Edward's transmission to him of the kingdom. The gesture represents the king's will. Below, Edward is laid out and, to the left, his cortège moves solemnly towards Westminster Abbey. In 1161 Edward was canonized, and his hagiographical literature composed at this time includes an account of a vision had by the old king near his death, foretelling the ills of the kingdom to follow and its eventual reunification in the hands of one of his successors. Death could bring about breaches of time and space, and moments of insight into the future not of the self, but of the dynasty.

The good death formed an important part of the posthumous mythology of the great Christian king; St Edward was one such, but a greater was Louis IX, King of France (d. 1270), who was canonized in 1297, the first and last major French royal saint. Louis died on crusade in Tunis, and his death, as related to us by his biographer Joinville, reflected the preoccupations of his life. According to one tradition he called his son Philippe to his side and gave him the necessary instructions for the performance of his duties, or *enseignements*, some-

what in the manner of medieval advice literature (Louis' letters to his daughters are similar):

'Finally, my very dear son, have Masses sung for my soul and prayers said for me throughout your kingdom; and give me a full and special share in all the good you do. My own dear child, I give you all the blessings a good father can give his son. May the blessed Trinity and all the saints keep and defend you from all evils; and may God grant you grace to do His will always . . . Amen.'

When the good king had given these instructions to his son, the illness from which he suffered began to take stronger hold on him. He asked for the sacraments of Holy Church, and received them with a clear mind and in full possession of his faculties, as was evident from the fact that while the priests were anointing him and reciting the seven special psalms he repeated each verse after them in turn.

The king then had himself laid on ashes arranged on the floor in the form of a cross, and died. Implicit in this kind of ideal death – the 'tame' death identified by Philippe Ariès – are notions of peace, purity and reconciliation, which were frequently of monastic inspiration. The happy man died in bed in a domesticated and regulated fashion. Earlier, pagans had hoped for a quick (and presumably pain-free) death; Christians, as their wills often show, feared a quick death - a *mors improvisa* – because it robbed them of the opportunity to render themselves penitentially into a state of grace. Here, as we shall see later, was part of the threat posed by Death personified, namely his capacity to surprise. But late-medieval Christians in dying could aspire to strengthen the permanent bonds of solidarity between the dead and the living, and solidarity of this type was essentially an affair of kin and family.

But if the living could not always live in a state of absolute preparedness, treating each day as if it were their last, they could at least hope to die in such a state, Death permitting. Christianity is a religion of example. This meant above all that the dying, especially if they were laypeople, needed to understand the basis of sin, confession and penance. By the thirteenth century the western Latin Church had generated a complex and highly institutionalized culture of sin and penance, and in this period was endeavouring to spread knowledge of this system to the laity. At heart the system was legalistic in character, the system of tolerances or indulgences (relaxations of the penalties for sins committed) being juridical in its basis. This was a time when the doctrines of the afterlife were being formulated in terms appropriate to the quasi-scientific law of the medieval Church. Central to the definition of sin and punishment was the issue of the attitude in which a sin was committed: what defined the gravity of sin was the intention or will behind it. Involuntary sin was thus defined as venial, or pardonable; voluntary or wilful sin, as mortal. The distinction between involuntary and voluntary sin yielded a corresponding penitential structure. The graver of the two types of sin, mortal or voluntary sin, could be erased only in two stages:

first the sinner had to acknowledge guilt through confession, and second the sinner had to undergo a suitable punishment, which, having been received, yielded satisfaction. Confession and satisfaction thus effaced guilt, or *culpa*. Satisfaction further required the completion of penance, and this could go on if necessary after death, in Purgatory. It followed that it was sensible to acquire satisfaction before death in order to free the sinner from Purgatorial punishment, and this could be done, if necessary, on the death bed; the sinner, however, could choose, since the system was premised upon the idea of free will, on the voluntary character of sin and penance. In this stress on the voluntary character of sin lay an important element in the construction both of the idea of the sinner and, more importantly, of the individual sinner.

Naturally it followed from this that the process of confession and satisfaction should be personalized. The major document of this initiative was the Fourth Lateran Council of 1215, canon 21 of which required auricular confession once a year on the part of laypeople to a priest, and the performance of penance on pain of excommunication and the deprivation of Christian burial and resurrection. Such massive sanctions lent growing weight to the importance of private, as opposed to communal, confession, and to its increasingly formalized character. They also, of course, transferred equally considerable authority to the Church, which already enjoyed the power of binding and loosing from sin. At work here, with the assistance of a formal instructive literature of penance, including confessional manuals, episcopal statutes and sermons, was the construction of a new psychology: that of sin and sinning. As the Church absorbed the intellectual procedures of the great schools of western Europe, so sins and their remedies became susceptible to classification and systematic description. Knowledge was power. In turn the laity had to acquire a basic knowledge of the Seven Deadly Sins, the Ten Commandments, the Seven Acts of Mercy and Seven Sacraments, and so on, just as, eventually, they had to have some practical ability to prognosticate through knowledge of the Four Last Things (Death, Judgement, Heaven and Hell). This new form of categorized knowledge system, frequently explicated by mnemonically clear numerical and diagrammatic structures in literature and images, is to be seen represented in much later-medieval parish church art, as for example in the stained-glass windows at All Saints' North Street, York, or in Franciscan-inspired images like those in the early fourteenth-century *Psalter of Robert de Lisle*. By the fourteenth and fifteenth centuries this type of literature was as capable of aestheticization as the will: it could become a genre. The sinner emerges as a distinct literary persona or psychological type in the writing of Langland, Chaucer and Gower. He was a type, namely one who was transformed by penance.

Like St Louis' advice to his son, and like the literature of sin and penance, the norms of death could be categorized and regulated. This did not have to occur

Wealthy York merchants supplied the early 15th-century window of the Fifteen Last Signs at All Saints', North Street. Based on the poem the *Pricke of Conscience*, the scenes show events in the last fifteen days before the Last Judgement.

with the assistance of the clergy; in fact, it could occur at home. In the later medieval period there was a flourishing literature of advice, typically courtly in nature, to be used in a domestic context, which regulated mundane behaviour and household practices. Literature of this type could have a serious ethical and political purpose, as in literature giving advice to princes of a type based on Aristotelian tradition. More often its basic tenet was that one should approach life with 'cunnynge', or practical wisdom. Such was the essence of the *Ars moriendi*, the how-to-do-it of death, a practical handbook for the ordinary (i.e. venial) sinner *in extremis*. One English text of the *Ars moriendi* is aimed in its own words at 'carnall and seculer men', though a clerical, perhaps Dominican, origin for the tradition of such texts seems highly probable. The early English publisher William Caxton made the link between the *Ars moriendi* and advice literature explicit. He translated a text from the French in the *Arte and crafte to knowe well to die* around 1490, including a list of texts concerning manners and accomplishments – how to converse, the use of correct table manners or playing chess. This association has led some commentators such as Philippe Ariès to link the late-medieval culture of death with a subtext of hedonism. But the *Ars moriendi* was critically concerned with the manner of death in this specific sense: that the character of one's death could be reasonably detached from the manner of one's life, and that self-improvement could, if necessary, be a matter of eleventh-hour reform. Actually for Ariès the issue of the *Ars moriendi* was more fundamental still: for him the 'tame death', the death of peaceful reconciliation, was supremely the death of the individual as opposed to the community. As John McManners has shrewdly pointed out, Ariès here dramatizes something more profound than the eschatology of the medieval individual, which may explain the extraordinary impact of French writing on the subject of death in the modern period. At heart Ariès is tackling (though without acknowledging the fact) the tension in modern, post-Revolutionary, French secular thought between the enlightened conscience and the tenets of Catholicism, which could result in the deathbed conversion. The drama here is thus also a modern one: between the individual conscience and the forces of unenlightened authority.

In any event, the *Ars moriendi* consisted of a layperson's version of forms of preliminal ritual developed by the medieval Church. In some respects, as a text of pastoral reassurance, it resembled the *Ordo visitandi* of the priest. In this sense its pattern of development resembled that of the Book of Hours, which was basically a layperson's equivalent to the texts used by the clergy in the public offices of the Church. It was an essentially late-medieval text, and is now preserved in over three hundred Latin and vernacular versions. The fact that it was eventually printed points to its widespread character in answering to a need. As a literary genre it developed in the late fourteenth or early fifteenth century, and is divided roughly into two textual types: the *Tractatus artis bene moriendi* and the

Ars moriendi itself. The latter was disseminated in the vernacular by block-book printing with illustrations. The *Tractatus* seems to have emerged at around the time of the Council of Constance, *c.*1414–18 which, like the landmark Lateran Council of 1215, stressed the importance of devout living amongst the laity. It seems to have followed from a section called *De arte moriendi* in the *Opusculum tripartitum* of Jean Gerson (d. 1429), the Chancellor of the University of Paris, a text which aimed at assisting the laity in the deaths of others, and not themselves.

The block-book version of the *Ars moriendi*, which is generally the most commonly illustrated text, consists of eleven woodcuts depicting a series of deathbed temptations of its central character, the dying man, *Moriens*. It is a form of bedside drama, which plays on the inescapability of death and also on the fragile but fundamental character of human choice – *Moriens* is in effect controlling the character of his own death, and so of his destiny. The most important thing is that he should die in a state of preparedness, that he should be 'shriven' (absolved) of his sins; to give someone 'short shrift' means to allow them little time for confession and satisfaction before death, to treat them curtly. He has to ponder the routes set out by the demons which cluster around and under his bed, or that prescribed by the holy presences of Christ, the Virgin Mary and the saints, before choosing the latter path and commending his soul to God, to the chagrin of the devils. In essence this is a restatement in rather direct form of a much older, and typically interiorized, struggle, that between the Virtues and Vices in Prudentius' *Psychomachia* in the old monastic culture. But here the struggle is objectified and rendered in simpler, more pastoral terms. Essential to both is the identification of the subject as a lone warrior facing an ordeal (and the *Artes moriendi* are a late survivor of this old judicial notion), rendered more telling in the case of *Moriens* by the isolation of death.

But the ordeal, like a catechism, is primarily one of interrogation. The ordinary sinner must contemplate a series of temptations against the theological virtues of Faith, Hope and Charity. The first two consist of temptations to unbelief and to despair. Not surprisingly, a focal image of the *Ars moriendi* is that of the model death of Christ, alone and suffering on the Cross. This is to be a central icon of contemplation in the vision of the dying, marking the idea of the imitation of Christ (*Imitatio Christi*), whose most famous contemporary exponent was Thomas à Kempis. A priest brought a cross for the contemplation of the dying in the *Ordo visitandi*. A third temptation is that to impatience. Illness, as a consequence of sin, is a form of Purgatory on earth, and the greater the sin the longer and graver the sickness; hence pride, which prevents contrition, also forms another temptation to the dying, and it is to the example of St Anthony as a model of suffering humility (like Job) that the dying should look. Models like this were already cited in the oldest Christian death prayer, the *Commendatio animae*, or Commendation of the Soul (based on Psalm 31:5). Finally there is avarice, the

The temptation to impatience (left) and the good death (right), from a late 15th-century *Ars moriendi*; in each case the demons are especially voluble.

storing-up of treasure on earth but not in Heaven. In some versions of the *Ars moriendi* this is accompanied by a series of interrogations of *Moriens*, some of which go back to St Anselm, and are again ultimately of much older monastic origin. The eleven illustrations of the standard *Ars moriendi* include, aside from the five temptations to unbelief, despair, impatience, pride and avarice, and five illustrations of the inspirations against them, a final picture of the good death.

The *Ars moriendi* represents a lay appropriation both of a body of knowledge and of a body of procedure; its pastoral character reminds us of those widespread efforts by the Church from the thirteenth century to educate laypeople in the basic tenets of sin, its character and remedies. In presenting death as a series of symbolic temptations, it serves, like many symbols, to simplify the reality of a messy process. At heart it acts as preventative medicine for the soul. Its nature as a procedural guide or codification might be explained, as Huizinga and Beatty suggest, by the tendency in late-medieval culture to formalize and regulate behaviour of all types. But the *Ars moriendi* relates much less successfully to what we might call late-medieval 'necromania'; it does not belong with the genres of the macabre with which it emerged historically, except in so far as it regulated anxiety. Rather, it confronts death with tried and tested forms of Christian consolation. Nevertheless, its fundamental premises were clear, and related to newer issues in the culture of death and dying. For one thing, one of its central preoccu-

pations, the solitary character of death and the role of everyman, *Moriens*, in assuming choice and so responsibility, remind us that in this period there was a new attention to the notion of particular judgement, the judgement of the individual rather than mankind in general. Its assumption must be that death is followed briskly by at least one form of judgement; and this shifted importance to the critical stages of death itself, and to one's state immediately afterwards. It did not guarantee final salvation, which was a matter for the general Resurrection and Last Judgement at the end of time, but rather provisional salvation. In assuming a particularity of judgement it also implicitly favoured, but did not actually require, some experience of the Godhead immediately after death, a sensitive and confusing issue much debated in the early fourteenth century, to which I shall return in the last chapter. Finally, the assumption that the dead were in some sense judged at death closed that gap which had opened up between death and judgement with the postponement of the Christian promise of the Last Things.

Other images of the period relate to the complex, and never absolutely determinate, body of beliefs and procedures represented by the *Ars moriendi* and the culture of penance. A famous illustration to the Office of the Dead (PL. IV) by the so-called Maître de Rohan, in a Book of Hours illuminated for Yolande d'Anjou in the early fifteenth century, shows a moment of death and the *Commendatio animae*, the commendation of the spirit. A dying man, naked and laid out on an expensive-looking cloth which only enhances the pathetic character of his body, speaks to God in Latin written out on a long banderole: 'Into Thy hands O Lord I commend my spirit. You have redeemed me O Lord, thou God of Truth.' (From Psalm 31.) His soul issues up from his head (the soul was usually believed to exit via the mouth) and is rescued by St Michael from a demon. God, a mysterious and venerable figure with a cruciform nimbus, appearing to blend the qualities of the first two persons of the Trinity, replies in aristocratic French: 'Do penance for thy sins, and thou shalt be with me in the judgement.' Here *Moriens* is with God but is not judged finally; rather, like St Louis stretched out on ashes in readiness for death, he is a penitent, and his judgement is provisional. At one level the ideas here are very old: the notion of demons coming for the soul of the dying, as in the *Ars moriendi*, can be traced back to the Apocalypse of Paul. By the same token, the dying man in the Rohan Hours is as naked as when he was baptized, reminding us of that ritual reversal noted earlier in discussing rituals of death and purification. Here the sentiment is Pauline: 'Know ye not, that so many of us as were baptized into Jesus Christ were baptized into his death? Therefore we are buried with him by baptism into death ... so we also should walk in newness of life.' (Romans 6:3–4.)

Another feature of the *Ars moriendi*, the old theme of the ever-present threat of Satan, and of spiritual death, had figured for generations. We find it in such

contexts as representations of the Last Judgement, like that sculpted on the west facade of Bourges cathedral in the thirteenth century, where St Michael, guarding the saved, wards off demons attempting to tip the scales of judgement in their favour. Images of this type are in their essentials inseparable from the visualization of the Last Judgement in paintings, like that by the fifteenth-century Netherlandish master, Rogier van der Weyden, in the hospital of the Hôtel Dieu at Beaune, in Burgundy. The patron of the Hôtel, Chancellor Rolin, had called for thirty beds to be set in a ward continuous with a chapel at its end, in which Rogier's tremendous image was erected in order that it could be seen by those too infirm to go up to the altar. Here the world of bedside images in the *Ars moriendi* is given its most dramatic expression. In similar vein, Dürer's contemporary Grünewald depicted the temptations of St Anthony, together with one of the most grotesque Crucifixions in medieval art, on the Isenheim altarpiece in Colmar, which once adorned the chapel of a hospital. This is scarcely the comforting image of Christ on the Cross of the *Ordo visitandi*. More modestly, Bosch's sixteenth-century painting of the Death of a Miser (PL. 1) elaborates in single framed form the temptation to avarice. At the foot of the miser's bed, in a fashion common in medieval domestic settings, is his treasure chest: the miser sleeps with his money and not with Christ, and has stored up treasure on earth. But he can still redeem himself. Death enters through the door to his chamber, but the true route of salvation is indicated by way of the image of the Cross in a window above. Typically, the images of the good are smaller than the images of the bad. Choice is hard and the way of salvation is narrow: of the rich man who turns away from Christ in sorrow Jesus remarks, 'For it is easier for a camel to go through a needle's eye, than for a rich man to enter into the kingdom of God.' (Luke 16:25.)

The Last Judgement, by Rogier van der Weyden, Hôtel Dieu, Beaune. The imagery of Rogier's largest folding altarpiece, which was made in the 1450s and originally placed on an altar in the Salle des Pauvres at the Hôtel, conforms to most Last Judgement images. The patron and his wife are depicted on the exterior of the altarpiece.

The Martyrdom of Saint Denis, by Jean Malouel and Henri Bellechose, *c.*1416. To the left the imprisoned saint is given the Last Sacrament by Christ in person, and is executed to the right; Christ crucified represents the model death.

From what has been said already, it is clear that the ideal Christian death was peaceful. But a violent death was not necessarily bad and could in itself represent an ideal: martyrdom for the faith. Saints who died peacefully were confessors; those who died violently in the service of the early Church, martyrs, the warriors and athletes of Christ. The early Church was fascinated by the phenomenon since the death of the proto-martyr, Stephen, whose profession of faith and death by stoning before St Paul is witnessed in Acts 7. Martyrdom was more than an ordinary mortal death; rather, it was in itself a sign of the transcendence of death, and of it the relics of the martyrs were proof. Frequently martyrdom was accompanied by signs and wonders. St Denis, the Apostle of Gaul and patron of France, had been executed by the Romans outside Paris at *Mons martyrius* (Montmartre); having been decapitated, he picked up his head and walked, to the astonishment of his persecutors. His body was the principal focus of the monastery at Saint-Denis whose crowd scenes were described earlier (p. 18). To triumph fully over death, it was necessary first to die. In keeping with this central Christian victory, the Church collected the stories of the suffering of its elect in

texts known as 'passionals', and 'martyrologies', which informed the writing of saints' lives, hagiography. One magnificent instance is the *Vie de Saint Denis* manuscript of 1317 in Paris, produced during the reign of Philippe IV of France at the instigation of Jean de Pontoise, Abbot of Saint-Denis, and finally presented to Philippe V. The manuscript's seventy-seven images are frequently cited for their marginal representations of daily life in Paris; as I noted earlier, one of the merits of sainthood was that it served to identify and emblematize a sense of place. But the bulk of the pictures relate a story of sorry sadism, the passion and death of Denis himself.

Narratives like this show that Christianity never entirely shed the ancient idea of the *cursus vitae*; but it spiritualized it and transformed it by the process of hagiographical writing, so that a saint's death stood as the summation, the final accomplishment, of his or her mortal life. In this process the transition of Christian cults from cults of martyrs (who died violently for the faith in its earliest period) to cults of confessors was important: the cult of the confessor was essentially a cult of a certain style of spiritual life and good works, especially miracles, whereas the cult of the martyr was centred principally upon a remarkable death. Each yielded a different type of personal history. Christ's example blended both. The religion had as its central sign the Cross, the means by which the universally good death had been obtained, and redemption won. Christianity is at once a religion of example and of history. It originated at a definite moment, and its commemorations addressed historical events. Of these the Crucifixion, the moment of redemption itself, was central. As with the lives of the saints, the story of Christ's Passion was expanded and dwelt on as a specific focus of devotional attention. Crucifixion scenes were probably the single most common in medieval art, together with images of the Virgin Mary. Canon Law eventually required the presence of this sign of expiation on the altar before the priest at Mass, the mystical commemoration of this sacrifice, and giant sculpted and painted crosses, or roods, stood at the centre of churches of all types as public objects of devotion. Images of this type evolved dramatically in the course of the Middle Ages. At first the Cross was a sign of triumph, but, with the rise of a new affective piety in the eleventh and twelfth centuries, the Crucifixion became a barometer of changing attitudes to Christ's incarnation and suffering. By the thirteenth century the Gothic Crucifixion showed a dead Christ with nails through each hand, and one through both feet, hanging uncomfortably from the tree, being known as the *Christus patiens*. To either side stood growing numbers of witnesses in ever more distressed condition, Mary and John grieving and, in the tremendous Italian Golgothas of the type developed towards 1300 in Tuscany, a positively operatic array of onlookers. These witnesses were important, because their affective gestures and expressions of despair marked out a mode of response relevant to the audiences of such images. For this reason contempor-

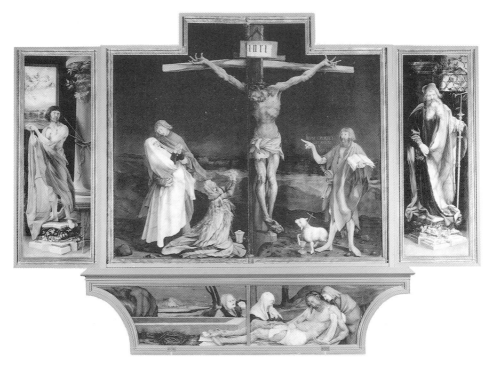

The Crucifixion and Lamentation, by Matthias Grünewald. Painted *c.*1515 for the Antonite monastery and hospital at Isenheim (St Anthony is shown on the image's left-hand side), this gruesome tableau represents the outer of three possible arrangements of the folding altarpiece.

ary Latin Passion Plays like the Italian *Planctus Mariae* contain exact stage instructions for gestures and speech. This threnodic mode of response was related to the growing importance of identifying imaginatively with the facts of Christ's bodily suffering, of which St Francis' reception of the stigmata on his hands, feet and side in 1224 was the most well-known example at the time. By such imaginative means, Christ's suffering was universalized and repeated. As with the *Ars moriendi*, texts and images were prescribing behaviour; their character was thus normative.

Not surprisingly, representations of the Crucifixion were a matter of debate and sensitivity. One commentator of the period, Bishop Lucas of Tuy, objected to the presence of Crucifixions with only three (rather than the older four) nails as being heretical. But such three-nail representations had the advantage of looking more excruciating (a word itself derived from the Latin for 'cross'). And when, in the early 1300s, a German plague or 'fork' Cross (*Gabelkreuz*) with Y-shaped arms was installed in a chapel in London, the image, which excited much popular devotion, had to be taken away by night and concealed. In both cases the artists who made the images, and not their patrons, were blamed.

Symbols had to be just right. In any event, all these examples point to one important fact about late-medieval Christian devotion, which will be of relevance to the culture of medieval death: many of its preoccupations were with the spiritual significance and representation of the body, whether divine or not. This bodily, or somatic, concern, is clearly related to the vividness and extremes of images like the fourteenth-century Röttgen *Pietà*, or Grünewald's horrendous Crucifixion on the Isenheim altarpiece.

The Bad Death

Christ died as a criminal, but he died well, promising the presence with him in Paradise of the good thief crucified with him, and commending his own soul to God. The bad death, and especially the violent death, was of course inherently more entertaining than the Christian notion of the 'tame' death, with which it contrasted. The Middle Ages inherited from the ancient world, and especially from the Romans, another view of death, which saw in it a form of justice without regard to supernatural remedy. In this sense death was not normative, but exemplary in the negative sense: it was an example of what not to do, and therefore could establish principles for action. Something of this can be judged from the account of the death of the Emperor Caligula in Suetonius' first-century biographical *Lives of the Caesars*, with its characteristically Roman blend of hedonism and violence:

On 24th January, then, just past midday, Gaius [Caligula], seated in the theatre, could not make up his mind whether to adjourn for lunch; he still felt a little queasy after too heavy a banquet on the previous night ... Two different versions of what followed are current. Some say that Chaerea came up behind Gaius as he stood talking to the boys and, with a cry of 'Take this!', gave him a deep sword-wound in the neck, whereupon Cornelius Sabinus, the other colonel, stabbed him in the breast. The other version makes Sabinus tell certain centurions implicated in the plot to clear away the crowd and then ask Gaius for the day's watchword. He is said to have replied 'Jupiter', whereupon Chaerea, from his rear, yelled 'So be it!' and split his jawbone as he turned his head. Gaius lay writhing on the ground. 'I am still alive!' he shouted; but word went round: 'Strike again!', and he succumbed to thirty further wounds, including sword-thrusts through the genitals.

The transition from this cynical and worldly outlook to the construction of a specifically Christian sense of the character of men's lives is marked, of course, by the historical and spiritual vision of Eusebius, Augustine and Orosius. This vision, though strongly anti-pagan in intent, recalls much of the rhetorical and ethical outlook of Roman moralists who viewed the activity of the historian as that of a censor. Antique form now took on Christian content; what concerned Augustine (in his *City of God*) and the many philosophers who followed him in the sphere of political thought, like John of Salisbury writing in the twelfth

century (e.g. the *Policraticus*), was the fundamentally corrupt nature of men's hearts. Rulership was now related to Christian notions of justice: 'We Christians call rulers happy if they rule with justice,' said Augustine. If justice was ignored, tyranny followed; and the manner of a tyrant's death was a sign of the character of his rule.

Medieval monasticism inherited this viewpoint and generalized it. The great thirteenth-century English chronicler monk Matthew Paris, writing at St Albans Abbey, had a wicked eye for moralizing narratives of death. Of that of Enguerrand de Coucy 1244 Matthew writes in his *Chronica Majora*:

Enguerrand, the old persecutor of the Church . . . died in a remarkable way; for he died, as it were, by a double death. Whilst living, he was a zealous builder up in material matters, but in spiritual matters a sad dissipator. One day, when travelling, he had occasion to cross a certain ford, when his horse's foot stumbled over some obstacle, and he fell backwards into deep water, into which he was unfortunately dragged by his stirrups; as he fell headlong, his sword escaped from the sheath and pierced his body, and thus drowned and pierced by his sword, he departed this life to reap the fruit of his ways.

Matthew's tangy rhetoric recalls Sallust or Cicero, but it points to ordinary concerns of the day, specifically the relationship between temporal and spiritual power that had erupted so viciously in the life of Thomas of Canterbury a generation earlier. His illustration of Enguerrand's death reminds us of the Fall of Pride. Matthew, in keeping with his contemporaries, saw unjust rule or behaviour as a form of disturbance of the natural order. In the ancient world the death of

The historian as moral censor: Matthew Paris of St Albans represents the death of Enguerrand de Coucy (1244) in his mid-13th-century *Chronica Majora*.

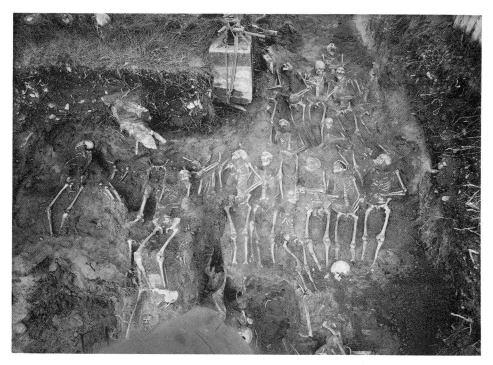

Mass burial formed the aftermath of the battle of Wisby, Sweden, 1361.

the mighty was often preceded by omens, like the comet which appeared before the death of the Emperor Claudius. Exactly this inheritance is reflected in the Bayeux Tapestry's account of the fall of King Harold. As we have seen, the tapestry includes one elaborate scene, that of the death of King Edward, which in representing the transmission of the kingdom to Harold at Edward's behest at least established that idea of continuity important to moments of liminality and passage. Edward is of course thus subtly implicated in Harold's assumption of the crown, notwithstanding Harold's oath to William the Conqueror that he would renounce his claim to the succession. Harold having been crowned and thus having committed perjury, the following scenes show the appearance of Halley's comet in 1066 and its warning to Harold; the ill omen provokes in Harold the ghostly vision of the ships which will bring William to England to conquer it. Harold's breach of the feudal order thus results in a portent of nature, and Harold's subsequent bloody death at Hastings by blinding is seen as a form of censorship and moral retribution (physical blindness equating with moral blindness); it is an exemplary death in the negative sense, because it restores order.

This kind of narrative, drawing on epic and biblical ideas, was popular in high circles in the Middle Ages; the fall of the bad pagan rulers, an Augustinian theme,

was illustrated in images in the palaces of Charlemagne, like that at Ingelheim, and the thirteenth-century English kings had scenes of the fall of Old Testament tyrants depicted in the Palace of Westminster. The theme became something like a genre, as in Boccaccio's fourteenth-century *De Casibus Virorum Illustrium*, Chaucer's *Monks' Tale* and Lydgate's *Fall of Princes*, all accounts of the great tragically brought low by their failings. But the violent death was not necessarily a matter of moral deflation. Facing death is at least in part about the virtue of courage, and both Aristotle (*Ethics*) and Aquinas (*Summa Theologiae*) thought that courage was shown above all in battle. The noblest deaths in the Christian-chivalric world-view, as in the *Song of Roland* or the great Arthurian cycle, were in battle. It became possible to construe biblical history as a history of warfare, as in the stories about Abraham, Joshua and David in the great mid-thirteenth-century French Morgan Bible Picture Book, which include some of the most telling scenes of gratuitous violence in medieval art, worthy of Joinville's accounts of the horrors of the Crusade. In these cases the history of the violent death is at one level a history of virtue; but it is also the history of a certain type of masculinity, and the history of a certain view of power. Death can exemplify both good power and bad power and, as we shall see shortly, can exhibit contested views of power in relation to the treatment of the body.

Reinstalling the Dead: Mass and Office

The bad death by its nature contravened the norms of preparedness and virtue that marked the ideal Christian rite of separation. Rites of reinstallation customarily follow rites of separation; and in the case of death, this required the reinstallation of both the living and the dead, a state which was attained through ritual. The role and importance of ritual is always problematical, since rituals can be defined in various ways as enacted symbolic representations understandable in psychological, social and historical senses. Rituals serve to communicate and to affirm beliefs, and because it is central to ritual that it tends to assume formal and invariant shape, rituals also act to stabilize moments of crisis, like death. But despite the fact that rituals are symbolic representations, and as such need to be both simple and correct in their content and performance, they nevertheless relate the individual to the social group, and to belief systems, in ways that are disputed. One school of thought, descending from Emile Durkheim, a founder of sociology, suggests that rituals are a form of social control: they express and reinforce ideas of group coherence. Individual responses to traumas like death are thus conditioned and articulated by rituals that express pre-existing social arrangements and expectations. The role of religious belief and symbolism in such arrangements is thus annexed, like the individual, to broader ideas of social order. The preponderance of such ideas in the study of 'deathways' has led

inevitably to a marginalizing, or even to a retreat, of religion, whereby religion itself is understood merely as the outcome of social expectations, and not as a primary motivation of such expectations. This problem – perhaps the hardest and deepest with which the cultural historian has to deal in considering the relationship of society, the individual and belief – is for our present purposes insurmountable. Religion is not separable from the social units that subscribe to it, and Christianity's great strength was that it could assimilate and rearticulate ideas – attitudes to the 'impure' corpse, for example – of pre-Christian pagan origin, which were both religious and social. Neither religion nor society are pure categories in themselves; they intersect in a complex order of symbolism, and that symbolic order is expressed in ritual.

The medieval symbolic order of death emerges most clearly in ritual forms and in tombs. In assessing rituals we have also to recall that the historian or archaeologist has to make a rigorous distinction between what can, and cannot, be excavated: generally in considering ritual we are considering not belief as such but behaviour; not what people thought but what they did. In suggesting that highly organized rituals were a means of negotiating the trauma of the living, and of reinstalling both the living and the dead, we must recall the artificiality of ritual. This is perhaps especially apparent in two areas, emotion and gender. There is little agreement as to whether the powerful emotions usually provoked by death helped to condition ritual or whether they were conditioned by it. Because thoughts, or *mentalités*, are (at least to my mind) beyond reconstruction, all we can ponder is the formulaic or conventional character of emotion. Grieving was certainly formalized in the Middle Ages. The Bible presented notable examples of male mourning, as in David's grief, covering his face, at the news of the death of Absalom (2 Samuel 18); but grief did not become a king. Joinville in his biography of St Louis notes that the king was prostrate with grief on hearing of the death of his mother, the formidable Blanche of Castile; but he also tells us that a certain seneschal of the king reproached him for too obvious a display of emotion before his subjects. The contemporary visual culture of French royal tombs, which we shall consider later, indicates this notion of decorum: the great thirteenth-century tombs of kings and queens at Saint-Denis erected during Louis' reign are quite devoid of any emotional content; images of 'weepers' carved on tomb-chests of French royal burials were to be found instead at Cistercian Royaumont amongst the burials of the lesser members of the French royal family, and so distanced from the sites of power.

In grieving, gender divisions are equally notable; usually in medieval art the codification of grief is the special preserve of women. This had long been the case, in keeping with practices of hiring professional female mourners in the ancient Mediterranean world. St John Chrysostom complained of Christians who 'hired women, pagans, as mourners to make the mourning more intense, to fan

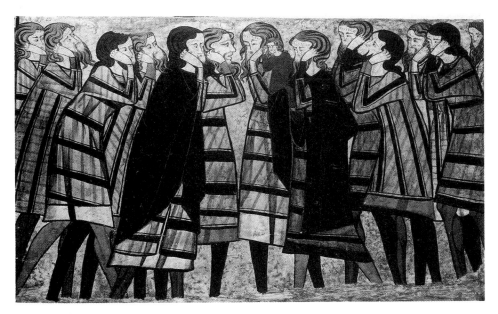

Formalized gestures of despair, in this case male, accompany the 13th-century Castilian sarcophagus of Don Sancho Saiz de Carillo.

the fires of grief, ignoring the words of St Paul'. Here mourning, the *planctus*, was unacceptable because it was related to pre-Christian notions of placating and honouring the dead. It may be partly for this reason that later there was some inhibition (primarily monastic and clerical) about the presence of women at funeral rituals, and eventually mourning rituals were private. Women usually helped to prepare the corpse for burial. So-called 'gestures of despair' were a feminine attribute, and it is usually women who are seen as mourners on Spanish medieval tombs, or in Italian images of the Passion of Christ: the Virgin Mary fainting at the Cross, and Mary Magdalen tearing her hair, were especially notable exemplars of feminine behaviour in grief, rather different from the highly regulated norms of behaviour usually prescribed for women in advice literature. This illustrates the way that mourners were suspended from social norms for the duration of grieving. The occasion of death was one appropriate to a display of affective relations, whether brought about by the bonds of marriage or kin.

But this sense of occasion was most developed in the highly symbolic rituals of the Church. Earlier, I mentioned the domination of formal death rituals by 'technocrats of death', namely the clergy. After the good death, which required above all that Everyman had been confessed, given communion and anointed, the Church customarily possessed two basic types of ritual which speeded the process of reinstallation and which were primarily the preserve of the clergy: the Office and Mass. Van Gennep notes that rites of incorporation of this type are

much more fully developed in funerals than are the rites of separation and transition which precede them. As we have seen, the basic structure of medieval funeral rituals went back to the Roman *Ordo defunctorum*. The *Ordo defunctorum*, which provides one basis for the Office of the Dead, is characteristically well organized. It prescribes the performance of a service for the dead after the administration of the *viaticum*. Particularly important is the reading of the Gospel account of Christ's Passion at the deathbed; this sowed the seeds of the imaginative identification between the death of the Christian person and Christ's own suffering so central to medieval culture: this we witness in the *Ars moriendi* and in the content of van der Weyden's hospital altarpiece at Beaune. The *Ordo* advocated prayer without intermission for the dead. It retold the parable of Dives and Lazarus in Luke 16, with its comforting (and central) image of the dead pauper Lazarus in Abraham's Bosom, and Dives the rich man far off in Hell. The *Ordo* thus disclosed the basically bipartite (Heaven–Hell) vision of the afterlife which prevailed until the advent of Purgatory as a place as well as a state. Readings from the Book of Job, a central text on man's alienation in suffering from God, formed an important element. Psalmody was also vital to the *Ordo*. The Psalms, which in contrast to Job are essentially cheerful texts, formed the basis of the public offices of the Church. Psalms 22, 42 and 116–18 were especially important to early funerary rites and remained so.

Typically the mature later-medieval Office of the Dead served as the main funeral service and was performed before the Mass. The Office was customarily enacted in the chancel or choir of a church with the corpse in a coffin with hearse and drapes: the laity would usually not enter this space but could in theory follow the service in a Book of Hours or Primer. In churches of all types the Office consisted of a routine of sung and said worship based heavily upon the Psalter and divided into liturgical Hours. These texts were found in a Liturgical book called the Breviary, and it was from the Breviary and certain other texts that the Book of Hours, essentially a lay prayer book with strong emphasis on worship of the Virgin Mary, emerged. Books of Hours preserve the same types of rites as Breviaries, including the Office of the Dead. For this reason they demonstrate the same propagation of ideas from the clerical elite to the laity as the *Ars moriendi*. The Office was, of course, also to be found in many Psalters of the period.

As preserved and illustrated in most Books of Hours, among the richest source of illustrations of death, the Office of the Dead comprised three of the liturgical hours: Vespers, Matins and Lauds. In medieval wills stipulating its recitation, it is usually referred to by the opening words for Vespers and Matins: *Placebo* and *Dirige*. It is from the solemn antiphon of the first nocturn of the Office for Matins, *Dirige, Domine, Deus Meus, in conspectu tuo vitam meam*, that we derive the word 'dirge'. The Office of the Dead draws upon the type of imagery we saw

included in the *Ordo defunctorum*. That of Vespers typically draws upon the Psalms; that of Matins cites the book of Job extensively; and at Lauds are performed the last Psalms of praise, ending with the great *De profundis*, Psalm 129: 'Out of the depths have I cried unto thee, O Lord.' Representations accompanying the Office of the Dead in Books of Hours fall into distinct categories, not all of which are explicable by the tastes of patrons: such manuscripts were frequently mass-produced. One type of illustration could concern the deathbed and its attendant rituals, such as the administration of the *viaticum* at the Last Rites, and the drama of salvation enacted in the chamber. The solemn nobility of the church service which followed may explain why the Office of the Dead is the one office most usually accompanied by images of a liturgical type. Some of these, though rare ones, explicitly depict the beneficial effects of Mass for souls in Purgatory. Other subjects could include the Last Judgement, events from the story of Job as related in the Office itself, the Raising of Lazarus, images of Death, or the Three Living and the Three Dead. The Office of the Dead frequently stands as an inventory of late-medieval images of the macabre, to which I will be returning later in this book.

The performance of Mass as a votive offering was, as we have seen, directly related to the benefit of souls in Purgatory (PL. III), but it also carried with it the notion of rest, in allusion to the dead which sleep in Christ (I Corinthians 15:18); the Mass thus ensured *requies* in the *refrigerium*. The funeral Requiem Mass which developed in the Middle Ages especially from the Carolingian period, was usually performed either immediately after the Office (Masses and Offices tend to over-lap or even clash in medieval liturgy) or first thing the next day. Mass could be either a communal or a private affair, but it conferred benefits upon both the living and the dead. It was of course possible to perform Masses for the dead on occasions other than funerals: thus a *Gregorian*, named after Pope Gregory the Great (d. 604), is a series of thirty Masses for the dead, celebrated for a month. By the later Middle Ages patrons could ask in their wills for a thousand funeral Masses, and these could, in lavish cases, be said or sung concurrently in a church with many altars. In the Middle Ages the actual celebration of Mass was largely a clerical concern. The Mass could accompany the Office, but it had a slightly different function, and medieval illustrations of the two services are usually careful to distinguish between the two, typically by including a priest celebrating at an altar in illustrations of the Mass, accompanied by clerks or monks in black. The use of black for funeral occasions in the Latin West appears to be old (indeed anthropologically speaking it is common), but it was also cul-turally relative; the Eastern Greek Church employed white at such rituals, black or white standing at the poles of the colour spectrum. In the early twelfth-century debate between St Bernard of Clairvaux of the Cistercians (who wore white) and Peter the Venerable, a Cluniac (at Cluny the monks wore black), on which colour

was appropriate for the monastic life, Peter said that only black could express the humble and penitential character of monasticism, and noted that it was anyway used for funerals in Spain. Black is the colour of unconsciousness.

Burial and the Politics of the Body

After the celebration of Mass, absolution was performed by blessing and purifying the body with incense and holy water. The body was then buried in the appointed place. Illustrations to the Office of the Dead introduce us to the medieval graveyard (PL. V). In reading these images we should recall that the dead were usually laid out in a shroud for burial (like Edward the Confessor in the Bayeux Tapestry), though from the thirteenth century it was becoming common to transport, if not to bury, the corpse in a wooden coffin to the singing of the Penitential Psalms (nos 6, 31, 37, 50, 101, 129, 142). Funerals were thus in part processional activities. The development of the coffin for use in the pre-burial procession is for Ariès 'a major cultural event', since it was restricted principally to northern Europe, and attested to a change in attitudes to the corpse less apparent in the south, where the old habit of exposing the body at the funeral survived. Made-to-measure coffining was done in the deceased's house, whereas the ready-to-wear variety, for paupers, was rented. The graveside events amounted to a final laying-out. Corpses were manipulable and divisible for essentially practical reasons: graveyards were sites of recycling, and their earth and worms participated in a sacred ecology. For this reason the bones and skulls that litter medieval graveyard scenes are not signs of macabre neglect; they simply reflected the fact that coffins were used for transport and not burial. Once a body had been buried and had decomposed to the point of defleshing, it was normal to exhume it and to store the bones in a charnel (from the Latin *carnus*, 'flesh', 'carrion') house. One of the most famous examples of a medieval *charnier*, or *aître*, was the Cemetery of the Innocents at Paris, which consisted of ossuaries, or bone-storage 'units'. The existence of a specific grave was less at issue than burial in consecrated ground: and this in turn reveals general cultural issues about territory and social exclusiveness.

In law, burial – and so the person – was defined in terms of a hierarchical view of the body; so burial was where the head of the body, physically and metaphorically, was retained. The dead were normally buried in their parish of birth. But burial by its nature expressed, too, notions of loyalty and affection of a spiritual or institutional kind which could run against the ties of birthplace. Neither kings nor popes had fixed burial places, though exceptions to this arose with the establishment by the twelfth and thirteenth centuries of dynastic mausolea. There were in addition other pressures, such as the desirability of being buried in close proximity to a saint. Though the *Decretum of Gratian*, a compen-

dium of Canon Law, had determined that burial was a spiritual affair not subject
to financial transaction, the giving of 'gifts' became normal; the ordinary dead
were bound as a rule to pay mortuary fees to the parish of birth, though these
could be diverted to places of burial elsewhere. Since burial was a form of busi-
ness this could, as we shall see, give rise to antagonism. To stem disputes over
rights to a body or to mortuary fees, a papal Bull of 1303 assigned one quarter
of the mortuary fee to the parish of birth.

Burial, like the death and rituals that preceded it, was still a sacral matter. This
had spiritual and social dimensions. The necessity of proper burial, and the con-
cern of the dead for it, is attested by accounts of apparitions of the dead from
the time of Bede. Belief in the value of burial in consecrated ground explains
the growing concern amongst the laity for spiritual provision. Burial in a grave-
yard usually meant burial in association with a parish church, and parishes had
themselves grown in north-western Europe in tandem with the rise of minster
churches and manorial establishments founded by the laity. Even ordinary par-
ochial burial thus exemplified quite basic relations of territory, and so power, in
medieval society. These grew more complex as burial within churches became
increasingly common. The logic of the general Resurrection and Last Judgement
was still essentially communal. The great thirteenth-century Roman liturgist Dur-
andus, Bishop of Mende, stated in his *Rationale* that the dead were to be buried
with their heads to the west and feet to the east so that all, regardless of station,
were pointing in the right direction at the Last Things. But in reality the location
of the dead either inside or outside mapped the order of the social elite as, in
effect, a supernatural elite.

The graveyard was, no less fundamentally, the site of social taboos. The role
of the priest in marking the burial place in the churchyard with a cross, breaking
the ground and performing the final rites was central. The corpse, which had to
be of a baptized Christian, was to be ritually cleansed and covered in incense,
ivy and laurel. Women did not participate in the carrying of the funeral bier. The
graveyard had to be consecrated by a bishop, and required reconsecration in the
event of pollution by the spilling of blood or semen. A thirteenth-century council
at Rouen forbade dancing in churchyards doubtless, in part, to control the hor-
monal excesses of village youth. Later, the cemetery of the Innocents at Paris,
famous for its Dance of Death image, was also a favourite haunt of prostitutes.
Nor could these spaces witness the burial of the spiritually and socially mar-
ginalized: the unbaptized, heretics, lepers, Jews and suicides, were all proscribed.
So were excommunicants. For these other cemeteries existed. Unbaptized
infants, consigned spiritually to Limbo, were pathetically buried in the circuit of
the cemetery (to avoid this, midwives could baptize, one singular instance of the
administration of the sacraments by women). So Limbo, a periphery of Hell,
found its topographical equivalent on earth. Exhumation rewarded heresy: the

bones of William Wyclif (d. 1384) were disinterred in 1428 and cast into a nearby stream.

All these groups were in a sense socially and spiritually dead. The prejudices of life were extended into death; and the character of death reached into the life of the fringes. Heretics, and lepers especially, were treated as objects of spiritual contagion. Thirteenth-century France saw the development of a rite of separation for lepers which mirrored the separation rites of the dead: those smitten were parted from society and led, corpse-like, from the church to the chanting of the seven Penitential Psalms. They were required to stand in an open grave while the leper ritual was recited by a priest, and to be literally humiliated by having spadefuls of earth chucked over their heads. Jews were similarly ostracized in the increasingly intolerant period from the twelfth century. The gates of Jewish urban ghettos were locked at night to prevent the Jews from wandering amongst the sleeping faithful, and they had their own cemeteries. Of these practices, often defined by the clerical elite, R. I. Moore has noted: 'This was an age of classification, and it was in the eleventh century that cemeteries began to imitate the precise and sharp distinctions which were then rapidly and harshly being established among the living.'

Classification of this type also structured the nature of burial and its attendant sense of display, and we shall return to this important area of differentiation in considering death and representation. In doing so we will see that a fundamental prerequisite for the development of the medieval tomb was the strategy of burial within church rather than outside, which by the thirteenth century was becoming more common for privileged laity. The process whereby wealthy or aristocractic laity were buried within had begun with cathedral and monastic churches, which benefited materially from the possession of an influential corpse. Burial was in effect tied up with various forms of endowment. As a result – and ecclesiastical legislation proves as much – an important and competitive economy grew up around bodies, extending that which had previously grown up around the relics of saints. This sat uneasily with the standard forms of prohibition against burial in church which were repeated throughout the Middle Ages precisely because the demand for it was so widespread. Papal privileges permitted religious orders to accept the bodies of the laity within the monastery: the Benedictines were the first beneficiaries of this privilege, but with the development of monasticism other orders, notably the Cistercians, followed by the twelfth and thirteenth centuries. By the fourteenth century Cistercian monasteries like that at Waldassen in Bohemia were fetching corpses from miles around for burial in their cemeteries. By then the threat of the Cistercians was paling in comparison with the hold established over the devotional life of the laity in northern Europe by the Mendicant orders, the Dominicans and Franciscans. The Dominican General Chapter of 1250 in London decided that their churches should not be used for

burial, but the restriction was short-lived: by the fourteenth century, as *Piers Plowman* relates, the friars had become notoriously greedy in their pursuit of the bodies of the new urban elites. Alvarus Pelagius remarked in his *De Planctu Ecclesiae* that there were men

who having died unto the world, have literally come back to bury the dead of this world: and such men, lying spiritually dead to their sins, bury others who are dead in the body ... that they may feed upon their corpses as wolves and dogs feed upon the carrion of beasts; many have buried themselves in Hell for the sake of lucrative sepulchres.

By this Alvarus was alluding to the peculiar status of those in religious orders, who were in effect socially dead; as St Jerome said: 'The monk does not have the function of a teacher but rather of a mourner.' Monks could not hold private property and, according to one English medieval lawyer, could not inherit it. Reception of a monk into a monastery required his closure from the world for three days (as in death), before his resuscitation into the new life. Monks were usually buried in the monastic cemetery, while their superiors, the abbots, rested in chapter houses and, later, in the bodies of monastic churches, frequently in tombs vying in splendour with those of bishops. The spiritual power of monks lay in their separation from the world, their exile, enclosure and denial of worldliness, and in their position on the threshold between life and death. Their 'institutionalized marginality' was the source of their immense authority. The power of the friars lay, in contrast, in their entry into the world, and especially into the royal and aristocratic households as spiritual advisors and confessors: the development of late-medieval penitential piety owed much to Mendicant inspiration.

ROYAL BURIAL AND THE BODY POLITIC

In the thirteenth century, the competition for bodies between the older monastic and the newer Mendicant orders manifested itself especially in one new arena: possession of the body politic in as far as it was incorporated in the person of the king. This was a potential source of strain, since it brought into antagonism old tribal loyalties of a communal type and the interests of personal salvation. In France, the Benedictine Abbey of Saint-Denis had attempted, since the time of Abbot Suger, to reinforce its privilege as the traditional burial place of the French sovereigns. This practice at Saint-Denis had been noted by Gregory of Tours in the sixth century. For Saint-Denis, this was a matter of institutional prerogative, one compatible with the ideology of the oldest monastic order. But with the rise to favour of the Cistercians as protectors of royal families in Castile, England and France, a tension arose between the demands of lay burial and the

Right Royal effigies at Saint-Denis, Paris, from left to right: Philippe II (d. 1322), Jeanne d'Evreux (d. 1371 – compare illustration on p. 35) and Charles IV (d. 1328).

tenets of the order. In 1228 St Louis and his mother had founded the Cistercian monastery of Royaumont near Paris, and it was there that members of the Capetian royal house – though not the sovereigns – began to be buried. By the middle of the century Saint-Denis was forced to reply to this new and widespread trait by reviving its privileged past through the erection of restrospective tombs of the Carolingian ancestors of the royal house, buried beneath the abbey church. Royaumont, however, was in a quandary, and it is a sign of the importance of the possession of aristocratic lay bodies that in 1263 the abbot was instructed to return the church's ornaments to the simplicity required by the Cistercian Order, excepting the royal burials (*sepulchris regalibus*) in the church. This was only more

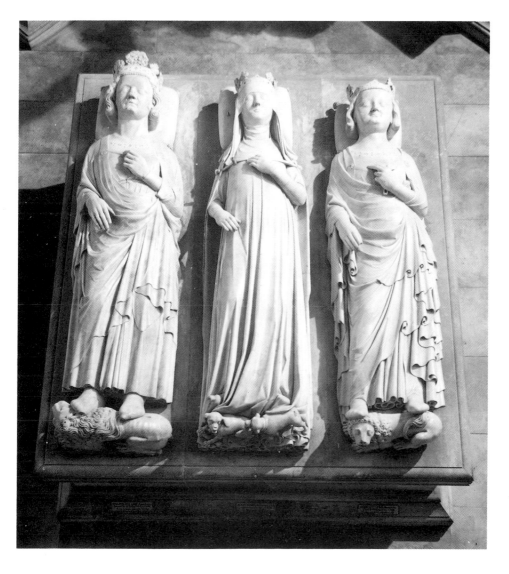

or less in line with Cistercian legislation of 1240 which stated, 'Let none be buried in our greater churches but kings, queens and bishops.' We know from the surviving parts of these tombs of the French royal family, and the children especially, that these tombs were gaily adorned and coloured, answering to the tastes of the laity.

The question was especially important in the case of those dynasties which possessed, or came to possess, royal saints. The emergence of a royal mausoleum at Benedictine Westminster in the late thirteenth century took place notwithstanding exactly the same competitive environment as that in France; in England, the role of Westminster's royal saint, Edward the Confessor, became especially important in virtue of that quality of sainthood we noted earlier (p.21), namely its capacity to offer a focus for local and national loyalties. This served to give Westminster an eminence not enjoyed by other royal Cistercian foundations. Burial could focus upon these new, saint-centred, loyalties in a period when sainted kingship offered a paradigm of Christian rule. Joinville noted of St Louis, canonized in 1297, that

... as the scribe who, when producing a manuscript, illuminates it with gold and azure, so did our king illuminate his realm with the many fine abbeys he built there, the great number of hospitals, and the houses for Predicants, Franciscans, and other religious orders ... On the day after the feast of St Bartholomew the Apostle in the year of our Lord 1270, the good king passed out of this world. His bones were put in a casket and taken to France, where they were laid to rest at Saint-Denis, the place he had chosen for his burial. At this tomb in which he was buried God has since then performed many fine miracles in his honour, and by his merit.

Royal sainthood declined as an institution from then on. The great royal burial houses of Europe were the last manifestations of that grouping of the very special dead that had begun a millenium earlier. But as from the thirteenth century royal government became increasingly identified with specific locations – London and Paris, for example – the royal mausoleum took on increasing importance within the framework of the state as a sign of that new centralization. The burial of a king was an act of state, a means by which the continuity of power could be expressed and assured symbolically; burial was thus inextricably linked to coronation as a rite of passage, since it was a guarantee of legitimacy.

The death of a monarch was a means of disclosing and enforcing forms of power. This had implications for the way kings were represented in death, as signs of order and hierarchy. Royal burial rituals, as public events, incorporated moral and social value systems; and they had also to observe constitutional conventions. Ralph Giesey's remarkable study of French royal burial ritual demonstrates the delicacy of these systems. When, in the fourteenth and fifteenth centuries, a king died, an elaborate series of rituals was developed to guarantee the transference of power, and to cancel the inevitable anxieties which arose at such

points of passage. This meant observing the ritual niceties of proper Christian burial sketched out earlier, only at a much amplified level. In the case of royal burial, however, the principal strategic problem was where power was located in the period between the death of one monarch and the inauguration of the next. An ingenious solution to this question was derived from the dual understanding of the body politic which emerged in this period in political and juridical thinking, and which has been discussed by Ernst Kantorowicz. This thinking was congenial to a Christian tradition which thought of the origin of all power, God, in synthetic terms, as a fusion of three entities forming the Trinity. In the case of temporal power the entities were double, one eternal (the office) the other mortal (the body). The nature of a king came to be understood as a corporation of two separate bodies – the natural mortal body of a particular king and the eternal, official body politic which survived the mortal body and was incorporated in the successor at his coronation. In the interim phase after the death of a monarch, the body politic could be incorporated not in a person at all but in an image: a funeral effigy, which could be ritually respected as if it were the king itself. This effigy was then displayed at the funeral of the king, and we know that this practice dated from at least the early fourteenth century in England.

A more extreme French instance concerned the effigy made for François 1 (d. 1547) which was displayed on a state bed in Paris:

And in this state the effigy remained for eleven days. And it is to be understood and known that during the time the body was in the chamber next to the great hall ... the forms and fashions of service were observed and kept just as was customary during the lifetime of the king: the table being set by the officers of the commissary; the service carried by the gentlemen servants, the bread-carrier, the cupbearer and the carver, with the usher marching before them and followed by officers of the cupboard, who spread the table with the reverence and samplings that were customarily made.

Behind this development lay a form of animism; this was a ritual of substitution which protected the office against destruction by investing it in a simulacrum. The power of such images is demonstrated in France by the fact that the Dauphin, the heir to the throne whose reign had notionally begun at his father's death, could not be seen with the image of his father lest two kings should be seen to rule in this state of political liminality. Late-medieval rituals were especially obsessed (as this example shows) with the minutiae of behaviour, and it may be the case that the elaboration of contemporary royal funerals resulted from improvements in embalming techniques which could buy time for rituals to expand. On the other hand necessity may have been the mother of invention, the drive to ritual elaboration provoking better mortuary practices. One can also see how these 'forms and fashions' could transfer to the permanent representations of royalty in death upon their tombs. Often monarchs are shown in their regalia, and we know that in the cases of Edward 1 (d. 1307) and his son

Edward II (d. 1327) kings were buried in vestments corresponding closely to their anointed coronation garb, indicating that concern with the symbolics of continuity noted earlier (p. 30) in discussing death and baptism. It was also often the case – certainly at Saint-Denis and Westminster – that sovereign tombs tended to have much more restrained representational systems than those of lesser members of the royal family, which often had brighter decoration and a richer imagery of celestial and familial comfort. The tombs of monarchs in the Anglo-French sphere tended to be of bronze or white marble – material counterparts in their pure and ineluctable quality to the extraction of the state, the soul of the kingdom, as an abstract entity from the mortal body of the king. The tombs of non-office holders, like unanointed royal children, did not need to reflect this aesthetics of the body politic. Hence the force of the exemption of

The ritual of a royal funeral is set out in a late 14th-century English Coronation Order, the *Liber Regalis*; two royal rites of passage are thus connected.

Royaumont from normal Cistercian practices of austerity. The restraint of sovereign burial reflected both a sense of the decorum of the body politic and, more fundamentally, an essentially new feeling for the character of the royal mausoleum as a showcase, a museum, of collective history unbroken by the individual pieties of the dynasty.

BODILY DIVISION

The conflict between tribal loyalty, or group solidarity, and individual piety also gave rise to another ingenious but controversial practice which enabled monarchs or other highly-placed patrons to have it both ways: the division of the body so that it could be buried at several places. By the thirteenth century bodily division had become something like a norm in the highest aristocratic circles, precisely because of the complexity and importance of the economy of death. At heart it bore witness to the importance of two competing priorities: priorities of place and priorities of the body. It also exposed inter-institutional rivalry. Ugly disputes could centre on this issue: thus in the 1260s there was an unpleasant row over the location of the tomb of Pope Clement IV (d. 1268) at Viterbo: who was to have it, the cathedral, the Franciscans or the Dominicans? John Peckham (d. 1292), the Franciscan Archbishop of Canterbury, planned to be buried with the Franciscans in London, but was dissuaded from doing so by the Prior of Canterbury; thus his body was left to the cathedral, and his heart given to the friars in London instead. A chronicler at Benedictine St Albans was piqued to note of the death in 1291 of Edward I's mother, Eleanor of Provence, that the nuns of Amesbury, where she died, got her body 'but her heart was buried in London at the church of the Friars Minor who . . . claimed for themselves somewhat of the body of any great folk who died; like dogs at a corpse, where each is in greedy expectation of his own gobbet to devour'.

Bodily division arose in the first place as a mortuary practice which acknowledged the fact that kings and queens tended not to die at the place of burial, and that embalming practices were insufficiently good to preserve the corpse during increasingly amplified royal death rituals. In the Anglo-French sphere division of the body reflected political and territorial divisions. Henry I of England and Normandy (d. 1135) wanted to be buried at Reading Abbey, but he died at Rouen. His entrails, brains and eyes were taken out on the spot for burial; so foul had the corpse already become that the surgeon involved died of septicaemia, and the body had gone off completely by the time it arrived at Caen. The funeral was less than fragrant. Nor were institutions necessarily delighted, in this early period of the practice, to receive those parts of the body which were lower in the physical hierarchy, and more closely associated with appetite, vice and disease: Roger of Wendover tells us (probably apocryphally) that Richard I's grant (1199) of his guts to the abbey of Chaluz caused positive offence. On the other

hand by the time Charles V of France (d. 1380) had his entrails buried at Maubuisson, his tomb representation could boast a large bag of the royal offal held proudly by the king's effigy.

By the thirteenth century embalming *more teutonico* ('in the German method') – which meant boiling the body down to the bones for easier transport and which appeared first in medieval Germany – was more widespread: St Thomas Aquinas was treated in this way, and so was St Louis, who died at Tunis in 1270 and was buried at Saint-Denis. Later scenes from the life of St Louis show him gathering up the stinking bones of the crusaders. Mortuary practices of this type were a form of extraction: by reducing the body to its bones, the dead person is reduced to a durable and pure essence. It follows that the practice of bodily division and extraction was taking on a more symbolic dimension. The hierarchy of the body was both a political one – the head remained the official site of the burial of the person – and an affective one: thus the heart was coming to be regarded as the seat of personal piety, and Christian bodily metaphors tended to be based on the head/heart pairing. The donation of different body parts reflected different views of the sovereignty of those parts. It was common, for example, to give the heart to the religious order particularly favoured for devotional reasons. Sweetheart Abbey in Kirkcudbright was founded in 1269 to enshrine the heart of John Balliol by his widow Devorguilla, the foundress of Balliol College, Oxford. The Mendicants, who enjoyed special favours as royal confessors, coming closest to the spiritual heart of the monarch, were special beneficiaries. Eleanor of Castile (d. 1290) gave her heart to the Dominicans in London, her entrails to Lincoln and her body to Westminster, marking the latter as the head of the kingdom. Each burial was marked by a different representation of the queen, and her images stood on the celebrated and triumphalist series of crosses erected in the 1290s to mark the path of her funeral cortège to London. Isabella of France, the queen of Edward II, was buried with the Franciscans in London with the heart of her husband under the breast of her effigy.

Division of the royal body amounted, in effect, to a final exertion of the royal virtue of largesse, power being registered by the gift of body parts. In this sense it related directly to the circulation of relics by theft or by gift, as a means of obtaining bonds through patronage. Indeed the more burials one had, the greater was one's sphere of influence, and the greater the number of prayers one received back for one's soul. But this cunning did not render division unproblematical. The practice exposed much deeper anxieties about fragmentation and the integrity of the person. Medieval culture had inherited from the ancient world a taboo about opening the human body for any purpose; medieval medicine worked extrinsically, by manipulating the bodily humours, and was less disposed to surgical intervention in view of the impurity of the body and blood (this, as Pouchelle has shown, marked the professional division between doctors and

surgeons). Henri de Mondeville's early fourteenth-century Parisian treatise on surgery, *Chirurgie*, reveals a profound sense of the metaphorical and symbolic value of the body: the body, especially the female body, is a court, a microcosm and an object of wonder (and for this reason bodily division was at first less common for queens than kings). Official dissections were not practised in Paris until the fifteenth century: the body was not to be a didactic spectacle.

The body politic was an especially sensitive arena. In an era of royal sainthood the royal person claimed thaumaturgical powers; kings in life touched for the 'king's evil' or scrofula, a glandular affliction, and miracles attended their tombs. The body politic was a site of health. Henri de Mondeville stated somewhat opportunistically: 'And just as we said above that our Saviour, the Lord Jesus Christ, decided to honour all surgeons by performing with his own hands the office of a surgeon, so also our most serene Prince, the King of France, honours them and their estate in that he cures scrofula solely by the laying on of hands.' As it happens, surgery lay closer to the work of the butcher, cook or executioner than that of the 'hands-on' saint. But the body politic was also a microcosm of the idea of the state. Mary Douglas has noted that 'The body is a model which can stand for any bounded system'. The bodily hierarchy was itself a kind of politics, based on a notion of friendship and interdependence. The higher faculties were based in the head and heart, especially the eye. There was some disagreement as to the exact priority of the head and heart, which related to notions about the medieval sensorium. The head, in a political system dominated by spatial metaphors of verticality and descent, traditionally dominated just as a king is head of his realm, but Mondeville also characterized the heart as the centre of the realm where the king is – a relatively new viewpoint which reflected the notion of political centralization itself. To Jacobus de Voragine, the author of the *Golden Legend*, the soul was in the heart with the blood. The heart was thus the site of devotional feeling and moral conscience. The bodily organs rendered quasi-feudal service to one another and to the higher organs, the whole system being supported by concord and gratitude. John of Salisbury's twelfth-century *Policraticus* uses an anthropomorphic analogy for medieval social structure, with the head as the prince, the heart as his counsellors, the feet as the peasantry, and so on; and a fundamentally similar model is found in Christine de Pisan's *Livre du Corps de Policie* (*c.*1407). Anatomical cohesion, based on an Aristotelian notion of the friendship between the various parts of the body, thus equated symbolically with political cohesion: to divide is to weaken.

There were several implications of this model. In the first place, it ceded immense power to the body politic in respect both of itself and other bodies within the system. Kings and queens thus had the power to divide themselves in death as signs of largesse, but they also had the power to divide others who threatened the body politic with division. This power was a form of 'surplus'

power over others, which acted in the feudal system upon bodies primarily because, in this period, the body was the thing most available to punishment. The body politic thus stood at the opposite pole to that of the condemned man. Judicial executions were becoming more common from around 1300: just as royal bodily division dramatized the process of salvation, public execution dramatized the reaffirmation of temporal power; and finally, in works like Villon's *Ballade des Pendus*, art sanctified it. Dismemberment, and especially the severing of the head, was the reward of traitors, and served as the most splendid ritual of contemporary punishment. After his defeat in 1265, the baronial rebel Simon de Montfort had his limbs, head and testicles cut off by royal forces and sent to various parts of the kingdom, division here marking an inversion of royal largesse in the interests of disempowerment. The Scots rebel William Wallace was dealt with thoroughly in 1305: he was dragged through the streets of London by the tail of a horse, hanged, then taken down and eviscerated while still alive (it was important that the victim should be able to watch himself in this process); his guts were thrown on a fire and he was dismembered, his limbs being sent to Scotland, and his head displayed on London Bridge.

Secondly, bodily division in the interests of salvation focused concern upon the exact nature of the person. The practice ties in with a general development in medieval spirituality noted earlier (p. 47) in connection with imagery of Christ's body and its suffering: the tendency for sprituality to take on bodily or somatic character. I will be considering this idea again in relation to notions of the macabre. The period which saw the rise of bodily division of aristocrats also saw the initiation of devotional practices directed towards the body of Christ. The most important of these centred upon the final formulation of the doctrine of Transubstantiation at Mass, and the feast of Corpus Christi. As it became possible to think of Christ in terms of His wounds, His heart (as in St Bernard's twelfth-century *Cor Jesu dulcissimum*) and the Instruments of His Passion, as well as the consumption of His body at Mass, so it became possible for this fragmented mode of spiritual attention to rebound upon the body of the layperson. Multiple burial – of one body at more than one site – thus reflected a form of devotional life within the *corpus mysticum*.

But, as the pagan Romans had sensed when they scattered the remains of Christian martyrs at Lyons, multiple burial also stood in a potentially antagonistic relationship to the logic of the Resurrection. This had been a source of mild concern in relation to the cult of relics. Although a saint was fully present in any particular bit of his or her body, just as Christ was to be fully present in fragments of the consecrated Host, even Prudentius had described how the martyrs returned in visions to command that their bodies, dismantled in different shrines, should be reassembled for ease of the Resurrection. This issue of the relationship of relics to the final Resurrection proved a logical quagmire. Guibert de Nogent,

in his celebrated twelfth-century critique *De sanctis et eorem pigneribus*, attacked cults of the tooth of Christ and of the Holy Foreskin because they implied that Christ had not risen in total perfection, and therefore that our resurrection too might be imperfect. Hence it was absurd to accept the validity of Christ's milk tooth kept at St Médard at Soissons, or the the milk of the Virgin Mary at Laon cathedral. Relics of the Holy Blood, though popular in aristocratic circles in the thirteenth century and earlier, were no less problematical in subverting the logical ideals of cogency and consistency of doctrine to which the medieval mind now aspired. Why had they not resurrected, and how many bodies did Christ actually have? There were scholastic arguments against this position, like that arrived at by the Paris-trained Thomas of Chobham in his *Summa de arte predicanti* of about 1210, which was designed to equip slower-witted preachers in replying to awkward questions from irritatingly intelligent congregations:

Certain people object that if Christ was resurrected in glory and His whole body was glorified, how is it that the Church claims that Christ's foreskin, cut off at the time of his circumcision, still remains on earth? There is an easy response to this, since just as by a miracle the body of our Lord can be at one and the same time in several places, so that same body can exist in several forms.

By this Thomas referred to the miracle of Transubstantiation at Mass. The crisis in this increasingly sophisticated morass of competing forms of interest was reached around 1300, by which time it had become hard to disentangle the spiritual, doctrinal and political elements of the equation. We will be returning to this in considering the related problems of the general Resurrection at a later point (see pp. 199–203). Division of the ordinary mortal body was a means of asserting spiritual and political power but it too touched sensitive doctrinal matters. Pope Boniface VIII grasped the nettle in the midst of his dispute with Philippe IV of France. In 1299 he issued the bull *Detestandae feritatis abusus* (An abuse of horrible savagery):

... we have thought it fit to abolish that abuse of detestable savagery which certain of the faithful imprudently practise in accordance with a horrible custom, lest this abuse should continue to lacerate human bodies and stir the minds of the faithful to horror ... for the aforesaid faithful, intent upon this vicious and reprehensible custom, at the death of any one among their kinsfolk who may be illustrious for nobility of race or dignity of rank (especially if he have paid the debt to nature beyond the limits of his own country), when he has chosen to be buried in his own parts ... truculently disembowel him, divide him limb by limb or gobbet by gobbet, and seethe him down in a cauldron.

The practice was banned under pain of excommunication, though one could be freed if one paid for an indult. Boniface did not offer complex theological justifications for this move, though he may have been influenced by Roger Bacon's view that decay was simply an attribute of ageing and that the living should

prepare for the Last Judgement by retaining both their moral and physical intactness (a notion which was rather hard on the medieval horde of amputees). Theological justification was in a sense unnecessary because the Pope's action was essentially political and polemical; it was aimed at the practices of a particular class at a time of maximum tension in relations between Christian kingship and the papacy. As it happens the gambit was ineffective: Boniface's bull was just not practicable, and Clement VI effectively killed it in 1351. The practice of evisceration was known amongst popes in the fifteenth century.

The practice of bodily subdivision amongst aristocrats had numerous analogies in the field of self-commemoration. For one thing it provoked new genres of

tombs, like the dapper late thirteenth-century heart tomb of Count Thibaut v of Champagne at Provins; in dividing the body it also coincided with the practice of multiple self-representation on tombs, again a new element in late-medieval funerary art. In a sense it marked the assimilation of the art of power to the art of the cult of relics, where the Christian cult of the dead had begun. Kings and queens, bishops and popes, were as divisible as the saints, even if they were not quite as powerful; in 1210 Otto, Bishop of Würzburg, requested that the convent of Ahausen should be given a barrel of excellent Franconian wine and in return that his right arm might be buried in the convent. The visual economy of body parts which had so tempted the eye of the pilgrim was now universalized, and the elites were now clothed in death with the same metallic decorum as the saints, in the commemorative art of their tombs.

Left Part of the heart tomb of Thibaut v, Count of Champagne (d. 1270), at Provins.

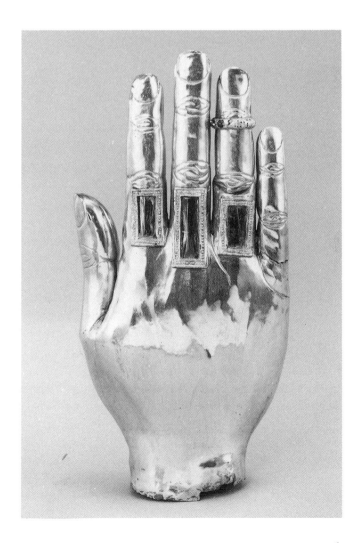

Right Hand from an arm reliquary, silver parcel-gilt, Flemish, 13th century.

69

CHAPTER TWO
DEATH AND REPRESENTATION

Christianity brought together the living and the dead, but it also divided the body and the soul, thereby creating two spheres of representation: that which was known and manifest, and that which was unknown – not the process of death, but the state of death, which by its nature was beyond ordinary experience. To discuss death simply as a mortal process without paying regard to its consequences would be like confusing a wedding and a marriage. For this reason, death as a state can rightly be regarded not as something which is sometimes represented, but rather as something that can only be represented. This axiom may help us to understand the odd confusion of cause and effect in medieval art which showed death in the world – in various forms of personification, usually as a corpse – literally as the cause of itself. Temporal reversals of this type are deeply implicated in the visual culture of the macabre, which will be discussed in the next chapter.

Representing both the process and the state of death was thus problematical. Medieval art was geared to rendering real that which was beyond human perception. It was an act of hypostatization whose concerns with coherence, visual logic and truthfulness to textual discourse loosely matched the tendency of medieval thinking to build internally consistent conceptual systems or patterns. For this reason, many modes of medieval illustration were symbolic and allegorical, and could grapple only with difficulty with some concepts whose institutional importance was immense. The classic instance of this is the failure of medieval culture to produce (with the exception of Dante literature) a widespread visual culture of Purgatory; a failure or absence which may reflect the possibility that the more concrete an institution was in practical terms, and the more it was assimilated into the imaginative order of a culture, the less important its visual manifestation became.

In this chapter we will consider the relationship of death and representation in so far as it affected the material body, postponing discussion of the afterlife to the last chapter. As has already been suggested, the body posed particular problems because of its ambivalent standing in Christian thought. On the one hand, the body was a site of traditional taboos of impurity and the site of vice: flesh was inherently fallen through Adam's disobedience. On the other, Christianity resocialized the dead body by renegotiating its importance as a site of the holy and incorruptible. The medieval body was thus an ambivalent sign, in being

both Here and Beyond. The tension in this paradoxical system was exposed specifically in thinking about the body–soul nexus in the context of the doctrine of the general Resurrection. What relationship did the body and soul have to one another, given that Christianity divided the two entities, yet insisted that they should come together at the Last Things? This issue was basically a dialectical one, since the dead body stood in an important relationship both to the living – and so was inextricably bound up with cultural attitudes to social and political coherence and its reaffirmation – and to the afterlife, wherein the issue of how a person survived, and so what a person actually was, was critical. In turning first to the tomb as the meeting place of these dialectical relationships, we must accept that tombs were both about bodies and about the afterlife, and so were in some sense pivotal. Their importance as representations, and as art, reflected this cardinal role.

The Medieval Tomb: Burial and Space

The astonishingly rich and diverse character of the western European medieval tomb, or *tumba* (from the Greek word for a mound of earth over a burial place), renders it an important and common source for the study of this ambivalent relationship between body and soul. The tomb stood for the dead, marked their resting-place, and lent them a voice; and yet the complexity of the medieval effigial tomb reflected the existential complexity of the state of death itself. Not all medieval tombs had to have effigies. The shrines of the saints were specialized tombs which excluded these bodily surrogates, perhaps in order not to cancel out the power of the body within. When they occurred, effigies could represent an arrestation of time in showing the body in a 'steady state' form, or they could show death as a process; or they could allude to both. It is in this uncertainty about what an effigy really depicts that some of the uncanny anxiety of the macabre lies.

The chief character of any memorial, one which lent it its validity, was stability and permanence, and also accessibility. But medieval tombs were not simply memorials. Their character shared much with medieval beliefs about the relationship between the living and the dead, in being premised upon a transactional system of mutual obligation between them. By the late thirteenth century, as a result of a growing dogmatic certainty as to the character of Purgatory as a state, many tombs acted on behalf of the dead to offer to the living remission from their time in Purgatory, in exchange for prayers for the dead. Tombs thus provoked both memory and action, good works, in the living, and their systems of display were related to this dialectical relationship. In his account of tomb sculpture as a genre, Erwin Panofsky placed surprisingly little emphasis on the salvific dimension of memorials, which was helping to structure their forms of represen-

tation and, in their epitaphs, their language. He hardly mentions Purgatory at all, notwithstanding its role as one of the most important influences on church organization and design at this time. Panofsky, however, made one clear-sighted observation about the distinction between the tomb of the ancient world and that of the Christian era: that the ancient tomb (like that of the Renaissance), represented the *cursus vitae* of the person commemorated, and that its vision or sense of tense was accordingly retrospective; while the Christian tomb, positioned within a new sense of the course of time, was essentially prospective, in other words goal-oriented. Its ends were concerned with the future state of the living and the dead, rather than with the recitation of that personal history which related to the Greco-Roman notion of happiness. However, in seeing tombs as primarily the sphere of a medium of art, namely sculpture, Panofsky severed the link between them and their audience, and so lost sight of their essentially instrumental character.

The key development in the history of the medieval tomb was not in fact the particular emphasis on any one component, or the special development of the tomb as a representative of any one medium; tomb media were in fact extremely diverse. It was instead the admission of the dead to the interior of churches. The medieval tomb was essentially, if not absolutely, an interior art form, and it was this factor which separated its development from the exterior monument of the old Mediterranean world, and from the ancient mausoleum. As the Middle Ages progressed, a privileged few were at first admitted to the interior of the church for burial: saints, clerics and, later, royalty. By the end of the Middle Ages about one-half of the dead sought burial in church. Lay burials were already common in Cologne Cathedral by the sixth century, and the issue remained contentious: ninth-century Carolingian royal edicts inveighed against the practice, and the Council of Mainz in 813 decreed that 'no dead body was to be buried within a church, except those of bishops and abbots, or worthy priests, or faithful laity'. There was of course some latitude as to who precisely might correspond to these definitions, and also where, within a church, the dead might be buried. Lay burial could occur on the fringes of a building: thus burial in the *porticus*, or atrium, of churches was already sanctioned by the seventh century. The first English Christian king, Ethelbert (d. 616), was buried in such a marginal space at St Peter and Paul at Canterbury. Medieval magnates and other princes were motivated to patronize churches, and to seek benefit from the intercessory prayers offered up by their foundations, but could not strictly, as laymen, be buried in the church proper. Even monastic practice tended to restrict burial to the cloister garth with the exception of the abbatial elite, who were buried in the chapter house.

Right The 12th-century wall-tomb of a papal chamberlain, Alfanus, Sta Maria in Cosmedin, Rome.

Until the twelfth century, lay burial was thus an affair of the threshold. The early terminology of medieval burial, moreover, reveals a deep-seated adherence to Greco-Roman formulae for expressing ideas of space in domestic terms. As we shall see later, Early Christianity still thought of the afterlife as consisting of receptacles for the dead – the 'many mansions' of the Gospels (John 14:2) – with antechambers, or atria, Paradise itself being basically a walled garden. The doctrine of receptacles related both to the kinds of physical containers for the dead on earth, sarcophagi, *loculi* and so on, and also to the topography of burial. The atrium of the church could be defined as the area around its apse or its portals: in essence this meant simply the area around the building itself, the

courtyard, so the distinction between the church and the cemetery was not always clear. The old French word for cemetery, *aître*, is derived from the Latin *atrium*, and the medieval word for a porch-space, 'parvis', is derived from *paradisum*, which the churchyard was thought to represent. King Fernando I established the Panthéon de los Reyes in the atrium of the former church of San Isidoro at Léon. The counts of Toulouse lay in a niche adjoining the south transept doorway of Saint-Sernin at Toulouse. And the Counts of Burgundy, who chose Cîteaux as their resting place, were interred in a chapel under the porch of the abbey church. Popes and bishops could occasionally seek burial in these circumstances, though for different reasons: Pope Boniface VIII (d. 1303), whose bull *Detestandae feritatis* we have already noted (p. 67), was buried by an altar against the facade wall of Old St Peter's in Rome, and Bishop John Grandisson (d. 1369) had a tomb and altar complex erected within the west facade wall of Exeter Cathedral, next to processional routes but also, perhaps, within the Heavenly Jerusalem that the facade represented. These old practices of liminal burial persisted late into the Middle Ages, as witnessed by the piled-up sarcophagi under the porch of the abbey of Souillac in France.

The development of the tomb was thus tied up with the emergence of a certain politics of space: those seeking burial had to compete for space in buildings which, unlike mausolea, were not necessarily planned as specialized burial sites. Others, like Boniface VIII, sought burial in special locations because of their prior associations, such as the presence of relics or saints nearby. The thirteenth-century Roman liturgist Durandus advised against burial in the choir of a church, a sure sign that it represented a problem. Churches were multifunctional buildings catering for the clergy and for laity, for Masses as well as the Offices; and this could not be ignored when housing the dead. This complexity had two consequences: it forced the tombs of the laity into ever closer proximity to those of the saints and the clergy, and it obliged the development of the tomb to take account of its physical context, a factor which has to be recalled in considering them as a genre. As churches began to fill with tombs, the placement and design of the tomb had to take into account the regard of the onlooker with ever greater efficiency. And in their distribution within a church, tombs could reflect the social hierarchy of the living as well as the dead.

Even royal mausolea had to contend with the politics of space. As we noted in the first chapter, royal burial was an act of state associated with symbolic sites of power. It was natural that the important process of Christianizing the most powerful people in society, kings and aristocratic laity, should have its triumph signalled by the admission of their bodies to church. Burials of this type were beneficial to all the parties involved: the privileged dead ensured care for their souls, and the clerical and often monastic carers gained substantial financial inducements in return. By the thirteenth century in England royal anniversaries

were exempt from subsidy. Shrines too were an important source of revenue. When, as at Saint-Denis, or later at Westminster, the mausoleum church was also a shrine church, the issue of space became more complex still. Until this period one model for the dynastic mausoleum was the imperial burial church at Speyer Cathedral; but by the critical period between the eleventh and thirteenth centuries the appropriation of burial privileges by monastic orders was consolidated and jealously guarded, and, as we have seen, was threatened by the new urban-based Mendicant orders who were winning the loyalty of the increasingly powerful urban elites. Burial was becoming a means of asserting specific loyalties. These could be familial, as in the case of the dynastic mausolea of northern Europe, or of the medieval popes, whose families, like the Colonna and the Orsini, sought burial at the Lateran and Vatican basilicas respectively. They could be territorial: William the Conqueror planned his burial with the Benedictines at Caen in Normandy, and the abbey of Fontevrault, the old burial-place of the Angevin kings of England, still claimed the heart of Henry III in the late thirteenth century long after those ties had ceased. And they could be devotional: the house of Castile designated the Cistercian monastery at Las Huelgas near Burgos as their burial place, and the Capetians employed Cistercian Royaumont for the burial of the royal children.

But very few of these churches were planned explicitly as burial churches. Saint-Denis, a comparatively modest basilica until its rebuilding in the new Gothic style under Abbot Suger, had been in effect a tribal burial site, marking the continuity between the monarchy of France and its Frankish forebears. But the development of its role as a mausoleum was affected by numerous extrinsic considerations. As we saw in the last chapter, the historical ties of a mausoleum like Saint-Denis were challenged by new aristocratic devotional loyalties. In this period, Saint-Denis was still having to reinforce its privileges against not only the new Cistercian royal houses, but also against the old coronation church, Reims, which was being rebuilt to colossal proportions. Suger's church of the 1130s and 1140s was rebuilt almost a century after its erection, to reflect the magnificence of France's new political architecture. The tomb was caught up in this new environment of competition. In the middle of the thirteenth century Saint-Denis, perhaps with the support of the crown, inaugurated the construction of a series of sixteen effigial tombs which retrospectively commemorated the old rulers of France: the tombs are of a standardized type with effigies of kings and queens in their regalia, projecting through their display an anachronistic vision of continuity, and thus legitimacy. This stresses the role of the effigial tomb itself as a cultural form whose stability lay, as with royal rites of passage like the coronation ritual, in its seemingly unchanging character, its apparent resistance to contingent circumstances. Royal tombs, like royal ceremonies, resist the idea that power is subject to the play of accidental fortune.

But resistance of this type is usually a symptom of contingent circumstances. At Saint-Denis the erection of tombs to the old French kings, starting with the founder, Dagobert, by the high altar, was tied in closely with the emergence of the abbey as the home of France's royal chronicle writing: here it marked itself out in deliberate contrast to either Reims or Royaumont, its competitors. The sovereign tomb was assimilated into the construction of royal, and hence national, narrative in early texts like that of the Saint-Denis monk Rigord, who employed the tombs in Saint-Denis as a framework for the recitation of the history of the state. By the end of the thirteenth century, Saint-Denis was responsible for the *Grandes chroniques de France*, as it were the official history of the country focused on its patron, St Denis himself. The historian Duby has called this approach (which we might relate to the imagery of the Tree of Jesse, Christ's own family tree, or to the galleries of kings on the facades of northern French cathedrals or in the principal palace in Paris, the *Cité* under Philippe IV) an 'ideology of filiation'. The effigial tomb observed its own path of development, its own internal logic, but was nonetheless absorbed into the new aristocratic fashion for genealogy. The older religious orders – as at Benedictine Westminster, also an important home of history writing – could thus answer the discourse of private devotional loyalty with the discourse of history itself. They could construct what were in effect museums. It is not coincidental that this notion of the royal museum at Westminster was to develop into the national pantheon of worthies which it has become today.

Saint-Denis was also a relic church troubled, as Suger witnessed, by the ordinary popularity of the saints. As rebuilt by Suger with enlarged portals, a crypt and radiating chapels, and with an elevated shrine in its midst, Saint-Denis' planning reflected the practicalities of human 'flow' around the building, and the royal tombs which had to spread westwards into the spacious crossing of the church reflected this priority. Westminster Abbey, erected from 1245 by Henry III in self-conscious imitation of the Gothic planning of great French royal churches like Reims, saw a similar crisis of space centred upon its shrine, with the royal tombs seeking burial in its proximity jostling for space and eventually, by the fourteenth century, pushing some out of the space altogether. The great Gothic church as a 'type', with its chevet, ambulatories and radiating chapels, was one that could be annexed for burial, but was not designed for burial: its priorities were rather with greatly enlarged liturgies, processions, and extensive communal and private Mass celebration. Much of the history of the interiors of such churches is to be explained by the friction between these competing functional needs, which focused especially on the tensions between the needs of the privileged laity and an ever more powerful clerical class with its own growing sense of solidarity.

Friction of this type is creative. Tombs had to fit in to a highly determined

environment, and it is because of this that their form was so immensly diverse. Being both numerous and prominent, they had to work, to a certain extent, by being visually differentiated as well as contiguous; just as we come to know to whom an altar is dedicated by means of its altarpiece, we know who is the subject of a tomb by virtue of its appearance and epitaph, by its points of difference. The prescriptions made in wills for the nature of tombs, though usually less common than concerns for where a tomb should be placed, point to the importance of this consideration for patrons. The will of Cardinal Hughes Aycelin de Billom (d. 1297) specified that he sought burial in a metal tomb at the foot of the high altar of Sta Sabina in Rome, in order that the friars could see it and so retain his memory in their prayers. This echoed the old practice of elevating a shrine behind an altar so that it could be revered during Mass. Edward the Black Prince (d. 1376) specified in his will the exact appearance of his tomb down to the wording of its epitaph, and Richard II (d. 1399) had the design and epitaph of his and his queen's tomb guarded under a royal seal. The English royal habit of choosing the current royal master mason to design the royal tombs reflects patronal reliance upon specifically-favoured artists whose discrimination and sensibility could be relied upon. Some patrons with continental links, like William de Valence (d. 1296) and Queen Philippa of Hainault (d. 1369), both in Westminster Abbey, turned to artistic natives of their own territories abroad for their tombs. Celibate clerics could not rely on descendants to put their wishes into effect and, not trusting their clerical colleagues either, could erect a tomb in their lifetime, both out of self-respect and, as we shall see later (p. 143), out of penitential self-regard. Wills could specify the decorum of a tomb – that it should be *modestus* or appropriate to its place. But choice was still wide and growing. Charles d'Anjou, King of Naples and protector of Pope Innocent V (d. 1276), was able to seek out a tomb in the Lateran for his protégé either made of antique porphyry or like a French canopied tomb recently erected to a Frenchwoman in Old St Peter's. Fashionable or historically-sanctioned exemplars carried a great burden of authority in regard to display.

Displaying the Dead

The medieval tomb was thus the product of interior burial. But it was also affected by its position within a building; in this respect the tomb was a reflection of a very basic development which had transformed Christianity from being an underground movement, to one fully in the public realm. Tombs not only came indoors, but they also surfaced into the light, shedding their old subterranean association with the underworld. Though most burials were in the churchyard, deep in the earth, the socially-prestigious tomb was conditioned by metaphors of elevation as well as interiority.

The appearance of medieval shrines was premonitory of this simple but important fact. The first Christian dead had been positioned close to their altars in keeping with Revelation 6:9, and it was common to situate the relics of the saints within, upon, or above altars in special containers – though enclosed containers only became mandatory in the thirteenth century. As shrines became distinct objects of veneration, their separation from the altar and their siting elsewhere ensued, either beneath in a crypt accessible to the public, who were thereby kept away from the clergy above, or on a separate raised platform behind and beyond the main altar of a church. In 687 St Cuthbert's precious remains were translated at Lindisfarne from a grave into a still-preserved, raised wooden coffin; later they were moved to Durham Cathedral, and in 1104 were installed in a new shrine of metal set on a platform with legs. The original coffin has images of Christ, the Virgin Mary and the Evangelists: it was a sarcophagus, and belonged in an intermediate position between older Christian sarcophagi and the ornate shrines of the high Middle Ages decorated with events from the lives of the saints contained in them. Shrines then were specially installed elevated sarcophagi, intended to illuminate the church spiritually: the text 'No man, when he hath lighted a candle, putteth it in a secret place . . . but on a candlestick, that they which come in may see the light', from Luke 11:33, was occasionally read out at translation ceremonies like that of St Edward the Confessor in 1163.

The elevation of relics in this way became normal by the twelfth century, and attests to an important epistemological shift in the understanding of the holy dead: originally, as we have seen, the holy dead lay in shrines with closed surfaces accessible to the touch, and their power worked through the contagion of contact. But the high medieval stress was increasingly upon the faculty of sight; shrines were to be touched and even entered (and for this reason they required a certain amount of 'devotional' space around them) but they were also to be seen, even from afar. Elevation amounted therefore to a proof of triumph. The saint was now a focus of display. This shift in the sensory apprehension of shrines entailed major architectural adjustments of the type witnessed around 1140 at Saint-Denis, when Suger extracted the relics of his church and raised them on a platform over the crypt in the main church surrounded by a delicately planned diaphonous ambulatory or walking-space. In erecting this new shrine arrangement Suger was really doing two things: he was catering in a practical way for a greater demand for access by the devout laity, but he was also separating them from the monks and the performance of monastic Masses and Offices. He was in no sense a populist, and the shrine space was surrounded by glazed windows filled with obscure Christian allegories explained in Latin. Very similar arrangements were followed at Canterbury Cathedral in its Gothic rebuilding after 1174. St Thomas' empty tomb was kept as a site of devotion and healing

in the crypt (the marble columns around the tomb are rubbed smooth with the touch of pilgrims, like the miraculous healing columns of Byzantium). A new metal and stone shrine was raised in the main church above, surrounded this time by windows relating the saint's life and miracles in altogether more lively and demotic fashion than at Saint-Denis. All this was complete at his translation in 1220. The crypt remained an attractive site for burial – here Edward the Black Prince sought rest – but it was eventually in the circuit of the shrine space above that he was buried near his Lancastrian successor Henry IV.

Shrines were thus the first sign of new concerns with touching and seeing the dead. By now shrines in France and England were designed to satisfy both forms of curiosity: they were elevated, but they were rendered tangible and penetrable by means of niches or holes, 'squeezing places', into which the sick and devout could (in theory) get. Orifices of this type, letting into the dust of the relics above and within, are shown in representations of contemporary shrines at Canterbury and Westminster, and several, like that of St Osmund at Salisbury, still survive. Woe betide the corpulent: it was not unknown for over-enthusiastic pilgrims to get stuck. Whether all major shrines were really used in this way is hard to know: what counts is the visual language of expectation and desire, the traces of implicit behaviour.

The interior tomb is both a descendant and an adaptation of the sarcophagus of the ancient world. After the fall of the Roman Empire the production of

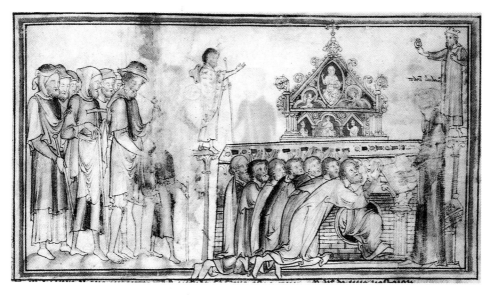

Healing at the tomb of St Edward the Confessor, Westminster Abbey; the sick, mostly blind, enter the tomb's 'squeezing places', while a monk sings the *Te Deum* to the right, in this mid-13th-century illustration.

Quasi-apocalyptic images of Christ and worshippers adorn the sarcophagus of Bishop Agilbert, Jouarre Abbey, *c*.680.

sarcophagi was rare, and so it was common for Christians to re-use pagan ones. St Lusorius was placed in an old hunting sarcophagus at Déols; in his *Liber de gloria confessorum*, Gregory of Tours tells of the fifth-century St Germanus of Auxerre worshipping at this tomb, of Parian marble. Similar types were evidently still being made in Italy in the eighth century, like the hunting sarcophagus of a Lombard Duke at Città Castellana. The imagery of such tombs could be Christianized. The magnificent sarcophagus of St Agilbert (d. 672), sometime bishop of Winchester and later of Paris, at Jouarre, shows Christ in Majesty surrounded by worshippers making gestures of ecstasy. But the hold of the aesthetic standards of the ancient world was still strong and sustained what might be called a discourse of improvement: marble, if it could be found, was better. Cuthbert had been placed in a wooden coffin, but St Etheldreda of Ely (d. 680) was eventually placed in a Roman white marble sarcophagus found at Grantchester. Charlemagne was installed in a Persephone sarcophagus at Aachen. In Spain, the relics of the saints could even be put in Islamic-made ivory boxes. This language of appropriation of the aesthetic values of older or other cultures was at heart one of Christian triumph. Sometimes, however, it could reveal a surprising level of cultural sympathy. The representation of the burial of Joseph in the great eleventh-century, Anglo-Saxon, paraphrased sequence of Old Testament illustrations, the Aelfric Hexateuch, shows Joseph's body being carried by two men in what must be one of the few medieval representations of an Egyptian pharaonic

mummy-case. How such pre-archaeological knowledge got to medieval Canterbury is mysterious.

By the twelfth and thirteenth centuries, royal power too could appropriate this venerable language of forms and materials. The tombs of the new dynasty of Norman kings of Sicily at Palermo, like that of Roger II (d. 1154), are made of porphyry, a material with numerous imperial resonances and funeral associations. Popes like Innocent II (d. 1143), who was laid in Hadrian's sarcophagus, continued to reinforce their Roman roots, and by the thirteenth century Clement IV (d. 1268) could be buried with an antique strigillated sarcophagus set in a Gothic canopied context derived from France. French tombs were influential in England, but so (more rarely) was Roman art. Henry III (d. 1272) was buried at Westminster in a tomb of Roman Cosmati mosaic extremely similar in style to those used by contemporary popes. Intersections of this type tell us much about the way kings, Henry especially, conceived their rule as a quasi-priestly office. Henry's tomb has little *fenestellae*, or niches for reliquaries, which lend it its shrine-like appearance. One of them has a sarcophagus-like pedimented opening of a type used on medieval Roman tombs hinting at the next world. The neighbouring shrine of St Edward, which also has niches, is made from the same Roman type of mosaic: king and saint are thus blessed by the same language of materials. Clergy also favoured tombs that resembled ancient sarcophagi or even shrines. Antique motifs in the form of medallion heads, perhaps copied from antique gemstones of a type loved by contemporary bishops, adorn the tombs of Arnulf, Bishop of Lisieux (d. 1181), and Hubert Walter, Archbishop of Canterbury

The burial of Joseph, from the 11th-century Anglo-Saxon Aelfric Hexateuch.

(d. 1205); the latter though made of marble is adorned in the manner of a metal-work shrine. Clerical and royal taste was closely related. The transportation and use of marble for such purposes from the Mediterranean, Rome and Byzantium especially, represented an aesthetic ideal of the period; so when buildings like Westminster Abbey and Canterbury used marble fittings extensively, their symbolic order was remarkably similar to that of the tombs and shrines they enclosed.

Clement IV's canopied tomb at Viterbo, though French in general origin, reminds us of the extent to which the antique world was seminal in its influence on the medieval tomb. The catacombs had seen the use of *arcosolia*, or canopied tomb-niches set in walls, often richly painted. By the sixth century the dead were being buried in church in similar niched structures enclosing tomb chests. According to his biographer Einhard, Charlemagne (d. 814) was buried at Aachen beneath a gilded arch with an inscription. This type of arched wall recess became normal throughout Europe for higher-status burials by the twelfth century. Gorgeously ornate wall-niche tombs remained in vogue in the Gothic period, as

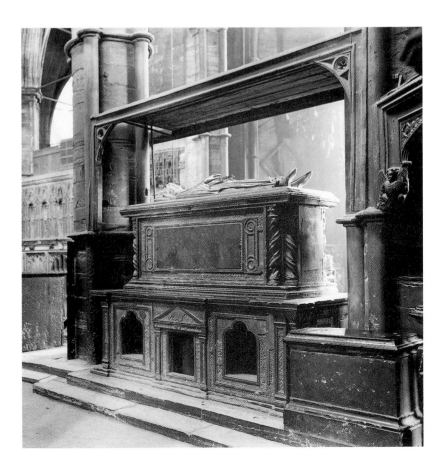

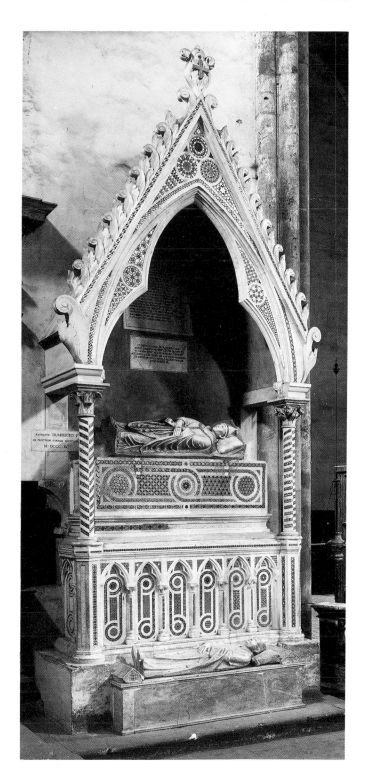

Left The niched Roman Cosmati tomb of King Henry III (d. 1272), Westminster Abbey. This side faces the similar shrine of St Edward (compare illustration on p. 79).

Right The tomb of the French Pope Clement IV (d. 1268), S. Francesco, Viterbo. Note the tipped-up effigy and French style of canopy.

at fourteenth-century Winchelsea and Bristol Cathedral. But this type of tomb had a disadvantage: in being bound to the mural peripheries of a church it was strategically inflexible, and could not penetrate the most important spaces of the building. The free-standing canopied tomb was its inevitable successor, since it picked up on the arch and sarcophagus arrangement of the older niche, but could be placed anywhere liturgically convenient. Thirteenth-century bishops, a powerful and influential class of patrons, seem to have been the first to adopt the canopied tomb, and the form was quickly picked up by popes, aristocrats and kings. Notable examples included the tombs of Alfonso II, Count of Provence (d. 1209), or Cardinal Jean Cholet (d. 1292) at Saint-Lucien at Beauvais, and in England the fabulous structures erected for Edmund Crouchback, Earl of Lancaster (d. 1296), at Westminster (immediately copied by one of the bishops of Ely) and the Despensers at Tewkesbury Abbey.

One reason why clerical patronage may have been important in the emergence of the canopied tomb, especially in France and England, may lie with the very significant increase in episcopal canonization in the thirteenth century. In the wake of Thomas Becket's canonization in 1173, a number of important bishops, such as Hugh of Lincoln (canonized 1220) and Edmund of Canterbury (canonized 1246), were either made saints or, like Robert Grosseteste of Lincoln and Thomas Cantilupe of Hereford, had cults formed in their name. One important component in the formation of cults of this type was the tomb, since tombs, in line with shrines, were potential sites of miracle-working, and miracles were now necessary for proper canonization at Rome in a way that had not been true earlier. Tombs were thus implicated in the making of saints; they were part of the necessary dossier of sanctity. In 1287, for example, a young and rather ill man, John de Tregoz, spent one night in a vigil at the tomb of Thomas Cantilupe (d. 1282) and had a vision of the bishop's spirit emerging from under the brass set on his tomb in the cathedral transept. The vision was cited in evidence of Thomas' sanctity (he was eventually canonized in 1320) and was probably influenced by the miraculous appearances of Thomas Becket oozing out of his tomb at Canterbury Cathedral. Thomas Cantilupe's tomb was a pseudo-shrine, elaborately finished, and in this it resembled other episcopal tombs of the period like that of Giles Bridport (d. 1262) at Salisbury or Walter de Gray (d. 1255) at York, which, like shrines, stood prominently apart as potential objects of veneration. The growing autonomy of shrines as evidence of a cult and as sites of special activities, and so in effect as propaganda, was also a prelude to the emergence

Right The formal canopied tomb (left) of Archbishop Walter de Gray (d. 1255), south transept, York Minster, and the contents of the coffin (right) beneath the tomb, opened in 1968. The lid of the coffin beneath the Purbeck marble effigy was painted with the image of the archbishop. The coffin contained a pastoral staff, chalice and patten, a ring and textile fragments. The tomb looks at first sight like a shrine with raised sarcophagus – compare PL. II.

of the free-standing canopied tomb, and probably lent considerable momentum to it.

Medieval tombs were thus what we might call a 'blurred genre', fusing, without any apparent system, the chief features of a number of forms of display. Some papal tombs took on the character of the great free-standing Gothic monuments appearing in northern Europe. Thus the Avignonese Pope John XXII (d. 1334) has a tremendously elaborate canopied tomb of English appearance in line with episcopal and royal exemplars. One such, at Gloucester Abbey, appears to have been the tomb of Edward II (d. 1327) erected by one of the royal master masons; this fuses the kind of niched tomb-base apparent on Henry III's tomb at Westminster with a courtly canopied display above. Like Henry, Edward was

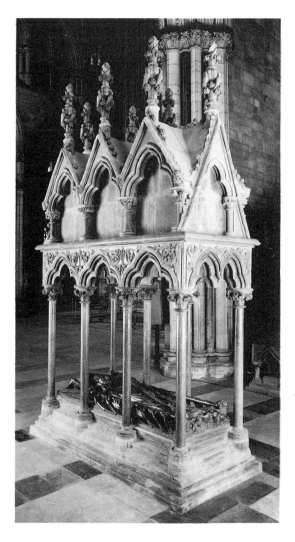

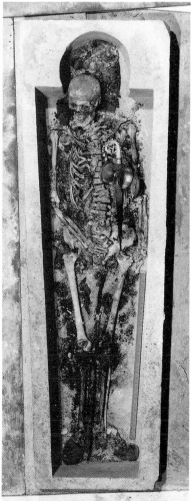

picked out as a potential saint. Unlike Henry's tomb, which had to remain lower than that of the nearby shrine of St Edward at Westminster, Edward's had no such shrine in proximity to it, and its sense of decorum as the most important monument in the choir of the abbey was thus unconstrained.

The adoption of canopy motifs was itself a sign of the 'intervisual' and synthetic character of medieval tombs. The ancient world had viewed the sarcophagus tomb as a kind of eternal residence, a *domus aeterna*, a sign of eternal life which, in its attention to domestic detail reveals the importance of the accuracy of symbols. Medieval arched and gabled canopies similarly marked out spaces of sanctity. From the twelfth century they were found over the figures grouped around cathedral portals in France, and by the next century had become a routine component of any important object of veneration: beautifully-finished canopies adorned the reliquary displays in the chapels at Saint-Denis and, most spectacularly, in the Sainte-Chapelle in Paris erected for St Louis in the 1240s. These helped to create a taste for quasi-metallic ornamentation on later aristocratic tombs like those in the sanctuary at Westminster. Great sculpted portals seem to have been especially important in developing a wide array of motifs appropriable by tombs, possibly because of the latent connection between the portal and the tomb as sites of liminality – we have already noted the little pedimented opening on Henry III's mosaic tomb. The coalescence of portal and tomb had already occurred on the twelfth-century monument of Ogier the Dane, one of Charlemagne's paladins, and his page Benedict, at Saint-Faron at Meaux *c*.1160. This was self-consciously related to the *Chanson de Roland*, in which Ogier features heroically, and had a tomb chest illustrating the story of how he became a monk at Saint-Faron. The components for a particularly handsome twelfth-century tomb were incorporated into one of the portals at Reims Cathedral. A sophisticated portal-like tomb with a crocketed gable and pinnacles was erected retrospectively for Dagobert, the founder of Saint-Denis, in the mid-thirteenth century. In effect a cenotaph, or bodiless tomb, the monument shows Dagobert's effigy between his wife Nanthilde and son Clovis; and the back wall of the tomb relates the story of Dagobert's salvation from demons by SS Denis, Martin and Mauritius, drawn from the *Gesta Dagoberti*. As with Ogier's tomb, the monument has a literary character, conveyed to us by the sort of demotic and lively sculptures, depicting the deeds of the saints, found on the cathedral portals of the period. Through such quasi-historical means the tomb could be personalized and absorbed into a wider national and spiritual history. At Salisbury, Bishop Bridport's elaborate tomb is one of the first to include biographical elements about the bishop, rather like the type of saint's narrative found on shrines. By the next century this dual assimilation of the person – as an individual and as the representative of a class – into a wider history of salvation was to be much more common as new iconographies of the personal Last Judgement became more

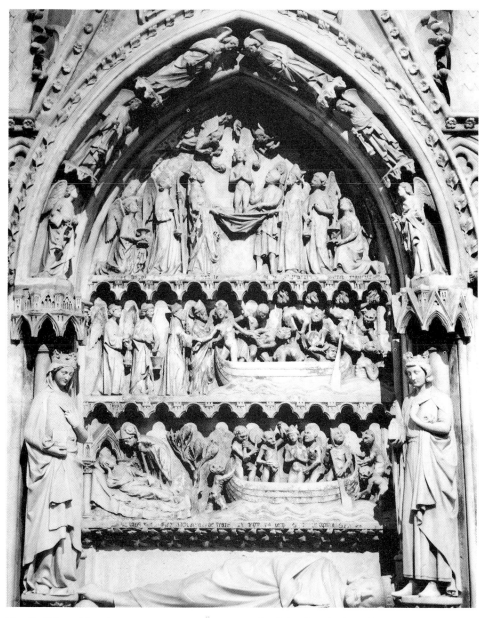

Detail of the mid-13th-century retrospective cenotaph of the founder Dagobert in the sanctuary at Saint-Denis, Paris, with scenes pertaining to his death.

evolved. Tombs thus stood as markers of personhood but also as exemplars in themselves.

But display is always paradoxical. The emergence of the canopied tomb in the critical period between 1100 and 1300 is one of the most striking artistic developments of the period, as rapid and complex as the simultaneous appearance of the altarpiece. But it also issued in its own range of problems. As noted earlier (p. 59), the Cistercians at Royaumont were troubled about the conflict between their aesthetic and spiritual ideals and lay-motivated displays of this type. As the tomb rose to prominence, so too did its critique as a sign of *vanitas* and *superbia*. One aspect of this critique was related, as we shall see later, to the culture of the macabre. But more often it took on the conventional guise of the Christian homily against pride of a pungently anti-clerical type. *Pierce the Plough-man's Crede* notes ironically of a Dominican church that its windows were blazoned with secular heraldry and merchant's marks, and that it had tombs of lofty pinnacle work wrought of alabaster and marble, with knights lying on the tombs as demure as saints 'and lovely ladies lie by their sides, in many gay garments that were goldbeaten'. The strength of this thumbnail sketch of the romance of medieval death lies in its hostile accuracy. Once the elevated tomb had risen to full prominence by the fourteenth century its standards were plain for all to see. Rich ornament and colour were distractions. St Augustine held that there were three main sources of sin: *superbia, curiositas* and *lascivia* – pride of life, lust of the eye and lust of the flesh. The great Cistercian St Bernard, like Tertullian before him, attacked the vice of *curiositas* in monastic circles. But *curiositas* could intersect with *lascivia*. In a late fourteenth-century sermon, Master Rypon of Durham said:

. . . certain women give artificial decoration to themselves by painting their faces to please the eyes of men. In truth, whosoever do so have the likeness of harlots . . . and . . . are well compared to a painted sepulchre in which lies a foul corpse.

Royal and episcopal tombs could also be signs of *superbia*. The greater the patron the more inconvenient the monument: King John was buried in the middle of the monastic choir at Worcester Cathedral, and his son Henry originally in the sanctuary at Westminster. St Hugh of Lincoln had been concerned that his tomb should not cause obstruction or injury. Bishops were not free of criticism. In around 1297, Bishop Godfrey Giffard of Worcester, who was on generally poor terms with his monks, arranged for the erection of his tomb by the side of the high altar. In 1302, the Archbishop of Canterbury noted that the tomb had displaced that of a locally venerated bishop, overshone the shrine of St Oswald and darkened the high altar (an especially grave error given the new stress on the visibility of the Mass) and ordered that it be taken down. One could have no better instance of the competing, and sometimes ruthless, claims to space in a multi-functional building.

But there was an answer: the cultivation of self-consciously humble tombs that could thwart critiques of this type. This was best done by reversing the metaphor of elevation that had so influenced the canopied tomb in the first place, and cultivating instead a notion of humility – literally being brought to earth – in the form of the flat but adorned grave slab. For Panofsky, the Middle Ages saw a transition in tomb types from flat adorned grave slabs in the early periods of Christianity to the fully sculpted tomb memorial: for him this amounted to a form of liberation, associated in his mind with the various proto-Renaissances (of the ninth and twelfth centuries especially) that marked out his narrative of medieval art. Gothic sculpture, on tombs as on portals, was thus related to an idea of autonomy. It is certainly the case that flat decorated slabs were used in the early Middle Ages, like that of Queen Frédegond (d. 597) from St-Germain-des-Prés in Paris; and flat representations of the dead could be displayed vertically too. But the flat tomb was not displaced by the three-dimensional tomb; rather, its strategic and, as it were, ethical advantages were refocused as a result of the emergence of the sculpted tomb. The newer religious orders were, as usual, aware of these implications. In 1237 the Cistercian Order insisted that tombs of the dead buried in cloisters should be flat, in order not to

The 14th-century knightly dead congregate in brass on the floor before the high altar at Cobham Church, Kent; the brass of Joan de Cobham (compare illustration on p. 113) is before the altar step, to the left.

offend the feet of passers-by. Dominican cardinals could will that their tombs should be moderate in height without excessive pinnacles and images, and that they should not exceed in height any altar nearby – a problem already met with at Worcester.

Incised grave slabs met these requirements while offering their own discreet field of display. Such tombs could be of inlaid stone or of metal, gilded, enamelled and incised – techniques which hinted at the splendour of the erect tomb but which also offered resistance to wear, and so satisfied the need for permanence and stability central to a monument. Sometimes they could be exceedingly grand. The incised stone slab commemorating the architect Hugues Libergier

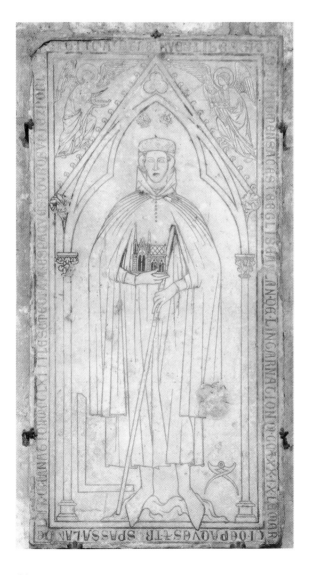

Tomb slab of the architect Hugues Libergier (d 1263), now in Reims Cathedral. Hugues is identified by the tools of his profession, including compasses and staff – an old tradition (compare illustrations on pp. 23 and 85).

(d. 1263) now in Reims Cathedral is large and, in its themes, pretentious: the mason is shown in civic garb with the tools of his trade, holding the church he built, Saint-Nicaize, for all the world as if he had been its founder. A church is held as a sign of patronage on the tomb (c.1240) of Henry the Lion, Duke of Brunswick, at Brunswick Cathedral. Later, on the brass at Cowthorpe, York, of Brian Roucliffe, Baron of the Exchequer (d. 1494), and his wife, the couple support an entire parish church which Brian founded and built. Hugues' tomb is simpler. He stands beneath a canopy and is censed by angels; although the tomb is flat, it manages to insinuate through diagrammatic means the signs – whether iconographic or spatial – of hierarchy and *divisio* generated by the elevated tomb. In thirteenth-century France and England it was becoming more normal for tombs like this to be reinforced with enamel components and with hard latten, a type of brass; according to Bartholomaeus Anglicus in his thirteenth-century *De proprietatibus rerum*, brass and gold share the common quality of glowing virtue. The brass was thus a sign of durable untarnishable memory. Though only one such inlaid tomb now survives in France, in Noyon Cathedral, brasses became common in England from the late thirteenth century, again starting with high clerical patrons, and from around 1310 were being serially produced to standard formats in centres like London. By the 1330s brasses of elephantine proportions were being made for patrons with aristocratic links like Bishop Louis de Beaumont (d. 1333), whose slab stretches grandly across the sanctuary of Durham Cathedral, again in a founder's position, yet conveniently planar. By this time brass manufacturers in Flanders had made a monument to King Eric Menved (d. 1319) at Ringstead in Denmark, and Flemish exports gained immense prestige across Europe from Spain to Poland, with some examples being made for the Flemish trading communities in the east of England (such as those at King's Lynn or Newark).

For reasons which are obscure, brasses from the Middle Ages survive most frequently in England. One reason for this may be that the commercialization of the London-based industry from the early fourteenth century encouraged the formation of a large and socially diverse market. Most English brasses in the period before 1400 were either simply inscriptions or crosses which could cost as little as £3 – a far smaller outlay than that needed for a huge rectangular Flemish plate. Putting crosses on the floor even as memorials reveals a degree of desensitization to religious images in a period of image-proliferation: canon 73 of the seventh-century council of Trullo had stated that the cross should not be represented on the ground as it was a trophy of victory, and should not be stepped upon. But this was precisely the advantage of the memorial brass; it, together with its figures, canopies and saints, came into being precisely because they could be, *had* to be, stepped upon. Ariès misunderstands the flat tomb in thinking of it only as exhibiting a simple, and essentially nihilistic, secular

'vocation to humility'. Its strategy was more cunning. The brass, which now insinuated itself into every aisle and nook of the medieval church very often at the specific request of its subject's will, was rather an economical and irreproachable solution to the politics of space and display which had arisen with mass burial in church.

The Tomb as a Sign of Selfhood

From what has been said already it will be clear that tombs were a complex field of display; and this display was inextricably bound up with notions of selfhood. By this I do not necessarily mean the much-vaunted notion of 'the individual' which stands so centrally in accounts of medieval death of the type offered by Philippe Ariès, or even Panofsky. For Ariès especially, the history of the tomb is that of the loss of sense of self with the early Middle Ages, wherein burial is anonymous; and the rediscovery of that sense after the eleventh century with the return of the epitaph and 'portrait' representation. For Panofsky, the early history of the Christian tomb was bound up less with the individual than with the rhetoric of future salvation, with a conception of the person in a totalizing history, of the Faith, in which images of salvation were essentially collective. The legacy of Judeo-Christian eschatology had left powerful texts like that in St John's

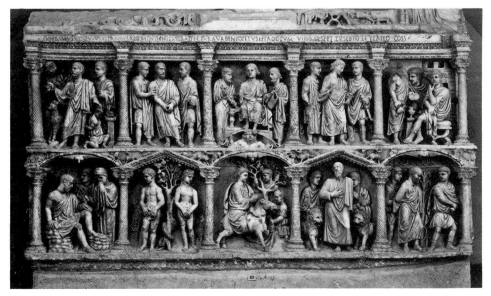

The early Christian sarcophagus of Junius Bassus (d. 359) presents a mixture of scenes including (numbering 1–10 from top left to bottom right) Christ with Peter and Paul (3), the sacrifice of Abraham (1), the afflictions of Job (6), the Fall (7), Christ's entry into Jerusalem (8) and Daniel in the lion's den (9).

Revelation which related fundamentally to mass experience. The greatest early Christian sarcophagi erase the narrative of the person – the subject of the old eulogistic formulae – by means of the narrative of the Faith. That of Junius Bassus, Prefect of Rome (d. 359), shows Christ with the apostles Peter and Paul, together with Old Testament subjects like the afflictions of Job (as in the *Ordo defunctorum*), Daniel in the Lion's Den (a type for the Resurrection) and the Fall of Man (and so the admission of death into the world). Such concatenations of biblical images point forward from a specifically triumphalist and salvific perspective to the typological and historical narratives of the Middle Ages. This erasure of the narrative of the person – rather than any decline in aesthetic consciousness with the collapse of Greco-Roman art – brought with it a decline of funerary portraiture and, by *c*.500, of the eulogistic epitaph.

In noting that the history of the medieval tomb is in large measure one of the recovery of a sense of the person commemorated, by means of images and texts, we should not confuse this recovery with an incipient 'rediscovery' of the individual; the tomb's representational strategies were geared primarily to a new set of strategies for the afterlife which implicated both the dead and the living in a new interactive relationship of mutual obligation. The person reappears first as a socially and culturally constructed entity. Image and text – what Richard of Fournival, a thirteenth-century canon of Amiens, called the two portals to the house of memory, *painture* and *parole* – were thus geared as much to positioning the person within a system, as to the assertion of individuality. The medieval tomb became a framework for images and texts which conveyed increasingly large amounts of information about the deceased in relation to the afterlife. In this respect, medieval tombs were structurally similar to medieval images of any type: at the level of *painture* they witnessed a growth in internal complexity, multiplicity of reference, and the capacity to implicate the spectator. Their textual components, in the form of epitaphs and votive inscriptions, expanded remarkably, especially in the fifteenth century, as the *parole* of the tomb served both commemorative and penitential purposes.

At the heart of these systems of *painture* and *parole* lay the effigy; impersonal narrative elements on medieval tombs, especially those drawn from the Bible, withered in almost all of western Europe with the exception of Italy, where Christological imagery remained in use. The effigy, like the will, was a central means by which the dead were given a voice and a presence in medieval art. But effigies are curious and ambivalent. Their ambivalence resides in part in their three-dimensional character and hence power, and in their existential ambiguity. Where, as is often the case in medieval art, the effigy shows a recumbent person in a state of frozen alertness, a state of conflict arises between the temporal notion of death and lifelikeness. Effigies are not unlike real corpses in their irresolvable position on the boundary between two existences. On the other

hand, unlike corpses, they are 'idealized', showing the deceased in the state of perfection they would attain at the Resurrection. Context can sometimes help to close these points of irresolution. And we will see later in the next chapter that macabre tombs play quite self-consciously on ambivalences of time and state. Recumbency too offered some resolution. Saints' shrines eschewed recumbent effigial representations, and anthropomorphic images of saints were restricted to the enclosure of body parts in the form of sculpted heads or limbs. Discriminations of this type point to a developed sense of the power of the body in relation to its simulacrum: where, as with a saint, the body was genuinely powerful, because it stood for a person who was in some sense still alive and capable of dramatic intervention in the world of the living, its representation (rather than its enclosure for the sake of preservation) was irrelevant, and potentially even harmful as a focus of displaced attention. The tomb of the non-sainted person, in contrast, effectively masked the reality of the dead and ineffectual body by means of the recumbent simulacrum. If it had a vertical image, that image stood for the person 'in life', as can be seen on the royal family tombs formerly at Royaumont. The medieval effigy cancelled the body until that point, after *c.* 1400, when the relationship between the corpse and the simulacrum, a relationship of anxiety, could be thematized by means of the *transi* tomb (see pp. 139–52).

The history of effigial tombs begins in the eleventh and twelfth centuries. The earliest relief example of a layman is probably the bronze tomb of Rudolf of Swabia (d. 1080) in Merseburg Cathedral. But clerical patronage remained central, and bishops were commemorated by magnificent effigial tombs in twelfth-century Magdeburg and thirteenth-century Amiens. By the thirteenth century, the effigy had become a key means of asserting selfhood and history: hence the retrospective effigies we have noted at Saint-Denis, and the similar examples made around 1200 for the Anglo-Saxon bishops of Wells, which reflect the priority that the south-western English bishops gave to the early history of their church. Such anachronisms, which served to absorb the past into contemporary discourse, occurred too in the new system of heraldry, since coats of arms could be attributed to the long dead; and heraldry too was a means of signifying the person in society. Bishops usually did not bear arms, but their tombs represent some of the finest assertions of the most basic fact about the medieval effigy — that its formation was inseparable from a notion of social station. Episcopal tombs are amongst the most triumphal of the period, and signal the rise to power of the clerical class as a whole. Like the saints who trample their vanquished opponents on northern French cathedral portals of the period, bishops are shown in effigy as a class of victors, garbed in full pontificals, and spiking evil's manifestations beneath their feet in allusion to the seminal text of triumph, Psalm 91:13. Their role in the transmission of power in the Holy Roman Empire is witnessed by the tomb of Siegfried of Eppstein, Archbishop of Mainz (d. 1249),

Bishop Evrard de Fouilloi (d. 1222) is represented triumphally in bronze in the nave of Amiens Cathedral. Like Hugues Libergier (compare illustration on p. 90), he is censed by angels.

crowning Heinrich of Raspe and William of Holland. Pastoral images of this type demonstrate the role clerical tombs had in influencing those of the lay elite. The Angevin rulers of England were commemorated in the early thirteenth century at Fontevrault by effigies in painted stone. But bronze was especially favoured by the episcopal class, as at Amiens, and was adopted for some French royal tombs. The Emperor Charles the Bald was rewarded posthumously with a bronze tomb at Saint-Denis, and Queen Blanche of Castile (d. 1252) had a latten tomb at Maubuisson. In England bishops like Robert Grosseteste of Lincoln (d. 1253) were the first to have major bronze tombs, and two of them, Boniface, Archbishop of Canterbury (d. 1270), and Pierre d'Aigueblanche, Bishop of Hereford (d. 1268), were court favourites who had metal tombs for their burials in France. These, together with the royal French tombs, were probably the prelude to the adoption under Edward I of gilt-bronze effigies for his father Henry III and his wife, Eleanor of Castile (d. 1290), made by a goldsmith, William Torel, in the early 1290s. The bronze tomb of Bishop Wolfhart von Roth (d. 1302) at Augsburg Cathedral includes the text *Otto me cera fecit Cunratque per era* (Henry made me of wax, Conrad of bronze), celebrating the division of labour usual in such splendidly permanent monuments.

Bronze tombs were restricted primarily to those holding office, sovereigns (in England) especially. Lying behind this restriction was a sense of the poetics of materials as acute as that favouring marble and porphyry: the tough, ineluctable and untarnishable character of gilt bronze metaphorically represented the stability

Detail of the gilt-bronze effigy and French epitaph of Queen Eleanor of Castile (d. 1290), Westminster Abbey, executed by William Torel, a goldsmith.

of office itself. Gilt metal could be rendered in stunningly plausible form, as on Torel's tombs, which are among the most brilliantly sensitive characterizations of the period. But the fact of metal served to distance these simulacra from the instability of the flesh; the impermanent natural body was displaced by a permanent official body which bore the signs, regalia, vestments and so on, of that office.

The contents of the tombs themselves made play with the antinomy of permanence and impermanence. When the tomb of Edward I was opened in the eighteenth century, the king's body was garbed in royal vestments like those worn at the coronation, and bore a crown, sceptre and other ornaments which survived the decay of the corpse itself, notwithstanding the fact that the ornaments were mostly cunningly-contrived theatre jewellery. Grave goods effectively disclose the symbolism of rank. When opened in 1967–9, the graves of two archbishops of York, Walter de Gray (d. 1255) and Godfrey de Ludham (d. 1265), contained, aside from the detritus of vestments, perfectly preserved chalices, pattens, archiepiscopal rings and pastoral staffs exactly of the kind represented on episcopal effigies of the period. Scenes of the Last Judgement sculpted on cathedral portals show bishops resurrecting in full vestments, and even going to Hell in them. A

twelfth-century bishop of Paris was buried with a note attached to his chest: 'I believe that . . . on the last day of the world I shall be resurrected', and Louis de Beaumont's brass at Durham once had a similar inscription over the head of its effigy: *Credo quod redemptor meus vivit qui in novissimo die me resuscitabit ad vitam eternam, et in carne mea videbo deum salvatorem meum,* from a response in the Matins Office of the Dead, derived from Job 19:26. The same text was found on the monument of Jean Dissé (d. 1350) formerly at Ste-Geneviève in Paris. The tomb's goods in effect rendered it a time capsule awaiting opening at the Last Judgement, when the body would be restored to the same perfection as the objects buried with it, and the person could be judged, in their plenitude, for good or ill at the end of their journey.

This intersection of image, station and ritual could affect the character of tombs in various ways. The adoption in the thirteenth century of trapezoidal, coffin-shaped grave slabs perhaps resulted from the growing use of the wooden coffin itself as a means of transporting the body for burial, which in turn reflected the importance of processional activity. On grander tombs, numerous representational elements seem to witness to the impact of ceremonial decorum: draped biers, cushions and candle-bearing brackets were all funereal paraphernalia. By the fourteenth century knightly funerals witnessed the procession of the dead knight's steed and heraldic trappings, and the knight's armour, itself later donated to the church as a mortuary offering. This occurred at the funeral of Edward the Black Prince in 1376, and his armour was hung over his effigy. Tombs in the Mediterranean sphere were especially prone to ritualized representations of the dead. Though occasionally northern European, and especially Flemish, effigies are shown with their eyes closed in death, like the mosaic slab of William, Count of Flanders (d. 1109) from St-Bertin or the great brass to Bishops Godfrey and Frederick von Bülow (*c.*1375) at Schwerin in Germany, the practice was more southern, and was normal for papal and Mendicant tombs, like that in mosaic of the Dominican Master Muños de Zamora (d. 1300) at Sta Sabina, in Rome. Italian tombs develop the imagery of the deathbed to its fullest, primarily for the benefit of the spectator: thus the effigy is commonly tipped up on its side to be seen better from below, despite Durandus's contemporary recommendation that 'the dying man must lie on his back so that his face is always turned towards Heaven'. A contemporary commentator noted that such tombs were *sicut thalami adornantur* (decorated like bed chambers). This may explain the common southern motif of curtain-drawing angels or acolytes, a survival in the medieval sphere of the old Roman *velarii* of cemetery paintings, drawing curtains aside to reveal orant figures. Strategies of this type reveal the same type of spectator orientation towards the art object as contemporary Italian fresco-cycles from the workshop of Giotto. Rhetorical figures like this spread more rarely elsewhere, usually in imperial or curial contexts: the tomb of the Emperor Henry VII of Luxemburg depicted in

Tomb of Cardinal Guillaume de Bray (d. 1282) by Arnolfo di Cambio, S. Domenico, Orvieto. Note the *velarii* (curtain-drawers) and the image of the Virgin Mary.

the early fourteenth-century Trier *Codex Balduinus* shows Roman-style *velarii*, while the real tomb of Cardinal Reynaud de la Porte (d. 1325) at Limoges has a curtained arrangement of Roman type in an otherwise Gothic context. Italian effigies were also more inclined to have their hands folded in death, a devotional posture related to submission or passivity, which was noted by Tertullian, Gregory of Tours and the *Chanson de Roland*, and one common in later Italian religious painting.

The dead person was thus framed by a new and occasionally grandiloquent rhetorical language of gesture and equipment; the tomb was a piece of theatre, a proscenium. Hans Belting has shown how motifs of ostentation of this type were developed on contemporary reliquaries; the tomb in effect socialized and broadened these motifs. The ostentation of funerary sentiment was again prevalent in Italy and Spain; the splendid late thirteenth-century painted sarcophagus of Don Sancho Saiz de Carillo, originally from Burgos, now in Barcelona, includes an entourage of weeping folk tearing their hair in a conventional gesture found also in Italian Passion paintings, again a survival of the public mourning rituals of the ancient world. France also took over such motifs by the mid-thirteenth century in developing what have become known as 'weepers', usually a small number of figures represented around the tomb chest in attitudes of grief. These resembled the arrays of small figurines that had been placed around metalwork shrines since at least the twelfth century. In fact such groups of figures, which appeared on the tomb of Louis of France, a son of St Louis, at Cistercian Royaumont, are seldom ritualized, and more often represent an entourage of personalities aligned with the deceased in kinship or allegiance of other types. The weeper motif is thus at heart a motif of solidarity. On the other hand there are spectacular examples of late-medieval tombs which emphatically are ritualistic, and the greatest are Burgundian: the tombs of Philip the Bold, Duke of Burgundy (d. 1404), from the Chartreuse at Champmol, and of Philip Pot, Grand Seneschal of Burgundy (d. 1493), from Citeaux.

Medieval Burgundy lay directly at the heart of the main lines of communication between Italy and the north. The north-south axis which seems to divide the history of the effigy with a fair degree of consistency, may turn on structurally deeper attitudes not only to funereal rhetoric and artistic traditions, but also to the way cultures negotiate the dead body itself, and I will be returning to this question in considering the macabre. Northern Europe, unlike the Mediterranean south, developed a much more diverse, and in some ways more confusing, visual culture of the effigy as an alert simulacrum. The notion of alertness was conveyed both through the visage of the effigy, which in the north is typically that of an awake and attentive person, but also through the dynamics of bodily posture. Occasionally alertness can be contextual: the visage of the painted effigy of Edmund Crouchback, Earl of Lancaster (d. 1296), at Westminster looks out

Tomb of Philip the Bold, Duke of Burgundy (d. 1404), by Claus Sluter and others, commissioned in 1381 for the Chartreuse at Champmol. The mourning vigilant figures at the sides are executed in gilded alabaster set against black Dinant marble.

towards the abbey's high altar and rood with clear open eyes, as if in permanent veneration of the Host. It was extremely common to confront an alert effigy with a devotional image represented over it on a vault, canopy or tester. But the dynamics of posture and attitude are essentially signs of class. Gothic England favoured remarkably lively recumbent effigies of knights and ladies, like the celebrated 'Dying Gauls' with crossed legs and swords ready to be drawn of the sort at Dorchester and Aldworth. Again, as with the blessing or crowning cleric, such images relate to perceptions of station rather than the individual: here, the virile knightly class is epitomized. The cross-legged motif of many English effigies, both male and female, was one developed on twelfth-century French portal statuary, and has no specific meaning except, perhaps, indicating a certain aristocratic nonchalance; in his (admittedly late) *De civilitate morum puerorum*, the great humanist Erasmus assigns this posture to the princely class. Nonchalance of a different type is indicated on three fourteenth-century tombs of knights at

Ingham, Reepham and Borrough Green in East Anglia, where the male effigy lies on a bed of cobbles, a clear allusion to the idea of hardiness whose undercurrents are penitential and romantic. The *Miles Christi* (soldier of Christ) is ever alert and ever ready to challenge the idea of eternal rest. At Minster-in-Sheppey, Kent, a knight identified usually as Sir Roger de Shurland lies with his horse and squire, and Sir Richard Stapledon rests at Exeter Cathedral with an armed guardian, a squire and his steed.

It is unlikely to be coincidence that tombs of this rather cheerful type figure increasingly in contemporary romance literature associated especially with the Arthurian canon. The collective sensibility of the aristocratic classes was intimately linked, especially from the twelfth century, to the culture of the romance, and not surprisingly tombs figure as signs of the deeds of knights. In the old French Perceval legend we read of the Black Knight who went to Avalon, where he met a lady who challenged his love; she built an invisible castle and painted the image of a knight on a tomb. The Black Knight had to fight anyone who read out the words written on the tomb, for this constituted a challenge to the image; and he succeeded until vanquished by the knight Perceval. Later Perceval freed a knight trapped in a tomb. Contemporary-looking images of tombs enter the romantic imagination. In a late thirteenth-century French Maccabees romance, the tomb of the Maccabees is shown as a Gothic canopied structure with an arcaded tomb-chest, and an idol of Moses standing within it, which spoke a panegyric on the family whenever the wind blew through it. The effigy and its trappings were, in short, ways of acting out class expectations. If knights were alert, then aristocratic patrons could be represented precisely as patrons: on her (restored) tomb at Fontevrault, Queen Eleanor of Aquitaine, a noted patroness of troubadoric literature, is shown in a state of *studium* with an open book. What its contents might have been we can only imagine.

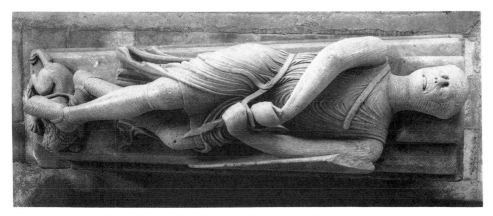

Sword-drawing knightly effigy, mid-13th century, Dorchester Abbey.

INDIVIDUAL AND GROUP LIKENESSES

How the dead were represented, and what their effigies were made of, were thus in the first instance issues of group identity and not individuation: or rather, they were ways of presenting individuals only in so far as they were members of a group, eventually subsuming them to ideas of collective identity. The simplest graves of abbots and priests were marked with elementary signs of the person within, a crosier, or chalice and patten, as social attributes. A London fishmonger, Nicholas d'Aumberdene, has a splendid fish at the base of his cross-brass at Taplow, *c.*1350, and Peter Denot, a glover, has a pair of gloves over his epitaph at Fletching, Sussex. Work denoted station, and so self-consciousness and identity.

The issue of portrait likeness as opposed to typification – idealism versus realism – was related to this relationship between the person as an individual or as representative of a group. Portrait likenesses on tombs, in so far as they can be assessed at all, can only really be identified from the second half of the fourteenth century, in such celebrated cases as the monuments to Charles v of France, his brother Jean, Duc de Berry, and Richard II of England. Here individuation clearly mattered; but the issue of why it mattered is really inseparable from the history of the portrait as a genre of image in itself. There seems to be no special reason why a tomb likeness should have been seen as aiding the salvation of this *particular* person. The fact that most late-medieval tombs remained essentially stereotypical, suggests that portraiture in this regard was

Richard II, gilt-bronze effigy, Westminster Abbey. Executed in 1395 by two London coppersmiths, Nicholas Broker and Godfrey Prest, the contract for the effigies of Richard and Anne his queen specify that they were to *contrefaire*, or 'portray', the sovereigns. Richard's image resembles that on his painted portrait also in Westminster Abbey.

functionally superfluous: that it was a form of supplement whose role was not salvific, but ideological. The contract of 1395 for the metalwork for Richard II's tomb notes that the images were to *contrefaire* (portray) its images of the king and queen, which are palpably official likenesses. Here some consonance with the tomb's epitaph, which stresses the elegance of Richard's appearance, may be suspected: portraiture stands as heir to the tradition of post-mortem eulogizing, truth in the representation of appearance susbstantiating truth in the recollection of a king's deeds. The sermon of Bishop Brunton on the death of Edward the Black Prince makes allusion to his military exploits in much the same way as the epitaph on the tomb of Edward's father, King Edward III. Words like *contrefaire* (from the Latin *contrafactum*), used in medieval documents of this type in reference to representations, are ambivalent in so far as they implied copying, and hence second-order representation, which, in Platonic thinking, substituted or confused likeness for essence (hence the modern 'counterfeit'). This was partly the basis of Master Rypon's attack on make-up as concealment cited earlier (p. 88). To *contrefaire* the likeness of a king was to represent and so immortalize the natural accidents of that person's appearance; and to do it, as in Richard II's case, in bronze, was to blur the distinctions between the permanence of office and the impermanence of the natural body. Portrait likenesses, in other words, interrupted the symbolic discourse of the medieval tomb just as, when they took the form of separate framed pictures hung in galleries, they interrupted the discourse of history and continuity of the dynasty; portraits asserted an idea of authority — the authority of the royal image to command a mode of representation — but also challenged it, because portraiture shifted attention towards the values of surface, towards *vanitas* and impermanence, and hence mortality. Again, as we shall see later, this new fluidity or ambivalence in the representation of the natural body played a part in the symbolics of the macabre.

In any event, before 1400 portrait likenesses tended to occur in group contexts — in the context of the dynastic mausoleum or the palatial picture-gallery. This points to the paradox of the medieval (as perhaps of any) individual: that 'private life' is everywhere, and yet nowhere. Individuals were under formidable pressure to conform to the accepted norms of group behaviour, being constrained especially by ties of blood-relationship or political amity at a time when these represented the dominant social structures. Ties of kinship or lineage were vital even to the clerical classes. The 'individual' was divided across various lines of social and personal demarcation. Some of these we have seen already: for example, the conflict between dynastic solidarity and history on the one hand, and personal salvation on the other, and its resolution in bodily division (pp. 63–9). What Panofsky called the 'gentilitial' aspect of the medieval tomb also relates to this broad conception of the person in relationship to the group. Earlier (p. 99) I noted the growth of 'weeper' images which developed out of a

specific context of ritualized representation on tombs, and also that such representations were basically signs of solidarity. Weepers, which occur commonly in northern Europe from the later thirteenth century, are not usually mourners, but stand instead for ideas of lineage and adherence of other types. Clerics usually chose images of saints or apostles, or, in the case of bishops, their suffragans, as signs of their *familia*; Thomas Cantilupe at Hereford has images of knights Templars around his tomb-shrine for this reason. But others, like Louis de Beaumont at Durham, self-consciously asserted blood line through representations of subsidiary figures showing their family, and texts including the sentiment that Louis was *Nobilis, ex fonte regum comitumque creatus* (Noble, made from the fount of kings and counts). Chiefly such group representations were a lay phenomenon proper to non-celibates. Beaumont took the clerical line of stressing ancestry, not descent, in keeping with earlier aristocratic tombs like that of Marie de Bourbon (d. 1274) at Saint-Yved at Braine, which had an entourage of eighty figurines. Displays of this type are essentially a form of ancestral invocation: early epitaphs of the period are not eulogistic, but are devoted to naming the dead and their relatives in the interests of salvation, making it clear who it is that is to be prayed for. In the Middle Ages, the first name was the basis of identity, and the repetition of first names generation after generation indicated continuity and the strength of self-replication through blood line.

Images of allegiance could take striking forms. William of Wykeham (d. 1404) has three monks sculpted at the feet of the effigy in his chantry facing its altar, offering eternal suffrage. The sixteenth-century tomb of the Emperor Maximilian I in the Hofkirche at Innsbruck is surrounded by free-standing images of the emperor's ancestors and relatives which are larger than life-size and as uncanny as the mass displays of terracotta figures from the tomb of a Chinese emperor. Tino di Camaino's tomb of the Angevin Henry VII (d. 1313) at Pisa includes a tableau of the ruler seated with large images of his councillors. The tomb could represent a veritable court or even a guild. One such is the elaborate brass of Sir Hugh Hastings (d. 1347) at Elsing in Norfolk. Sir Hugh is represented beneath a canopy surmounted by images of St George and the Coronation of the Virgin; the canopy also houses a number of male 'weepers' constituting Sir Hugh's brotherhood of arms, in this case headed by Edward III. Some of Hugh's comrades were involved in Edward's foundation of the Order of the Garter, in effect a military guild under the protection of St George and the Virgin. Sir Hugh's tomb thus expresses a form of corporate identity, embedded in shared military honour and badges of allegiance – Hugh was a veteran of the battle of Crécy.

Sir Hugh Hastings' tomb illustrates a further point about the role of the tomb in instantiating personal privileges, since it provides us with a rare instance of a tomb cited as evidence in a legal action. This arose in a process which aimed to establish the right to bear the arms of Hastings, undertaken in the Court of

Chivalry in 1408 between Sir Edward Hastings and the plaintiff, Reginald, Lord Grey of Ruthyn. The court met at a Priory in Norwich, and moved subsequently to the parsonage of Elsing. Here, Sir Edward cited evidence in Elsing parish church, including Sir Hugh's brass and arms, and stained glass windows, which indicated his right to bear the Hastings arms, over Lord Grey's. The forensic use of a tomb indicates the inordinate importance attached to issues of precedence and lineage in the period, and it may be partly because of this that patrons were more inclined than ever before to specify in wills and contracts the exact appearance and even wording of a tomb. Heraldry was one of the central signs of this preoccupation, and was of considerably greater symbolic importance than portraiture. Heraldry indicated both selfhood and, more importantly, the bonds of blood and family alliance and affinity, which, unlike portraiture, belonged in the realm of the permanent. These bonds were almost always expressed through the male line, women taking their father's or husband's arms as their own. As heraldry spread throughout all the media in the twelfth and thirteenth centuries, it found an especially important role in personal emblematics and commemoration. Shields, adorning grave goods or sculpted and painted on tomb-chests, were popular in Spain and England from the mid-thirteenth century. Knightly tombs like that of Edward the Black Prince had the arms and armour of the warrior suspended over them, a fashion which seems to have started in the thirteenth century. In England, as on the tomb of Eleanor of Castile, sculpted shields were sometimes shown slung from verdant branches, suggesting the irrigation of blood lines by marital ties of affinity: the body politic was a heraldic body.

By the fourteenth century the tomb indicated the consequences of ties of affinity by developing family imagery, and there can be no doubt that in this period we do see a confluence of various elements – portraiture, devotional imagery and 'affective' elements tied to the idea of the family – which personalized the tomb. One major example of the new orientation is the tomb of Edward III (d. 1377): ostensibly this is the monument of a venerable and heroic monarch, but its tomb chest has small bronze figurines of his children attached to it, showing that Edward is also a paterfamilias. The imagery of descendants, and so a prospective vision of the family as well as of the afterlife, now replaced that of ancestors, the tomb blending the notion of deference and obsequy with that of future largesse. The royal marriage and family are commodities of state. Marriage itself is increasingly thematized on late-medieval tombs, typically by the introduction of double effigies of man and wife, often holding their right hands. These appeared in the thirteenth century, like the tomb of Henry the Lion and Duchess Mathilda at Brunswick Cathedral. Richard II (d. 1399) and his queen Anne of Bohemia lie holding hands in effigy at the place of their union, Westminster Abbey, their childless marriage reflected in a painting on the tester overhead of the chaste marriage of Mary and the Church, the Coronation of

the Virgin. Marriage, the liturgies of which developed in the twelfth century, is represented as a eulogistic ideal, and as a sacrament blessed by the Church. But the marital tomb also reveals that affective relationships are exposed and reinforced both at the moment of their creation and in death, the crisis of mortality condensing affective sensibilities and social ideals.

Late-medieval tombs, with their canopies and exhibitions of family identity, amount to an encastlement of the family, a celebration of the line of ancestry and descent. They express the deep bonds between the dead and the living: bonds of amity and kinship were central to the obligations of the cult of memory, and of the practices associated with Purgatory. Their character has a domestic self-sufficiency, even comfort. Children begin to appear with their parents. In the early stages, ties of affinity could give rise to confusion: the tomb image of Henry III, Count of Sayn (d. 1247), with his miniature daughter, now in Nuremburg, appears to have prompted the tradition that the count, a kindly giant, had inadvertently killed a child by patting it on the head. Come the next century, the ideology of the display of scions was more self-evident: the old retrospective 'ideology of filiation' was now temporally reversed. In part this was the cultural product of the disclosure of ties of affinity and affection; but it may also have related to the increasingly unfavourable rate of child mortality in the later Middle Ages which increased the inherent value of offspring. Images like this suggest that high infant mortality did nothing to harden parent's feelings towards their offspring. But at the same time the growing trend towards promoting imagery of 'issue' from a marriage also lent to children the character of a commodity; they became as manifest a sign of achievement as the bearing of arms and a loyal marriage. On English brasses of the period, children are even lifted up on pedestals, as on the tomb of Sir Nicholas Hawberk (d. 1407) at Cobham in Kent, while on the brass of Baron Thomas and Elizabeth Camoys (1421) at Trotton, Sussex, a son nestles in the robes at the feet of Elizabeth. The odd brass at Stoke Fleming in Devon of John Corp (d. 1361), evidently provided by his granddaughter Eleanor (d. 1391), shows both figures set within a ship's prow with lanterns; Eleanor, a large figure, is lifted up on a mighty pedestal, perhaps to clear the couple of any marital or incestual confusion. But though children are in a sense idolized on such memorials, their presence is still subsidiary. This was not a child-centred culture. They belong to the same realm of family attributes as pets, like the lapdog Terri at the feet of Alice Cassy and her husband (1400) at Deerhurst, Gloucester. This realm of domestic attributes situates the late-medieval tomb in precisely the same position as many contemporary religious images —

Right Brass of Sir Hugh Hastings, Elsing, Norfolk, 1347. Sir Hugh's devotion to the Virgin Mary and St George, shown in the canopywork of his brass, emphasizes the links to the Order of the Garter of his entourage of weepers, headed (top left) by King Edward III.

for example Flemish devotional paintings – in blurring the distinction between an interiorized environment of social and emotional comfort, and the sublime associations of devotional ideals. Though hierarchical, the family tomb creates a kind of continuum between the attributes of temporality and spirituality. The family and the person are sublimated into a larger social order, one prospective in both earthly and heavenly senses.

The sublimation – literally the raising up – of the person, whether or not in a familial context, returns us to the metaphor of elevation which we identified in the formation of the canopied tomb. By the late thirteenth century the person could be elevated as a sign of temporal station. Such practices are found on the

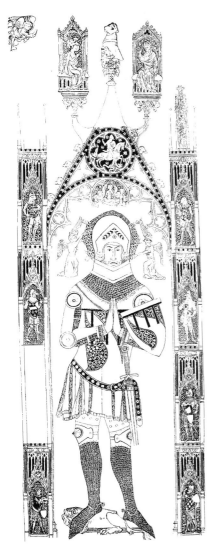

Above Brass of John Corp (d. 1361) and his pedestalled granddaughter Eleanor (d. 1391), Stoke Fleming, Devon.

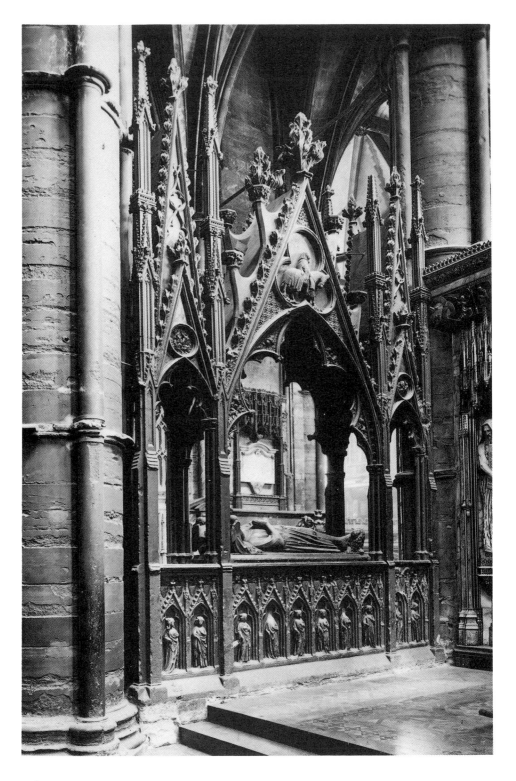

great fourteenth-century Scaligeri monuments in Verona which, like the authoritarian rider figures at thirteenth-century Bamberg and Magdeburg, are essentially equestrian monuments in the tradition of that of the Emperor Marcus Aurelius on the Capitol in Rome. Philippe IV of France (d. 1314) had an equestrian monument to himself within Notre-Dame in Paris. Around 1260 Thiébaut Rupez's tomb showed him on horseback at St-Memmie near Chalons-sur-Marne. The knightly image was sublimated on the tomb of Edmund Crouchback at Westminster, since Edward is shown praying on horseback in the gable of the canopywork over his effigy. In being shown three times on his tomb, once on either side of the canopy gable and as a recumbent effigy beneath, Edmund's tomb is premonitory of a new trait in the representation of the person: multiple self-representation.

Left Tomb of Edmund Crouchback, Earl of Lancaster (d. 1296), Westminster Abbey. Note the figure of Edmund praying on horseback in the main gable.

Right Eleanor Cross, Geddington, 1290s.

Lying behind this dual sublimation and multiplication of the self were several factors. One may have been the development in such practices of a representational analogy to the fashionable practice of bodily subdivision (and hence self-multiplication) for multiple burial discussed earlier. Edmund's kinswoman Queen Eleanor of Castile was commemorated in the 1290s by a series of stational crosses (reflecting perhaps the stations of Christ's own carrying of the cross) along the route of her funeral cortège to Westminster from the Midlands where she died. This idea might have derived from older English wayside crosses, or from the type of cortège memorial erected to mark the passage of St Louis' body to Paris earlier in the thirteenth century. Eleanor's crosses are, like Edmund's tomb, classic instances of self-replication, since each surviving cross has more than one elevated sculpture of the queen disposed around the polygonal geometry of the spire-like edifices. These monuments are like spiritualized versions of the geometry of fortress towers at Edward 1's Caernarvon Castle, and in a way their role is no less authoritarian. The strategy is twofold: the queen's gaze is rendered universal and panoptical, as a sign of her power over her territory; and her image is inescapable to the faculties of sight and memory of the onlookers, but protected and elevated by height. The Eleanor Crosses are the finest symbols of the role of the procession, which was central to the funeral ritual, in establishing ideas of power (because of their elaborate display) and surveillance (images should be seen as active). Here, too, the strategies of self-generation and memorialization intersect, and it is probably for the same reason that Henry de Mamresfeld, Doctor of Theology, had himself depicted twenty-four times in the fashionably courtly-looking glass of Merton College Chapel, Oxford, in the 1290s.

The image of the self could thus be repeated or conned by rote within a memory system that was directed through repetition to guiding the responses of the viewer. But it could also be divided within itself, since the medieval individual was not an *individuum*, but a corporate entity of body and soul. As the body split apart, so the soul split away entirely. Here was the classic image of self-sublimation, the so-called *Commendatio animae*, or commendation of the soul, to God. The soul was usually believed to leave the body via the mouth and to travel upwards (sins permitting) as a small childlike naked eidolon held in a cloth, typically to Abraham's Bosom, in allusion to Luke 16 where the leper Lazarus 'died and was carried into Abraham's Bosom'. It was an excellent theme for the hierarchical spatial arrangements of the canopied tomb; Abraham with the soul appears on the tomb of Sulpicius Cultor, priest of St-Martin at Plaimpied, and the soul of Abbot Lambert is carried aloft from the abbot's body to Christ, in a twelfth-century manuscript from St-Bertin. In the twelfth-century English Shaftsbury Psalter St Michael carries a group of souls to Christ above, and St Michael is represented with a soul nestling in a cloth on the tomb of Bishop Nigel

(d. 1169) at Ely. Here the canopy, on a low-relief tomb, is inscribed with a funeral antiphon relating to the soul's passage to Paradise. A similar sentiment, echoing the Roman anthem *Subvenite*, appears on the elegant brass of Lawrence Seymour (d. 1337) at Higham Ferrers: *Suscipiat me Christus qui vocavit me & in sinu Abrahe angeli deducant me* (May Christ who called me receive me; and may the angels lead me into Abraham's Bosom). Here Christ, with a cross nimbus, and not Abraham, holds Lawrence's soul in apostolic company. As Christ replaced Abraham as recipient of the soul, so tombs came closer to the imagery of the Last Judgement, in which Abraham's Bosom had figured as a sign of Paradise. Thus Christ exposes his wounds as Judge on one side of the canopy of the lavish mid-fourteenth-century Percy tomb at Beverley Minster, with either Christ or

Brass of Bishop Robert Wyvil (d. 1375), Salisbury Cathedral.

Fragments of the tomb of Margaret of Brabant (d. 1311), being raised by angels from the dead, by Giovanni Pisano, formerly at the Palazzo Bianco, Genoa. Compare illustration on p. 204.

Abraham on the opposite side of the gable – imagery already found on the earlier tomb of Ogier the Dane discussed above (p. 86).

Angelic images creating fragrant incense or carrying the soul upwards were a complement of this medieval imagery of apotheosis. In the Assumption of the Virgin Mary, an increasingly common theme from the twelfth century, it was not a soul but a body which was carried upwards by the angels. On the Coronation of the Virgin portal at Senlis Cathedral of c.1170, angels flutter and haul up the Virgin's body from its tomb to lead it upwards to its apotheosis, the Coronation itself. In a remarkable image in the English twelfth-century Glasgow Psalter, Mary is raised up still shrouded. Mary's ensuing spiritual marriage to Christ figures commonly on fourteenth-century tombs, and Giovanni Pisano adapted the theme of the Assumption in his stunning image of the Resurrection of Margaret of Brabant (d. 1311) from her tomb in Genoa.

EPITAPHS

Such thematic cross-overs show that religious subject-matter, like heraldry and portraiture, was itself used as a means of epitomizing the person commemorated. And the practice of surrounding an effigy with religious images, usually of the

saints or of the Godhead, created an explicitly devotional framework of assistance both to the dead and to the living spectator. This is again a system of invocation, a way of naming, like a Litany: the saints can accompany the dead in a symbolic manifestation of the Heavenly Jerusalem. Late-medieval clerics wore copes, processional vestments, embroidered with images of the saints, and so they are shown on their tombs. It was to such garments that the thirteenth-century liturgist Durandus referred in writing of 'the body rendered spiritual'. In creating this sort of devotional environment, *painture* collaborated with *parole*. The images and epitaphs on tombs stand as evidence for the religious interiority of the person commemorated, and also for the ways in which the spectator was implicated. Medieval epitaphs are strikingly neglected. In England many survive on brasses, either engraved on latten strips, or inlaid separately in capital letters around the grave slab, but they have never really been studied for evidence of language, dialect (when in the vernacular) or devotional practices and habits. Language varies with the orders of society; in England, a polyglot society, clerics tend to have Latin epitaphs, laypeople vernacular ones, at first Anglo-Norman French and then English. Usually, with the passage of the fourteenth century especially, the range of sentiments in epitaphs increases markedly by including biographical information, and French disappears.

But the earliest epitaphs are essentially labels. That on the brass of Sir John d'Abernon (d. 1327) at Stoke d'Abernon simply reads

> Sire iohan daubernoun chivaler gist icy, deu de sa
> alme eyt merci
>
> (Sir John d'Abernon knight lies here, God have mercy
> on his soul)

while that to Joan de Cobham, one of a series in the chancel of the parish church at Cobham in Kent, of the first decade of the fourteenth century, runs in couplets

> Dame ione de kobeham gist isi, deus de sa alme
> eit merci, kike pur le alme priera, quaraunte iours de
> pardoun avera
>
> (Dame Joan de Cobham lies here, God have mercy
> on her soul, whosoever for her soul prays, pardon
> will have of forty days)

Brass of Joan de Cobham, c.1300–10, Cobham, Kent, with surrounding pardon text.

Joan's tomb is in effect a 'pardon' brass offering a specific period in remission from Purgatory. Its text is the critical part, the image serving independently as a memorial. Texts of this type seem to have been more common on laypeople's tombs than on those of the clergy. Quite how a patron gained the privilege of offering what was in effect an indulgence on their tomb – usually a papal or episcopal privilege – is unclear; the practice of indulgencing certain images and texts had begun with the papacy a century or so earlier, as in the case of the indulgenced prayer composed around 1216 by Innocent III for the image of the Holy Face, the Veronica, which carried an award of ten days for each recitation of the prayer. Four recitations of the prayer were the equivalent of one prayerful visit to Dame Joan's tomb. As in many economies, inflation was a problem, and indulgenced images like the *Arma Christi* (see p. 125) carried relief of over four years per prayer by the next century; a pessimistic forty thousand years was not an uncommon period in the latest indulgences. Later epitaphs are as legalistically precise as contemporary wills. That of Pierre Cossart (d. 1404) at Cergy-sur-Oise is phenomenally attentive to detail, mentioning the exact sum left to the clergy of the parish from a business located in Pontoise 'at the corner of Rue de Martre bordering on one side Robin the turner, leading to the heirs of Richard de Quos, and on the other side on the king's highway' and the exact number of Masses, Psalms and Lessons to be recited for his soul.

Latin and English epitaphs have widely differing characters. What appears to be the oldest English epitaph, on a tomb slab of around 1300 at Stow in Lincolnshire, says simply:

> Alle men that bere lif
> prai for Emma was Fu(l)k wif.

The odd appearance of the brass of Bishop Robert Wyvil (d. 1375) in Salisbury Cathedral, which shows the bishop ensconced in a fortress set in a rabbity meadow, with an armed thug at its gateway, is comprehensible only to those able to crack open the meaning of the Latin marginal inscription. This explains that the bishop secured the possession of Sherborne Castle and Bere Chase for the cathedral, though it does not mention that the bishop required his champion to fight for the Chase, the champion being discredited when it was found that he had charms hidden under his clothing. Here we find an echo of the kind of sentiment on the splendid bronze tomb of Edouard de Fouilloy, Bishop of Amiens (d. 1222), in the nave of the cathedral, who 'laid the foundations of this edifice' and had the city entrusted to his care. In theory, though not in practice, humility was more appropriate to an epitaph than grandiloquence. Eudes de Chateauroux (d. 1273), a canon of Notre-Dame in Paris who had personally consecrated the Sainte-Chapelle, remarked in a sermon that pompous sentiments

... are frequently to be found in modern epitaphs ... [stating] that a person came from such and such a family, or held such an office, was wealthy, that he will have greater glory in paradise and a lesser penalty in Hell or in Purgatory. Such circumstances in fact do not increase the chance of a heavenly crown but rather diminish it ... such inscriptions are like false coin.

Eudes also noted that epitaphs were usually fixed outside tombs 'so that men can read, and in reading they may commend the dead'. But by the fourteenth century, epitaphs like Wyvil's amounted to a form of clerical joke, and few others would get it. Normally the strategy was to place a simple inscription near an aisle, passageway or door, like the text inscribed for John de Pitney by the entrance to Wells Cathedral, around the time of the Black Death. And few vernacular memorials can compete with the austere beauty of the English inscription for John the Smith, *c*.1370, at Brightwell Baldwin:

> Man com & se how schal alle dede be;
> Wen yow comes bad & bare, nothing hav ven ve away fare;
> All ys othermenes that be for care;
> Bot that ve do for godysluf ve have nothyng thare;
> Hundyr this grave lys John the Smyth,
> God gif his soule heven grit [peace].

The Cult of Memory: Catering for the Dead

A further alignment of memory and ritual in the service of the person occurred with the development of the chantry. A chantry was usually no more than an endowment of Masses (sung and therefore 'chanted', or said) for the soul of a particular patron for a given period: they could be perpetual or temporary, and they did not imply in the first instance a specialized site of performance. A chantry was an institution, not a building. Chantry endowments were a succinct expression of the widespread medieval belief in the efficacy of Masses, the liturgical, devotional and institutional ramifications of which were immense. Chantry Masses were the heir to the ancient practices of feasting at tombs, and in essence the notion of the chantry owed its character to the forms of private votive Masses, whose development had begun in the early Middle Ages. But the character of the chantry as a special endowment aligned it with the formation of other institutions whose character was high medieval, but which subliminally preserved the idea of Purgatory as a state or even place of further improvement: the colleges forming in this period at Oxford and Cambridge were in effect academic chantries, founded by specific patrons as good works, and staffed by scholars to support the patron's memory and soul; the whole development was premised upon the institutionalization of the doctrine of Purgatory and remission; and the chantry was essentially private.

Originally the endowment of memorial and other votive Masses had been the responsibility of monasteries throughout Europe, each of which kept a calendar or obituary register, in which the names of the significant dead were to be entered for the recollection of their anniversary. These ritual invocations became increasingly common in the Carolingian period, and at great monasteries like Cluny could amount to dozens each day. This eventually placed great pressure on communities gradually building up phenomenal Mass obligations, sometimes amounting to thousands of Masses each year. By the thirteenth century these clusters of votive Masses were replaced gradually by general commemorations of the dead, and by specially marked festivals of the dead, of which the feast of All Souls in November was the most important, originating in the eleventh century. The coincidence of a crisis in communal liturgical performance with the doctrinal acceptance of Purgatory in 1274 appears to have validated (if it did not actually cause) the branching-off of the votive Mass into a privately-endowed and separately-housed ritual entity. Growing lay demand for private commemoration accordingly funnelled resources away from ecclesiastical corporations in a process of 'privatization', which obviously had implications both for the politics of space of greater churches (though chantry foundations were common at the parochial level too) and for the broader relationship between communal and private bodies. By the fourteenth century the space of the greater church was under a variety of divisive pressures, from individuals as well as from urban organizations like guilds and fraternities, which were leading to an internal fragmentation of its ritual spaces. The privatization of Mass celebration in the interests of these social sub-groups was itself a response to the underlying tendency of the period for the saying of Mass to become primarily a clerical benefit: the private annexation of Mass was therefore part of a realignment between competing lay and religious interests.

By the fourteenth century at the latest this development also brought with it a privatization of space set aside especially for chantry Masses. The central requirement for a chantry was an altar, which may or may not have been associated with the tomb of the endower, and since altars had proliferated in churches of all types in support of Mass celebration, the chantry neither was, nor needed to be, physically impressive. Great secular churches like York Minster and St Paul's Cathedral in London had dozens of chantry priests, many of them not highly regarded. A chantry priest usually had no benefice and was thus a member of a kind of clerical proletariat. One text of the fourteenth century, *Piers Plowman*, gives an autobiographical sketch of one such cleric, probably its author William Langland. The tools of his trade include the 'Paternoster and my primer, *Placebo* and *Dirige*, and my Psalter and my seven Psalms' for the help of souls. The phenomenon of the private Mass was European-wide, but its physical embodiment varied regionally and nationally. Spaces for endowed Masses could be incor-

Fresco-adorned family chapels at the east end of Sta Croce, Florence, early 14th century.

porated into the design of pre-existing structures, like the early fourteenth-century chapels between the apsidal buttresses of Notre-Dame in Paris. And church planning could take into account Mass requirements. The thirteenth-century eastern transverse limb of Durham Cathedral, which houses nine altars, was a type which could be set aside for family commemoration, as at Sta Croce, the Franciscan church of Florence, which has ten chapels for family commemoration in its east-end transept, spectacularly decorated with frescos commissioned by the urban elites, like the Bardi and Peruzzi families.

In England, planning of chantry extensions to parish or greater churches was more *ad hoc*, in keeping with long-standing norms of architectural planning which favoured organic growth and not systematic absorption. The late-medieval chantry is thus part of the exterior crust of extensions and additions of many cathedrals and abbeys, whose boundaries had always been somewhat elastic. In the Province of Canterbury, grander chantry foundations eventually took the form of small cage-like buildings housing a patron's tomb and altar; and here, again, clerical patronage was of seminal importance. The earliest cage or closet chantries commemorate southern bishops like Bishops William Edington (d. 1366) and William of Wykeham (d. 1404) at Winchester. The Edington and Wykeham chantries both stand in the nave of a cathedral priory, and this location exemplifies for us the type of motivation which lay behind the erection of the chantry chapel. Bishop Edington had begun the rebuilding of the Romanesque nave of the cathedral, and Wykeham completed it: their tomb-spaces are thus distillations of their roles in erecting the larger space hereabouts, very much in the tradition of the magnificent bronze tombs of the bishops of Amiens Cathedral in its nave, who had erected its structure over a century earlier. Wykeham sought burial in the nave of the church because it was at an image here that he had been accustomed to pray as a boy — a form of institutional *pietas* known to patrons like Abbot Suger. The communal (and increasingly lay-dominated) space of the nave is thus annexed to a patron's sense of his own emotional landscape and history; the boy is father to the man, and Wykeham's employment of one mason, William Wynford, for the nave, his chantry and his foundation at Winchester College, discloses the patron's sense of his own good works having the impress of a certain style.

And these buildings are stylish, both in appearance and in the way they play upon the metaphors of interiority and exteriority that had been so fundamental to the formation of the medieval tomb-space in the first place. The cage chantry looks like a characteristically pragmatic English solution to the decline in great church building from the later thirteenth century, and which had prompted the national talent for small-scale architectural innovation. But the chantry chapel had no single cause, and it is a mistake to regard what appears to be a synthesis of developments in Mass arrangements and tomb design of earlier generations

Chantry chapel (1394–1403) of William of Wykeham, Winchester Cathedral nave.

as the product of an inevitable linear development. Though the possibility remains that the cage chantry was (like the reredos) no more than an architecturally committed successor to earlier, more temporary altar-enclosures in great churches, the genre appeared rather quickly in its full form, and has rather the character of a self-conscious innovation. Chantry chapels of this type were the consummation of the idea that tombs should be located strategically, either in public spaces to annexe intercessory prayer or in proximity to shrine-spaces. But chantries like those of Edington and Wykeham are self-contained; they are in the public sphere at the west end of the building, but they are inherently anti-communal in thought. Access to them is through small doorways, and the security measures are tight, the openwork, fenestral tracery of their architectural surrounds being stoutly barred and secured against public access. Yet in being fenestral in character, the sound and sight of what went on within was still (just) accessible; cage chantries tantalize the senses while cheating the desire to attain to the precious goods and stuffs, the liturgical appurtenances, and the rituals of transformation, within. The cage chantry is a prison turned outside-in, with the potential criminals on the outside and the free within; a world of private opulence located in a sphere of public squalor and relatively unstructured lay religious experience.

Galbraithian reflections of this type perhaps support the idea that the chantry chapel, in England at least, was the product of a culture of anxiety about issues like crime and the privileges of personal 'interiority' – in a sense, modern issues. Their spatial demarcation acted as a security system, and as the manifestation of that drift from the communal towards the private, which, as we have seen, had exposed numerous tensions in the culture of death and burial since the twelfth century. We can perhaps understand them by reference to Foucault's notion of the disciplinary space, 'the protected place of disciplinary monotony'. Like disciplinary spaces (by which Foucault would mean primarily prisons) chantries are enclosed and separate, intruding into the collective space of the church and disrupting its plural uses. Disciplinary space is usually cellular and owes its genesis to the monastic cell, that space set apart for the monk in the spirit of 'exile enclosure' from the world. It is also governed by a timetable, in the chantry's case that of liturgical performance and the calculus of memory and suffrages. The analogy between this annexation of communal religious space and domestic planning of the period is also relevant to the 'rise of the individual': the enclosure of altars, tombs and shrines by screens is analogous to the partitioning and specialization of planning in the private residence from the thirteenth century onwards, the chantry being to the nave what the chamber was to the great hall. Partitioning is related to autonomy; and autonomy is related to the definition of personhood, even if it does not constitute it. On the other hand, the remarkable standards of personal display which marked the small chantry building were

capable of massive inflation on a public scale. Henry VII's Lady Chapel at Westminster Abbey, essentially a grandiose chantry-like structure, was planned for the body of Henry VI, a potential saint, but was eventually annexed for the commemoration of the Tudor dynasty. Burial churches could aspire to these heights too: the mausoleum of Margaret of Austria, the daughter of the Emperor Maximilian and widow of Philbert II, Duke of Savoy, built in 1512–32 at Brou, is a magnificent instance of the interplay between austerity and opulence typical of late Gothic. And those who founded chantries also established colleges: William of Wykeham founded New College, Oxford, in 1379, and Henry Chichele, Archbishop of Canterbury, to whom we shall return presently, All Souls' College.

Whether or not the chantry chapel relates to the *locus classicus* of ideas of late-medieval anxiety, the Black Death of 1347–51, is very much a matter of opinion. Technically the chantry was a straightforward manifestation of strategies for the afterlife which had developed long before the demographic disequilibrium of the fourteenth century, though it might be the case that the enclosed chantry building arose from a need to reinforce social boundaries consequent upon the massive and unpredictable redistributions of wealth which occurred after the mid-fourteenth century and the plague. In this sense the study of the chantry requires a more interdisciplinary, and more pan-European, approach.

What is clear is that the cult of the dead and of memory was well established before the mid-fourteenth century. In ritual terms this routinely involved the celebration of anniversary Masses and obsequies on the seventh and thirtieth day after burial and on the first year's anniversary; there was also the general commemoration of the dead, All Souls or All Hallow's Day, the basis of the modern Halloween, as much as of Chichele's foundation at Oxford. Patrons could have their memories installed in parish liturgies and on their 'bede-rolls' (essentially lists of names of local patrons to be recalled on their anniversaries): the more communal the acts of remembrance, the more effective. Italian communal life developed such communal activities to a high degree. The study of urban life in fourteenth-century Italy, including the disposal of property and the care for souls, is assisted particularly by testamentary evidence which allows us to monitor the logic of estate-disposal in relation to the cult of memory. This appears to indicate that with the Black Death and, perhaps more importantly, with the recurrence of plague in urban centres thereafter (as for example in 1363), there was an increase in cities like Siena in donations to charitable institutions, and a growing concern for the cult of memory. Towns like San Sepolcro developed various strategies for the dead with the maximization of their population in the early fourteenth century: membership of major local fraternities, like that of San Bartolomeo, grew with their charitable status as an organized means of memorializing the dead. In turn, these were displaced by newer, smaller and generally more clubbable fraternities, organized by flagellants or *laudesi* singing

praises to the Virgin Mary. Such fraternities were basically laypeople's organizations which put into effect Christ's injunction in his warning about the Last Judgement (Matthew 25) that the saved should feed the hungry and the thirsty, care for strangers and the homeless, clothe the naked, visit the sick and the imprisoned – the Six Acts of Mercy – to which was added, from the twelfth century, the burial of the dead. Herein lay the charitable basis of medieval social security.

But the reinforcement of the cult of memory in the late Middle Ages remained a culturally diverse phenomenon, perhaps increasingly so from around 1400, notwithstanding the European-wide impact of the Black Death. Though western European Christianity was characterized by a prevailing system of exchange between the living and the dead reinforced by the central authority of the Church, the fifteenth century saw significant divergences which seem, again, to have parted along a north-south axis. As I have suggested, the tendency to personalize the tomb was already of long standing throughout Europe. When, in fifteenth-century Italy, humanistic discourse began to influence the formation of the tomb more in line with ancient notions of the individual, the changes amounted in the first place to a rhetorical adjustment within a pre-existing pattern which emphasized individual as well as communal salvation. Italian fifteenth-century funeral orations built upon, and replaced, older medieval traditions of scholastic sermonizing. In their stead arose the rhetorical order of the *exordium*, praise and peroration, dwelling less upon the prospective themes of the triumph of death and of the afterlife, and lauding instead the ideals of the good life, fame and civic virtue and service. By such means ancient ideals of personhood were re-annexed by the Christian urban elites. In the same way, the Gothic north was to develop a far more pronounced culture of the macabre than would be typical of the humanist idealists of Florence. And the same tendencies which were promoting religious interiority amongst the laity were conspiring, too, to usher in a critique of the institutional framing of the afterlife which was to prove devastating. The Reformation was finally to sweep away the hierarchy of the saints, the doctrine of good works and the hold of Purgatory, and with it the representational paraphernalia of the northern cult of memory. In England in 1529 Parliamentary legislation forbade the payment of Masses for the dead, and in 1545–7 the chantries were suppressed: over 2,500 dependent institutions were to cease, including collegiate foundations, hospitals, guild and free chantries, and with them the seemingly inviolate certainty of the medieval economy of death and sin. What appears to have survived, however, was something of the medieval culture of the macabre, to which we turn next.

CHAPTER THREE
THE MACABRE

The culture of the macabre which arose in late-medieval, and especially northern, Europe is one of the oddest and most compelling phenomena in the history of contemporary representation. For cultural historians like Johan Huizinga, the macabre stood as a metaphor of change in an entire culture: the imagery of death and decay represented a deeper decline, the 'waning of the Middle Ages', set against the healthy optimism, scepticism, egotism and fundamental modernity of the Italian Renaissance, as presented (and created) by Jacob Burckhardt in his *Civilization of the Renaissance in Italy* (1860). The influence of these broad, nineteenth-century canvasses is profound, even unshakable, and the antinomies which they have constructed between one culture and another, between fascinating decadence and authoritative, and authoritarian, rebirth, are useful precisely because they can be annexed in a number of competing ways. In this chapter, I will address only in passing the most obvious contrast between the culture of the north and that of Italy especially: that fifteenth-century Italy, unlike the north, appears not to have deployed the representation of the macabre with anything like the allegorical force, the universal force, with which it was used north of the Alps. Here I will suggest that the reason for this may lie not so much in alternative cultural visions, but rather in somewhat older social and representational practices; and to understand them we must return first to religion.

The Christian notion of the body as a sign is deeply implicated in the emergence of the macabre. Christianity, as we have seen, was the first exclusive universal religion to mark out the body as an object of veneration, both in its central sign, the Crucifixion, and in its pantheon of witnesses, the saints. The Christian holy body is as fragrant and as incorrupt as Paradise: 'Thou wilt not suffer thy Holy One to see corruption' (Psalm 16). Though body and soul were in some sense incommensurate (the soul was in a sense a body, and to many commentators represented the form of the body), the body became a central means by which late-medieval religion articulated many of its most important ideas: late-medieval religion is, paradoxically, at once deeply interiorized, immaterial and transcendant, and yet also somatic, body-centred and material, in its imagery.

In this respect the art of the Latin West was changing in the Middle Ages. By the Carolingian period a line of demarcation had opened up between the Western cult of relics, centred principally upon the cults of Christian martyrs, and the Eastern Church's emphasis on images. In the Greek Church, images could

function in the same way as the Western relic: they were a means of directly accessing the holy in Paradise, and like relics were potential objects of pilgrimage. The icons of the Greek Church were often regarded as not having been made by human hands, but by angels: like the holy body, they were not man's works, but represented the *opus Dei*. By the twelfth and thirteenth centuries, several factors were working to draw together these two separate attitudes to bodies and images. Among the most important of these were the spread of new images, usually icons of Christ and the Virgin Mary associated with liturgical and meditative practices, from the Greek Church to the West; and after the sack of Constantinople in 1204 by Western crusaders, the spread of increasingly large numbers of new relics into Latin hands. Some of these were important because they represented not the local relics of the venerated saints, but rather the universal relics of Christ and the Virgin Mary, like the Crown of Thorns or the True Cross. Western monasticism and new devotional practices also encouraged a new stress, from the eleventh and twelfth centuries, on the humanity of Christ and His mother, and especially upon the intercessory role of Mary.

The product of this was in effect a synthesis of the relic and the image into the 'image-relic'. The power of the image-relic was based upon its authenticity in recording the bodily likenesses of Christ or Mary (for example the Veronica, or image of the Holy Face, to be found in Rome but widely copied) and also upon its role in obtaining intercession through the indulgencing of images of this type, a process which had begun by the early thirteenth century. The image-relic arose as an important and complex instrument in the service of the doctrine of Purgatory. By the thirteenth and fourteenth centuries, this trend was exemplified by the absolutely central role that visualizing Christ's own body played in religious experience. As we have seen (p. 14), the saints, as witnesses to the power of the Christian body and the doctrine of the Resurrection, were routinely fragmented and scattered; the synecdochal relationship, where part of the body stood for the whole, ensured that the saints were universally present through the traces of their earthly form. To gain access to them the pilgrim had to travel to the relic site. Christ's body, though gloriously resurrected, could be submitted to this same process of fragmentation and contemplation, first ritually (at Mass) and then imaginatively. Here of course there were complexities. So-called contact relics that had touched His body – especially the Crown, Nails, Cross-wood and Spear of the Passion – were unproblematical except in their multiplication. Actual bodily relics like the Holy Blood and Foreskin were however problematical; if the resurrection of Christ was perfect, why had these too not ascended? Christ's own bodily history, a history of redemptive suffering, offered up the paradox that, as traces of His physical remains served to substantiate and authorize the Christian imagination, and literally to flesh out the Gospel text, so those relics also threatened central doctrinal tenets.

For this reason the sphere of representation, rather than actual physical evidence, offered a vital arena of imaginative liberation. Images could promote a mobility of mind in the contemplation of Christ's body which created no awkward conflicts of actual evidence. His body could be surreally deconstituted and reconstituted at will. Late-medieval, Passion-derived images like the *Arma Christi* (PL. VI) and the Man of Sorrows are for this reason free-floating syntheses, answering less to specific texts, or even liturgical practices (though they have ritual relevance), than to a kind of internalized pilgrimage of the mind. Where pilgrims had previously to travel to the relic, the image-relic now travelled to them; and so religious experience could withdraw from the world. Images of this type were affective, even magical, in import. Christ's body is mentally fragmented in illustrations which scrambled the historically sanctioned body and reprojected it in the form of small, and individually truthful, foci of devotion (PL. VII), which serve, as it were, to fill the imaginative gaps left by texts. The *Arma Christi*, popular in the fifteenth century, thus represent the individual motifs of Christ's Passion — the Nails, Crown of Thorns, Spear and so on, all technically relics — as well as close-up images of His wounds. Late-medieval images which answer to the textual omissions in the main readings of Christianity possess their own logic, the logic of the reordered Passion narratives of Books of Hours, or the shuffling-about of butchered images of Christ's body, his wounds and attributes of suffering in the *Arma Christi*; and it is part of their logic that they should serve to reorder religious experience itself. For this reason their presence as illuminations in devotional manuscripts or Books of Hours was fundamental to late-medieval spirituality. The private devotion acted as a microcosm of the older and larger order of pilgrimage.

I shall suggest that this deconstructive trait in attitudes to the body, based upon the cult of relics and upon the body of Christ Himself, is fundamental to the spirit of the macabre. For as Christ's body was broken up and reconstructed imaginatively, as it was subjected to critical rethinking, so too it was fetishized: it witnessed the transference of religious responses to isolated parts of the body, which had previously been presented intact in the conventional narrative iconography of the life of Christ which viewed him as a whole person. The facts and products of Christ's death were detached from the circumstances of His death. And with this fetishizing of what Lacan calls the *corps morcelé* came anxiety. Christianity, though premised upon a teleological notion of salvation and time, is fundamentally a religion of cyclical repetition and recollection; the religious year is divided according to this cycle, and at the centre of religious worship lay the regular commemoration, at Mass, of Christ's sacrifice and, in the temporal calendar of the year, of the lives of the saints. Within this broad ritualized time-frame developed the smaller, more interiorized cycles of repetition of private devotion: the saying of the liturgical Hours, and the repetition of prayers to gain inter-

cession for all and sundry. This compulsion to repeat is a hallmark of what has been described as the late-medieval obsession with 'quantitative piety': that actions are marked by their quantity as much as by their quality. The inflationary economy of Purgatorial indulgence was based upon this quantitative attitude to good work. But obsessive repetition is also a feature of neurosis; it marks an inability, at the most profound level, to assimilate experience. And there is something neurotic in the fetishizing scrutiny of Christ's body in late-medieval images; the history of Passion painting in this period is partly one of sophisticated, obsessive-compulsive voyeurism.

Repetition, trauma and voyeurism are central features of macabre images, and, like devotional art, they are involved also in the creation of normative responses. Images are a way of constituting experience: they can help to codify, if not determine, religious gestures of prayer and response, and they can validate whole spheres of conduct. Mystical imagery in literary form is frequently responsive to prior artistic image-making of a somatic type. Late-medieval texts are often marked by fantasies of incorporation and of wholeness; hence the force of St Francis' reception of the stigmata, the bodily impress of those things which ordinary Christians could only assimilate visually, if at all. By the same token, normative late-medieval religion was one centred upon quantifiable, and mnemonically valuable, categories of doctrine and devotion. The will of John of Gaunt of 1399 stated that around the hearse at his funeral should be candles symbolizing the Ten Commandments, the Seven Works of Mercy, the Seven Deadly Sins and, predictably, the Five Wounds of Christ.

The Macabre, the Black Death and Cultural 'Causation'

The macabre, then, marks the body as a site of anxiety quite as much as the inhibitions about bodily division for the purposes of burial discussed in the first chapter. But the macabre is different in that it offered a means, a vehicle, by which otherwise inarticulate ideas could be expressed. Its nature was essentially allegorical; it was another, better way of saying things. The macabre arose in a period when the symbolism and transformation of the body, especially the redemptive body of Christ, marked a positive means to salvation; but the macabre offered a negative mirror image to this symbolism of transformation. In it, the art of death became a new form of disclosure.

Conventionally speaking, there have been two routes to explaining this new allegorical understanding of death as a means of organizing belief. We can describe these as 'exogenous' and 'endogenous' routes, the first laying stress upon causes external to the culture of late-medieval society, the second stressing causes internal to that culture.

The most influential exogenous theory holds that the macabre was reinforced

by late-medieval demographic disaster, most especially the Black Death of 1347–51 (the dates vary according to region) and subsequent recurrences of the plague. The most concerted effort to trace the direct cultural impact of the Black Death – an unpredictable and exterior 'cause' – is represented by Millard Meiss's study *Painting in Florence and Siena after the Black Death*, published in 1951. In essence, Meiss argued that the impact of the plague upon Italian civic and artistic life marked a watershed. He was able to argue this because Italian city life of the period is relatively well documented, and because it produced, in Boccaccio's *Decameron*, a high literary validation of the idea that the plague was in some sense a cultural 'event'; that its devastating effects served to force out otherwise concealed ways of thinking. The plague, borne by fleas on rats, had entered the Mediterranean, and especially Sicily and Italy, in around 1347, and spread thence to infect much of north-west Europe. Though statistics vary, there is agreement that the plague at its most intense carried off between one- and two-thirds of the population in the areas affected. Worse, it recurred, in 1361, 1363, 1369 and 1374, and periodically thereafter. According to Giovanni Villani, half the population of Florence died in the summer of 1348. Florence, according to Boccaccio, was a giant sepulchre: at the start of the Decameron he notes '. . . they dug for each graveyard a huge trench, in which they laid the corpses as they arrived by hundreds at a time'. This was a disaster of biblical proportions, a punishment of an entire culture as effective as the chastizement of the world of Babel by the Flood. Images of the period depict the visitation of the plague in Apocalyptic terms, as a shower of malevolent, retributive darts from Heaven. Few literary responses measure up to Boccaccio's own, though even the English *Piers Plowman* said that 'these pestilences were for pure sin'.

The practical consequences of the plague were marked: mass population falls led to a drop in agricultural prices, to a rapid rise in wages, and to an unprecedented redistribution of wealth. Contemporary shifts and realignments in Italian urban oligarchies were noted with disapproval by Matteo Villani. Art production, like any industrial output, suffered a clear and obvious breach in continuity, with long-established masters like the Sienese Lorenzetti brothers almost certainly perishing in the main outbreak of the plague in the late 1340s. But to Meiss, Italian art itself changed after, and as a result of, the plague, and changed essentially rather than circumstantially. The post-plague malaise brought with it adjustments in the visual language of Florentine and Sienese painting: styles became perceptibly more abstract, even old-fashioned, in conscious reaction to the forces of innovation of the first half of the fourteenth century; images, too, took on an atavistic guise, moving away from the humane values of earlier fourteenth-century religious imagery towards subject-matter that was more austere, and which appeared to distance God from the world. Post-plague Italian art was one of awestruck transcendentalism, as represented in Florence by Orcagna's

formidable Strozzi altarpiece (1357), with its equally forbidding representations of Dominican intellectualism and the Godhead.

Meiss's view is not altogether isolated, since the literature on death and the macabre in the late Middle Ages regularly, even habitually, makes play with the Black Death as the single most striking event of a period frought with anxieties of many types, social, religious, economic and political. But for all its coherence, Meiss's view, as the most clearly-articulated and ambitious statement of its type, is not without its critics. Debate centres upon the exact extent of Black Death mortality and, more pertinently for representation, upon the vexing issues of chronology and causation. It has been pointed out that, as with the macabre, the ethos of crisis of the fourteenth century was established before, and not as a result of, the plague, and that some of the images which Meiss adduced as evidence for the impact of post-plague thinking, like the tremendous images in the Camposanto at Pisa depicting the Triumph of Death and the Last Judgement, may actually have been painted before 1347. Nor did Meiss demonstrate that specifically macabre genres of representation actually stemmed from this phase of crisis, though this was not really his aim; in fact his post-plague transcendentalism is in some ways antithetical to the bodily imagery of the macabre. As Henk van Os has suggested, Meiss may in fact have been engaging upon a project which can only be understood by placing Meiss himself in context. Meiss was a Jewish scholar writing in the immediate aftermath of another world disaster, the Second World War and the Holocaust. The analogy between the mid-fourteenth and mid-twentieth century situations was not lost on him: the accounts by Villani and Boccaccio of mass extinction and burial were, according to Meiss, 'sights not unfamiliar to modern eyes'. In short, Meiss's response was at a related level to Boccaccio's; but whereas for Boccaccio the plague was a pretext for the recitation of narratives of sin and guilt in medieval society, for Meiss the plague was a pretext for art history itself. Both were formulating narratives of cultural alienation in the wake of disaster; and, as van Os notes, Meiss's vision of post-plague art as one of transcendental rethinking bears as much relationship to the crisis of Abstract Expressionism in the aftermath of the Second World War, as it does to the actualities of later fourteenth-century Italian painting. Both were 'cultural events' which spiritualized art as a result of exogenous shocks to the system.

For van Os, the changes which Meiss recognized were in part a product of the plague, but their character was circumstantial and not essential: art, and especially painting, looked different because its production was reassumed by new circles of painters working for new patrons within a context of wealth distribution. Artistic conservatism was, in other words, the product of a profoundly novel set of social circumstances rather than cultural reconditioning. Social studies of Siena have shown that though one-half of the population died in the Black Death, the city saw a rapid recovery of its financial and administrative

I *Right*
Hieronymus Bosch, Death of a Miser, *c.*1510.
Compare illustration on p. 41 (right). As with
the Three Living and the Three Dead
(compare PL. VIII), the image concerns a
moment of moral hesitation.

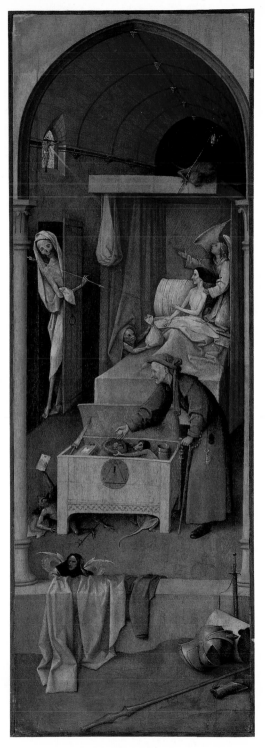

II *Below*
St Thomas of Canterbury emerges from his
raised shrine at Canterbury in a vision to one
of his hagiographers, as depicted on a
stained-glass window placed near the saint's
real shrine around 1200. Images like this
could stand as evidence for the power of
saints to intervene beneficially in the affairs
of the living; visions formed a legitimate part
of the dossier of sanctity. Compare
illustration on p. 79.

III *Above*
Requiem Mass (left) and
Souls in Purgatory inside
the 'D' of *Dilexi* (right),
from a Dutch Book of
Hours, c.1435–40.

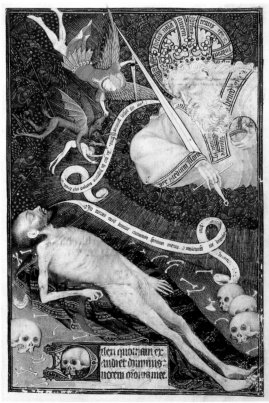

IV *Left*
The *Commendatio animae*,
from the Office of the
Dead in the early
15th-century French Rohan
Hours.

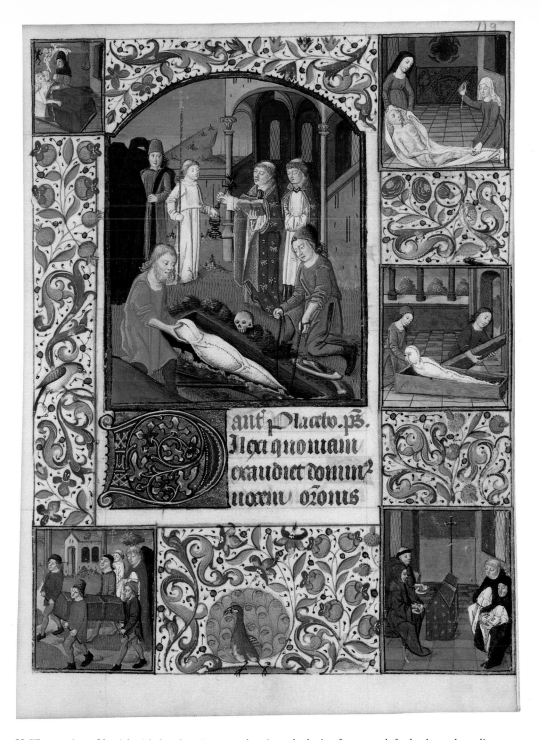

V The service of burial with border vignettes showing, clockwise from top left, death, enshrouding, coffining, the vigil and the procession to the churchyard. Note that the corpse is not buried in the coffin and is asperged by the priest in its shroud. The building at the back of the procession vignette is probably a charnel-house. From a French Book of Hours, *c*.1470.

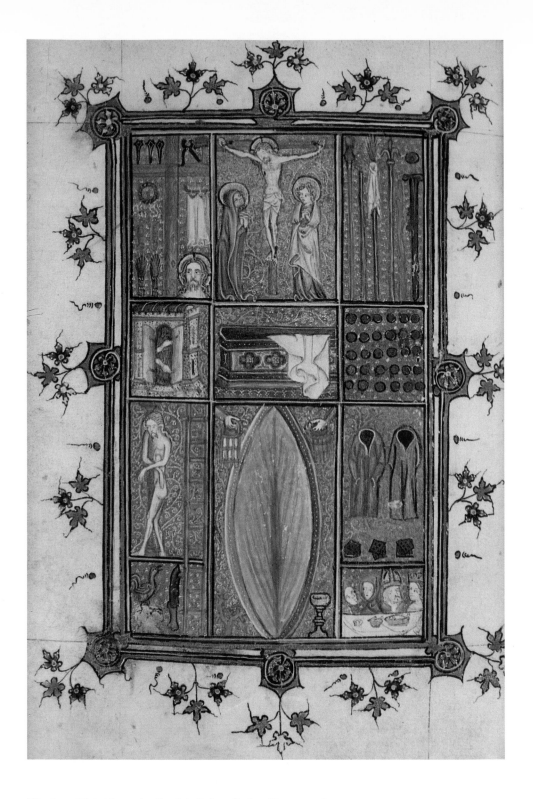

VI *Arma Christi* from the English Bohun Psalter Hours, *c.*1380.

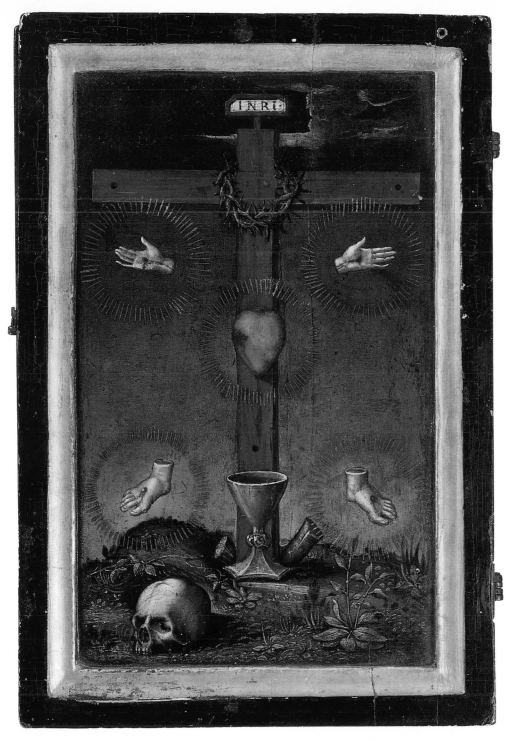

VII The radiant Five Wounds of Christ are surrealistically represented in this image on the outside of a Flemish diptych of 1523 made for a Carthusian abbot, Willem van Bibaut. Note the amputee-like section across the ankles.

VIII The legend of the Three Living and the Three Dead in the Psalter of Robert de Lisle, *c*.1310.

IX *Right*
Hell's jaws locked, from the
mid-12th-century Winchester
Psalter.

X *Below*
Two historiated letter Bs for
parallel texts of Psalm 1, from
the 12th-century Winchester
Bible. The first shows David
releasing a lamb from the jaws
of a lion, the second Christ
casting out demons and
delivering souls at the
Harrowing of Hell.

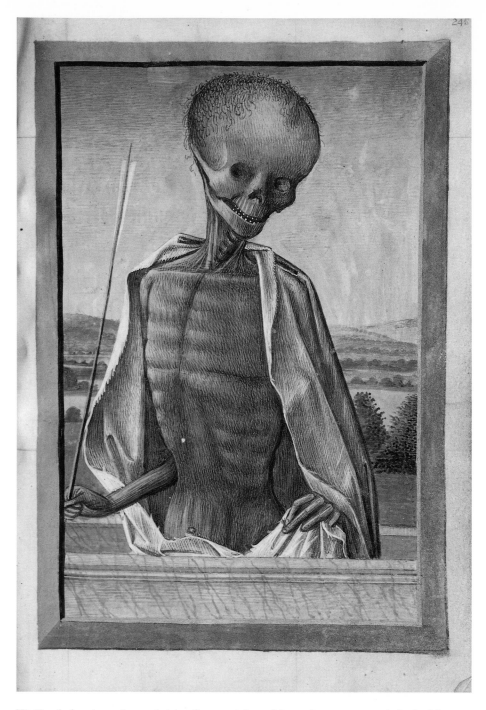

XI Death, bearing a dart and rising from a pink marble tomb, appears to mimic the Man of Sorrows (compare the centre of the illustration on p. 161), from the Office of the Dead in the *Hours of Anne of France, c.*1470, illustrated by Jean Colombe.

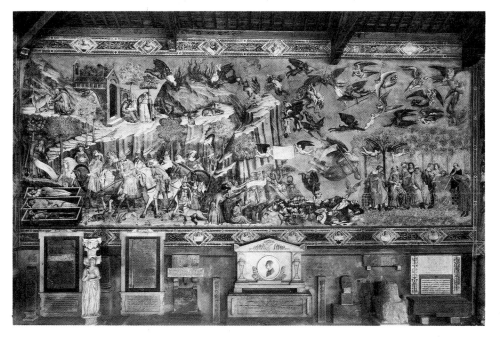

The Triumph of Death, Camposanto, Pisa. Painted in the 1340s, this celebrated image shows (to the left) the legend of the Three Living and the Three Dead and (to the right) the Triumph of Death, bearing a scythe.

structures, and the rise in effect of a class of *nouveau riche* patrons whose taste and ideals were now the primary considerations in the formation of art. What is at issue, then, is not the fact of change, but rather the nature of its causality. It is extremely hard to believe that the recurrent character of the plague and the generally unfavourable effects of the prevalence of disease in late-medieval societies did not have consequences, and I have already adduced factors of this type in considering the commodification of children in memorial art from the fourteenth century on. But the plague was a pan-European event, and the obvious riposte to theories which adduce it as the single most important factor conditioning culture of the period, is to ask why the plague should not therefore have had pan-European consequences. No-one has replicated Meiss's findings for other areas of mid-fourteenth-century European art, and the reason for this is that, at heart, his account offers no theory of cultural causation itself: why, and whether, people respond at all to exogenous events. To put it another way: the impact of exogenous shocks to a culture or an economy is linked inexorably to endogenous response – cultures respond in certain ways to events because they are already predisposed to do so.

To understand this, we need to consider briefly the conventional ways of arguing about the macabre which do not lay special emphasis on an external

shock like the Black Death, before we turn to look at macabre representations themselves. In doing this we must remain aware of the cultural and ideological diversity of the Middle Ages: responses to death, especially in the later Middle Ages, were more various than simple models of cultural explanation can admit. Here two, related strands of thought seem especially important. The first connects the macabre to such ideas as period psychology, secular individualism and hedonism, and owes its nature to ideas about history developed by German Romanticism. In *The Waning of the Middle Ages* (1924), Huizinga stated that

No other epoch has laid so much stress as the expiring Middle Ages on the thought of death. An everlasting call of *memento mori* resounds through life ... The medieval soul demands the concrete embodiment of the perishable: that of the putrefying corpse.

Huizinga's cultural history is shaped by a biological metaphor, that of birth and death: '... in history, as in nature, birth and death are equally balanced'. Thus the late Middle Ages were a 'perfecting and concluding of the old' in the process of 'expiring'. To Huizinga, this waning involved a culture of extremes, of violence, of sophistication, of love of life and fear of death, and of elaborate refinement in all spheres of human conduct: late-medieval northern European culture was one of anxiety. At no point does Huizinga trace this stance to the impact of the Black Death. It had a character, a psychology even, but no specific exogenous cause. Its character was rather that of a collective cultural instinct, contrasting to the positive life-affirming values of the Italian Renaissance. We might recall that in 1920 Freud had published one of the most fundamental texts on death, *Beyond the Pleasure Principle*, which asserted that organisms have a dualistic instinctual drive both to death and to life, and that (echoing Schopenhauer) death is the fundamental aim of life. Huizinga's account provides a generalized cultural commentary on this split between the lust for life and for death, *Eros* and *Thanatos*. To Huizinga, the culture of the fifteenth century in the north was as valid as that of Renaissance Italy, but its validity and appeal was that of decadence, of introspection and ingrowth; this was the true age of chivalry and of courtly love, of hierarchy and high formality, and of deadly conservatism. But it was also an age of fear, and the macabre was the product of a generalized sensibility. It was 'a great cultural idea'. At its most profound level, so the argument runs, the fifteenth century was, like the nineteenth century, an age of romanticism and heightened feeling, an age of individualism, and of a romantic sense of loss, apparent in the greatest French poetry of the period by Deschamps and Villon.

So influential is this metaphorical reading of the times, which stresses especially individual subjectivism at the expense of collective representation, that we hear an echo of it in Philippe Ariès. As I suggested earlier in this book, Ariès' model of understanding death is centred upon the relationship of the individual to the collective; the individual in the course of the Middle Ages emerges from,

and defines himself in relation to, the collective, and it is this emergence which conditions the new subjectivism of late-medieval death culture and religion. To Ariès, 'Huizinga clearly understood the relationship between the passionate love of life and the images of death ... "the sense of disillusionment and discouragement" ' at the heart of the macabre. For Ariès, like Tenenti, the macabre was a matter of period psychology, but one devoted, paradoxically, to hedonism, to what Nietzsche called the 'pessimism of strength.' To Ariès, late-medieval culture is inseparable from individualism, and hence from the nascent modernity that Burckhardt had attributed to Renaissance man: 'Man was conscious of himself ... only through some general category.' Ariès was more inclined to see this as a common attribute of northern as well as Italian fifteenth-century life. With the rise of the individual came a renewed sense of the individual in history, of the individual in life; and with that realization came its correlate, the sense of loss, of failure in death. Death becomes 'an awareness and desperate love of this life. The art of the macabre can only be understood as the final phase in the relationship between death and individualism, a gradual process that began in the twelfth century and that arrived in the fifteenth century at a summit never to be reached again.' According to this view, changes in religious and moral thinking were profoundly connected to desire.

Ariès' view is one congenial to a late twentieth-century perspective, in which an essentially hedonistic and death-denying culture is linked inextricably to the culture of the video nasty. And of course its presumption about the nature of individuality and the collective is problematic: does the 'rise of the individual' construct an individualistic culture, or does the emergence of this culture construct the idea of the individual? This issue (perhaps rendered most clear in the idea of the 'sinner' as a figure of the individual seeking salvation) brings us to the second line of argument.

The second important approach to the issue of the macabre sees it as a manifestation of a highly-developed guilt culture, within which the individual moved and responded, and within which hedonism was framed, but also criticized. This viewpoint was based upon the conventional Christian (and ultimately Platonic) reading of the body as a sign which expresses spirituality. In keeping with the thesis that the macabre is related to secular individualism, the proponents of guilt culture, most notably Delumeau, also take the long view: just as the twelfth century saw a return to the notion of the biography as the means whereby the individual was constructed, so it saw the fruition, in a culture of fear, of an ultimately monastic notion of Christian–moral penitential thinking. These traits were in place long before the demographic shifts of the fourteenth century. And like individualism, their cultural origins were pre-Christian. Roman moralists had developed the notion of a classless afterlife, the democratic Hades of Lucian's *Dialogues of the Dead* and of an inscription on a mosaic at Pompeii: *Mors omnia*

aequat (Death levels all). The theme of the passage into oblivion of the mighty, *Ubi sunt?* (Where are they now?), originated in Greek poetry. Horace's Odes contain the famous phrase, *Pallido Mors aequo pulsat pede pauperum tabernas, regumque turris* (Pale death boots the enpubbed peasant as much as the entowered monarch). Status was a matter for men and not the gods.

The Middle Ages inherited and redeployed these versatile formulations in its art and literature, submitting ancient themes to Christian ethical scrutiny. The theme of the transience of the world was of course deeply rooted in the Judaeo-Christian tradition; it is to Ecclesiasticus 10 that we turn for the idea that today's king is tomorrow's corpse: 'For when a man dies he shall inherit creeping things, beasts and worms.' The thirteenth-century English jurist Bracton said that God was no respecter of persons. But it was especially the heirs of Christian Platonic thinking, the Cistercians, and later the Franciscans, who developed this penitential mode of thinking to its fullest. By the twelfth century monasticism, under the influence of thinkers like St Augustine, had developed a powerful and conventional model of contempt for the world, and withdrawal from it into the angelic life: as we noted earlier (p. 58), monks were a form of living dead. This was also a period which saw a renewed interest in classical texts like those of Horace whose rhetoric of death was congenial to Christian penitential thinking. St Bernard of Clairvaux (d. 1153) marks one of the earliest medieval usages of the theme, 'What I am, they were, and what they are, I will be', common on macabre tombs in the fifteenth century, and derived from Roman funerary epitaphs. Jacopone da Todi (d. 1306), the Franciscan author of the *Dies Irae*, left us a poem called 'On the contemplation of death and the grave to counter pride'. Mendicant preaching of the fourteenth century encapsulates for us the paradox of penitential thought: that it is in the world, but against it, and that the individual is subjected to the inevitability of the larger, and ineluctable, order of mortality. The same paradox is apparent in contemporary attitudes to the body, for it was precisely this Christian Platonic tradition of asceticism, which ordinarily we would associate with denial of the body, that most keenly promoted somatic imagery as a common-sense form of religious understanding.

The step from this ascetic and moralizing viewpoint to the highly cultivated lay self-abnegation found in the poetry of Deschamps, Chastellain and Villon was a small one. Hatred of the body, and of the fleeting character of worldy values, is apparent in Francois Villon's *Testament*:

> Where is the wise Heloïse
> The queen who was white as a lily
> Who sang with the voice of a siren
> Where are the snows of yesteryear?

The passage of this value system from the enclosed world of monasticism to the lay world marks what Delumeau calls 'culpabilization': the spread of a coherent

and aesthetically sophisticated culture of guilt. The development of the *Ars mori-endi*, which we reviewed in the first chapter, is an example of this lay appropriation of older penitential systems of thought. So too was the construction of the sinner as a literary type. Forms of ritual self-mortification were cultivated at various social levels. As we saw earlier, St Louis had himself laid out on ashes at his death in 1270: ashes are a mark of the penitent and are associated with the Lenten phrase, 'Dust thou art, and unto dust shalt thou return' (Genesis 3:19), and the sentiment, 'They shall lie down alike in the dust, and the worms shall cover them' (Job 21:26). Cardinal Philip Repingdon (d. 1424) requested that he should be buried naked in a shroud and on the darker northern side of a church; Philippe de Mézières (d. 1405) asked to have an iron chain placed around his neck at the hour of his death, and that he should be dragged by his feet naked into church, tied by ropes to a plank, and then thrown like carrion into a grave. Procedures of this type were no more than the inversion of those norms of high artifice and cultivated ritualism which, for Huizinga, marked the demise of the Middle Ages; a masochistic reversed decorum by which courtly norms of behaviour could be exposed in all their elegant vacuity.

Secular individualism and guilt culture therefore represent two sides of the same coin. But located within guilt culture especially was something of relevance to the macabre: a sense of irony, and with it, wit. The textual and visual culture of the macabre is one of telling antithesis, of structural opposition: it is a culture of refined bathos, of self-reproach. Thus, the Christian soul reproaches its body in the fourteenth-century *Pèlerinage de Vie Humaine* of the Cistercian Guillaume de Diguileville. A northern English monk, perhaps a Carthusian, composed the fifteenth-century *Disputacione betwyx the Body and Wormes*. In Villon's *Debat du couer et du corps*, the soul is presented as the human conscience, the body as a kind of carnivalesque fool, on the model of the dialogue of King Solomon and the jester Marculph. Ironic and self-reflective mechanisms of this type are not provoked externally; they are fundamental to the ways a culture thinks, and to the way it allegorizes meaning. And they are fundamental to the shaping of moral and spiritual self-reflection between the twelfth and fifteenth centuries.

What is so curious, then, is that despite the structural similarities between these forms and the art of the macabre, that art should have been so postponed. In his account of the guilt culture, Delumeau very fairly observes that the central period of macabre art was no more than a parenthesis in the time-scale of European thought, lasting no more than about three hundred years from the fourteenth to the sixteenth centuries. This fact alone may have prompted the belief that its character was owed to a specific exogenous cause, like the Black Death. Here I shall suggest instead that this periodicity of the macabre – which anyway precedes in important respects the Black Death – can only be understood by seeing it as an internal development of medieval visual culture itself; that to

understand macabre images we must see them not just as by-products of individualism or guilt, but as constitutive representations which enjoyed their own cultural space, autonomy, impact and process of development. And to do this we must turn to their most characteristic forms.

Encountering the Macabre: The Three Living and the Three Dead

The legend of the Three Living and the Three Dead is essentially that of three young men who went down to the woods yesterday and got a big surprise: while out in their finery, hunting and hawking, either mounted or on foot, these three lads, gaily displaying by their splendour the signs of their social station, meet three cadavers in various stages of decomposition. A dialogue ensues in which the living express mortification, while the mortified admonish them to improve their ways, and to ponder the transience and essential baseness of the human condition. This tableau encapsulates for us some of the most important structural features of the macabre image: such images are 'split', employing dialogic interchanges between two partners or two social or moral types, and representing such dialogue by means of the doubled self as 'Other'. They are thus encounters. They also entail reversals or ambiguities of time – the dead illustrate death as a state beyond human experience by exhibiting the by-products of death, namely the human embodiment of decay, the effect illustrating the cause of the moral predicament. And they also entail decisive reversals of initiative – the hunting motif is important, because it is the living hunters who are now brought to bay by death, the hunter of all men, a theme apparent in many renditions of death as an equestrian cadaver after its mortal prey. This theme of the hunt is made explicit in a border accompanying a deathbed scene in the Grimani Breviary.

The legend also presents us with the Christian dilemma of choice and future contingency: in pondering the collapse of our mortal station, we are invited to mend our ways by means of a penitential injunction familiar from Christ's repeated admonition to sin no more. What is interesting here is partly the ambivalence of these figures, these revenants (who are they?), but also the ambivalence of the subject. At first it looks simply like a macabre tableau which plays on the themes of shock, fascination, self-realization and so on. But, more deeply, the subject, through its liminal and uncanny nature, concerns a moment of intellectual hesitation: the quick are provoked to think both about the consequence of death for the vanity of the self – which is in a sense the 'false' outcome of death, since it concerns the end of that which does not matter anyway – but also of the true end of the contemplation of death, namely the amending of life. Though uncanny, the image has a certain canniness.

In visual form the subject is a demotic one, traceable in many parish church wall paintings, and popular as a high-class representation in the characteristic genres of illuminated book of the late-medieval period, the Psalter, Book of Hours and so on: the image is one aimed at and conceived for laypeople whose initiative in sponsoring devotional and moralizing images in the period was burgeoning. But as with many such themes the initial occurrences were (as far as we know) literary. The roots of the legend may lie in the tale of Barlaam and Josephat, a Greco-Christian novel distantly related to the story of Buddha, translated into Provençal in the thirteenth century and installed thereafter in the *Golden Legend* of Jacobus de Voragine. A hermit, Barlaam, told the young man Josephat a parable about the emptiness of the world: a man fleeing from a unicorn (signifying death) fell down a precipice (the world) and tried to rescue himself by clinging onto a tree (life); but when he looked down he saw two mice gnawing away at the tree. However, he was distracted by honey (the illusory pleasure of the world) dripping from the tree's branches, and forgot the threat. Josephat's predicament is illustrated on the retrospective sculpted tomb of Adelais de Champagne, of c.1260, at Saint-Jean at Joigny. This shows that legends cognate with the Three Living and the Three Dead were associated with French funerary art by the later thirteenth century.

Geographically the legend of the Three Living and the Three Dead was fairly widespread in the thirteenth century, known in the Mediterranean and especially in Italy, where it appears to have been the only significant theme of the macabre, and where it often includes a representation of a hermit. Of the sixty-odd versions of the tale, the best known were produced in France and England, with French poems such as that by Baudouin de Condé appearing first; and by about 1300 the subject seems to have attained popularity as a pictorial conceit. In 1302–3, Amadeus v, Count of Savoy, purchased two panels, some kind of diptych, of the scene of the Three Living and the Three Dead in London for 40s. 6d., and it is in exactly this form, as a kind of diptych, that the subject appears amongst the remarkable display of Gospel narrative pictures, theologically inspired didactic diagrams and quasi-autonomous genre images in the Psalter of Robert de Lisle (PL. VIII), died 1344.

The devotional context of Robert's Psalter reminds us of the eremitical slant of the story itself. Robert had strong Franciscan leanings, and many of the subjects in those parts of his Psalter executed c.1310 exemplify a specifically Mendicant spirituality. The de Lisle Psalter illustration marks one of those evocative moments when a fashionably French-looking Gothic image breaks out into the English vernacular: the Three Living exclaim 'I am afraid', 'Lo, what I see' and 'Methinks these be devils three', while the Dead reply 'I was well fair', 'Such shall you be' and 'For God's love beware by me'. The dialogue then continues in French, in an abridged version of the poem *Le dit des trois morts et trois vifs*.

The First Living King:

Friends, look what I see:
Unless I have gone quite mad
My heart shakes with great fear:
See there three shades together,
How ugly and strange they are
Rotten and worm-eaten.

The First Dead King:

The first shade said: Lord,
Do not forget because of this bird
Nor for your bejewelled robes,
That you are not obeying well the laws
That Jesus Christ has commanded
By his holy will.

The Second Living King:

The second said: I desire,
Friend, to amend my life:
I have over-indulged my whims
And my heart is eager
To do, as much as my soul submits
To God the King of Pity.

The Second Dead King:

Gentlemen, said the second shade,
The truth is that death
Had made us such as we are
And you will rot as we are now;
Until now you were so pure and perfect
However you will rot before the end.

The Third Living King:

The third living, who wrings his hands,
Said, why was man made so lowly
That he must receive such an end;
This was too evident a folly.
God would never perpetrate this madness
So brief a joy and such great pleasures.

The Third Dead King:

The third shade says: know
That I was head of my line;
Princes, kings and nobles
Royal and rich, rejoicing in my wealth;
But now I am so hideous and bare
That even the worms disdain me.

What of course is so telling in the language and construction of image is the way it charts response. Here we have three fay and resourceless products of youth culture – prototypes of Dorian Gray – exposed to the naked truth of time. In this sense the representation is the outcome of numerous strands of development which characterize late-medieval religious art as a whole, namely that it itself depicts and so validates the character of reactions to it; the legend becomes a drama of reaction increasingly typical of the Christian image. We can chart this rhetorical language in thirteenth-century representations of the Crucifixion, where the onlookers faint (like the Virgin Mary) and wring their hands (like St John), or in such moments of high drama as Giotto's tremendous representation of the Raising of Lazarus in the Arena Chapel at Padua, where the stench of Lazarus's three-day old remains is made manifest to the nose, by means of the eyes contemplating the gestures of disgust of the witnesses. And it is exactly this rhetoric of response that marks out the most impressive of all representations of the legend, that of the mid-fourteenth century in the Camposanto at Pisa, where the horses upon which the living are mounted shy and recoil at the sight and stink of the bloated purulent flesh of the dead.

A corpse possessed of its senses hears and sees the approach of God, and responds with a sentiment from the Book of Job, from a 15th-century German Office of the Dead. Compare PL. IV.

This reflexivity, born of the divided character of macabre representations, reminds us of the way such images engage the human sensorium: death, as patristic literature argued, here enters in through the eyes, and spreads a kind of visual contamination or contagion. The dead are shunned, according to the de Lisle text, even by the worms. The dead, who mimic or parody the living but do not extend out to them except as images, are a new class of marginalized untouchables, like lepers, a class forced in life to go through special rites of separation and to relinquish their property much as the dead in the poem have lost their signs of earthly station. Here the dead act to mirror the living by the signs of sense-possession, for they too look back and respond, like the sinister little shrouded corpse in a fifteenth-century German Office of the Dead which emits a speech scroll saying: 'I have heard of thee by the hearing of the ear: but now mine eyes seeth thee. Wherefore I abhor myself, and repent in dust and ashes.' (Job 42:5–6.) The macabre thus lends the dead a voice.

The reason this type of image of death is so powerful – in the same way as the related genres of the Dance of Death and of Death personified – is that it is intimately linked to the psychology of anxiety. In the legend we have a classic instance of a moment of instability between two temporal realms, a sudden breach of existential boundaries between two worlds, which confuses the animate and the inanimate. The confusion brought about by the use of the *doppelgänger,* or 'double', motif is related to the notion of the uncanny, simultaneously denying and affirming mortality in an experience which, because of its inner contradictions, can never be quite assimilated, and which through its repression repeatedly throws out the same circular oppositions of dead and living. By means of doubling or repetition, the familiar is rendered unfamiliar in a daemonic experience of estrangement. In psychoanalytical terms death, like love, is linked to repetition and to the uncanniness of the doubled image that repeats, but does not reflect, its model. The image represents a future state – what the subject will become — and so contributes to the construction of the subject's sense of self. In this case the thing that is constructed (recalling the earlier discussion of late-medieval penitential culture on p. 37) is the notion of the sinner. But the image too is a thing returned to the spectator; the corpse, as image, stands for the absence that is death, returning to rebuke both the imaged living, and also ourselves as onlookers. The macabre implicates us in a *mise-en-abyme*, a hall of mirrors. And by means of its use of defamiliarization, it offers the capacity for self-examination. The organization of the macabre image is thus not just binary (playing on antitheses), but ternary (implicating the third-party viewer). We will be considering the emergence of ternary models of this type when we turn to the construction of Purgatory later on.

Transi Tombs

The subject of the revenant (that which returns uncannily) was of course to form an important component of folkloric thinking, especially with respect to the legend of the vampire. The heretical inhabitants of early fourteenth-century Montaillou thought of the spirits of the dead as *doubles* lurking around the living, and graveyards especially, before being quietened by Masses for the Dead. This idea of the dead as the temporarily homeless may have related to a deeper belief about the state of the soul reflecting the state of the body, the soul wandering only during the corpse's transitory or liminal stage of decomposition.

But the notion of the *double* also linked images like those of the Three Living and the Three Dead to other high cultural Gothic representations, especially the so-called double *transi* tomb (*transi* meaning 'gone over' or, perhaps more appositely 'gone off'). In such tombs, which came into being around 1400, a dichotomy is commonly, though not universally, established between the representation of the dead in their full social station, as complete, perfected representatives of a particular class or group in a state of timeless repose, and their representation as a corpse, naked or shrouded, in various stages of decomposition. Corpse or shroud effigies also existed on their own, as a sub-group of this genre. Earlier we saw that the notion of the double-effigy tomb had developed by the fourteenth century to represent the state of marriage. The double-decker transi tomb took this coupling in a different direction; instead of displaying the character of the family, it displayed the character of the body as a mirror of the soul. As with the legend of the Three Living and the Three Dead, tombs of this type at their most elaborate possess the structural character of division and confrontation – between the social and the natural, between the timeless and the time-bound, between the perfect and the fallen, and so on: again the body is deployed as a sign, and the themes of the uncanny (such as repetition and doubling) are equally present.

As the products of a specific medium, sculpture, transi tombs bear comparison with earlier three-dimensional manifestations of the notion of the decay or torment of the body as a sign of its inner sinfulness (and decay was thought of in a pre-modern sense as something intrinsic to the body and not extrinsically induced). Monastic culture was naturally inclined to this view of the body; the grandiloquent early twelfth-century sculptures in the porch of the Cluniac Priory at Moissac in France show the punishment of *Luxuria* (unchastity) in the form of a naked woman tormented by toads and snakes. And the same theme, unselfconsciously misogynistic, recurs later in the more demotic context of the secular church, in the image of *Frau Welt* as a human equivalent to Eve's rotten apple, superficially plausible and tempting but eaten from behind and from within by worms, as at Worms Cathedral in the fourteenth century. The two-faced

character of the world was, as we have already seen in citing Master Rypon on make-up (p. 88), a theme for sermons. Female *vanitas* concealed death: 'More bitter than death the woman whose heart is snares and nets' (Ecclesiastes 7:26). It may have been statements of such frankness that encouraged Jean, Duc de Berry, to commission images of the Three Living and the Three Dead for the portal of the church of the Innocents in Paris, a celebrated burial-place, in 1408, a unique occurrence of the subject in sculpture.

But the transi tomb cannot simply be seen as the outcome of the admission of these themes, already pretty long-standing, into the sphere of a specific medium, sculpture. Historically there is no evidence for the execution of transi tombs before the late fourteenth century, and accordingly they have been positioned as one of the natural outcomes of the late-medieval, plague-motivated culture of the macabre. But their occurrence is, in a sense, culturally even more specific. In the first place, tombs of this type were virtually exclusively northern European occurrences, being largely absent from Spain, Mediterranean France and Italy; and, secondly, the patronage which brought them into being was originally almost exclusively clerical, and only later lay. They represent the kind of phenomenon whose initial reasons for existence may have differed from those of their later spread and validation, and in this sense there cannot have been a single 'cause' of the transi tomb. Italy, though itself known for tremendous representations of the Three Living and Three Dead from the thirteenth century onwards, is devoid of such memorials for reasons which are obscure, but which may lie in the spheres of cultural practice by which attitudes to the body itself were negotiated. Philippe Ariès notes, for example, that the geographic distribution of transi tombs coincides with the practice of covering the dead in funerary ritual; macabre iconography occurs in those places where the corpse's face was concealed. The use of the coffin in northern Europe from around the thirteenth century effectively concealed the body in its entirety, prompting the use of simulacrum wooden or waxen effigies in its place for the duration of the ritual, effigies whose appearance resembles that of the permanent tomb effigy. Fourteenth-century examples of such effigies survive at Westminster Abbey, probably because they were hauled out later to mark the anniversaries of the royal dead. In the Mediterranean sphere it remained (and remains) normal for at least the head of the corpse to be exposed for the funeral, and the corpse was taken out by members of the family to be ritually cleansed, as in present-day Naples – entirely different cultural forms of attention to the body from those prevalent further north, where concealment became the norm. There were of course regional variations which suggest that the north–south distinction cannot be pressed too far. The Mediterranean practice is illustrated by the eleventh-century tomb slab of Abbot Isarnus from Saint-Victor at Marseilles. But some provincial thirteenth-century English tomb slabs like that of Emma, wife of Fulk, at Stow in Lincolnshire (whose

The back side of *Frau Welt* (Lady World) at Worms Cathedral, *c.*1310.

epitaph was noted earlier), show a coffin-shaped slab with a roundel exposing the dead woman's face, more in keeping with southern European practice. But these may be exceptions.

To be sure, as we have seen, Italian tomb designers established a conventional and very effective range of rhetorical motifs in the later Middle Ages. But what is interesting here is the exclusion of positive time-bound mortality embodied in the frank display of decomposition. One exception, Masaccio's Trinity fresco at Sta Maria Novella in Florence, of about 1425, with its exposed skeleton of Adam beneath the figure of the second person of the Trinity crucified, proves the rule. Delumeau rather unsatisfactorily explains this absence of the portrayal of decay by suggesting that the 'forms of fear' in Italian guilt culture differed from those in north-western Europe. Ariès also misunderstands the phenomenon in suggesting that the southern type of tomb, showing the effigy in death, laid the way open for the transi tomb. The reverse is exactly the case: the transi emerged only in those areas where the alert effigy remained the norm. The transi was quite as much a problem of representation and substitution: what was concealed by social practice in the north was revealed through art; what was revealed by social practice in the south was concealed, or even repressed, by art. Though, as Peter Burke has suggested, this absence of the macabre in Italian art may have been true only of elite circles, it remains to be explained why the macabre was developed by precisely the same elites north of the Alps.

The dialectic between bodily customs and art stresses for us the need to see transi tombs in the first instance as representations. Authorities have sought out complex literary and visual sources for transi tombs, in order to create a kind of textual genealogy of descent for them; but the underlying ideas were both so deeply embedded in conventional Christian thinking about the body, and so nearly universal in Western Christendom, that mapping a specific genealogy is probably not terribly helpful. The transi tomb embodied a specifically Gothic representational feeling for the threatening and the grotesque. Of about 270 corpse tombs which survive from northern Europe in this period, under half a dozen date to the fourteenth century, seventy-five or so to the fifteenth, and over one hundred to the sixteenth century. The genre gained in popularity. Early examples of true transi tombs include that of Cardinal Jean de Lagrange (d. 1402) at S. Martial, Avignon; Archbishop Henry Chichele (d. 1443), erected c.1424–6, at Canterbury Cathedral; Archbishop Richard Fleming (d. 1431) at Lincoln Cathedral; Archbishop Johan von Sierck (d. 1456) at Trier Cathedral; and also the tomb of the French physician Guillaume de Harcigny at Laon (d. 1393). Cardinal Lagrange's tomb, now fragmented, was certainly the most spectacular, employing a colossal reredos-like arrangement of ten registers 17 m high, with scenes concerning the Virgin Mary and the Nativity of Christ, with the Cardinal as a votive figure: this was a tableau whose roots lay in the multiple self-

representation of tombs of a century or more earlier, with correspondingly multiplied focuses of devotion and interest. Lagrange was himself dismembered: formerly a bishop of Amiens, his body was given to the cathedral there, but his entrails were buried at the papal curia at Avignon with his transi. The strange beauty of the Cardinal's cadaver is glossed by the following inscription:

We have been made a spectacle for the world so that the older and the younger may look clearly upon us, in order that they might see to what state they will be reduced. No-one is excluded regardless of estate, sex or age; therefore, miserable one, why are you proud? You are only ash, and you will revert, as we have done, to a fetid cadaver, food and titbits for worms and ashes.

Archbishop Chichele's polychromed tomb of a generation later possesses a more characteristically English restraint and polish, though it may reflect a French model like Lagrange's. It was erected well before his death, and is positioned opposite the archiepiscopal seat in such a way that Chichele could have pondered his own tomb in life as a *memento mori*, a self address. Chichele's upper effigy is shown in full pontificals. The tomb's epitaph reads in part:

I was a pauper born, then to primate here raised, now I am cut down and served up for worms ... behold my grave. Whoever you may be who will pass by, I ask for your remembrance, you who will be like me after you die: horrible in all things, dust, worms, vile flesh.

It isn't hard to trace the obvious points of intersection between this type of admonitory sentiment which, like Lagrange's, plays on the themes of beholding and transience, and the sentiments of the Three Living and the Three Dead. Employing a variant of the ancient *Siste viator* theme addressing the bystander, the spectator is not in the first instance admonished to prayer, but rather to a kind of abject self-contemplation: the epitaph's leonine rhyme plays with the idea

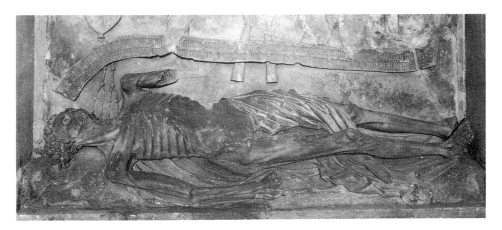

Transi effigy of Cardinal Jean de Lagrange (d. 1402), Saint-Martial, Avignon.

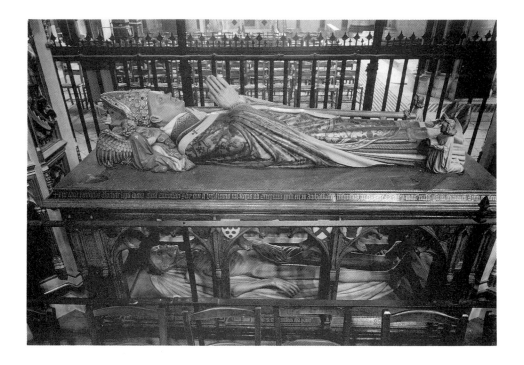

of the *cursus vitae* – born (*natus*), raised (*elevatus*), cut down (*prostratus*) and dished up (*paratus*) which sums up life's lot rather succinctly. It also employs the mirror-motif so common in late medieval imagery: *cerne tuum speculum* (behold your mirror). If Chichele contemplated his own effigy, he would have witnessed, like the lads in the Legend of the Three Living, his own outcome: by approaching his own tomb, he would have emerged eerily as his own revenant. To envisage Chichele pondering his own multiple representation in death is to open out a *mise-en-abyme* worthy of Hitchcock's *Vertigo*. The same self-contemplation and temporal paradox seems to have occurred with the tomb of Bishop Beckington at Wells. Beckington, who was known to Chichele, had his chantry and transi tomb erected in 1451, thirteen years before he died, granted forty days indulgence to those praying at his tomb from the city of Wells, and said Mass for his own soul in 1452. The interaction between image, text and spectator is taken a further stage. That this interplay formed a contemporary part of the culture and reception of the macabre tomb is indicated by the mid-fifteenth-century northern English poem *Disputacione betwyx the Body and Wormes*. The poet enters a church in a 'season of huge mortality' and sees a 'tomb or sepulture full freshly forged', sculpted and coloured. The accompanying illustrations show a pair of royal tombs, one male, one female, beneath which are displayed the maggoty contents of the grave. The image is equivalent conceptually to a double-decker transi tomb. Beneath the female tomb is the text:

Left Tomb of Archbishop Henry Chichele (d. 1443), Canterbury Cathedral. Note the long epitaphs.

Right Folio showing a royal tomb in the *Disputacione betwyx the Body and Wormes*, mid-15th century.

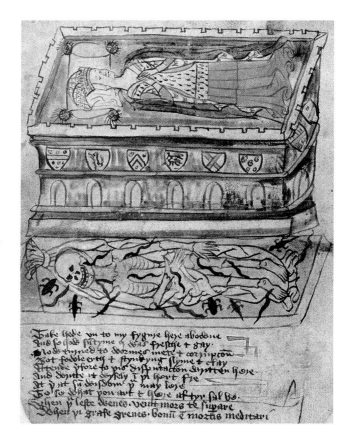

Take heed unto my figure here above
And see how sometimes I was fresh and gay
Now turned to worm's meat and corruption
Both foul earth and stinking slime and clay
Attend therefore to this disputacion written here . . .
To see what thou art and hereafter shall be . . .

The disputacious element between Body and Worms which emerges in the poem, concerning the role of worms in the consumption of flesh, is, as we have seen, a standard structural feature of these split images and texts. But of course the poem, like the legend of the Three Living and the Three Dead, is in the vernacular. The literary dimension of Lagrange's and Chichele's tombs is in contrast expressed in high clerical Latin verse, which immediately compromises these representations in two respects: it limits their readership, and it thereby undercuts the essentially democratic theme of Death as leveller, embodied in their lament for earthly station. Chichele was the founder of All Soul's College, Oxford, and, in being depicted on his tomb as a *literatus*, reminds us that sentiments of this type were first and foremost donnish conceits. These tombs reinforce precisely

the social and linguistic differences that Death undercuts: they are forms of self-reflection, not public address. And that self-reflection is essentially elitist. Transi tombs are in one sense the logical outcome of that trait we noted earlier in considering the over-mighty tomb, whereby clerical patrons deliberately sought out flat, but strategically well-placed, grave slabs as signs of humility. The discourse of the transi tomb is itself basically one of Christian humility (from the Latin *humus*, 'earth') in clerical guise. John Mirk, in his advice to parish priests, the *Festial*, had invited them to contemplate the dead bones of men to engender humility, and the tombs of the highest in the land were naturally best able to deploy this motif of being brought low, literally grounded, by death.

Medieval artists had long explored the relationship between pride, humility and death. An ancestor of this type of clerical sentiment is to be found in an innovative mid-thirteenth-century illumination by the Oxford artist, William de Brailes. In an illustration of the Wheel of Fortune, de Brailes cunningly contrives to coordinate small representations of the Ages of Man in the wheel's outer circuit, with the story of Theophilus, the proud clerk who yielded his soul to the devil, within. As man is laid low in death, so Theophilus is shown in his daemonic triumph, in other words in spiritual death; whereas when man is at the pinnacle of his powers, Theophilus is shown having been saved by the Virgin Mary, his

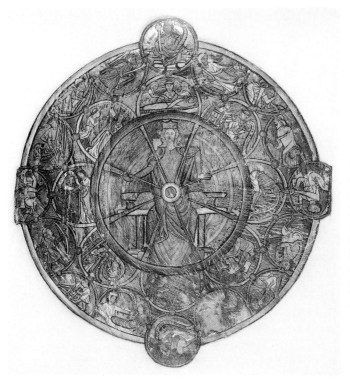

Wheel of Fortune, by William de Brailes, Oxford, *c.*1235. De Brailes has coordinated sixteen stages in the life of man in the outer circuit with eight episodes from the story of the clerk Theophilus and the Virgin Mary in the inner. The high and low points of each correspond to an image of death.

soul being commended to Abraham's Bosom, and so to spiritual life. At Rochester Cathedral, a contemporary Wheel of Fortune was painted over the clerk's stalls opposite the bishop's throne. It was an admonition against pride, aimed specifically at the clergy.

Nevertheless, it's fairly clear that to understand the why and when of the transi tomb, we have to sidestep this literary component, tempting as it may be to see the textual elements of such tombs as offering a simple key to their iconography and signification. Transi tombs are regarded too often as a transparent form of text – as the visual equivalent to a literary culture of guilt and penance, as sermons in stone – with multiple points of reference to a substantial body of thought, to which they are related as second-order epiphenomena. Owst long ago noted that the character of admonitions of the 'such shalt thou be' type were common in Mendicant-inspired sermonizing on death in the tradition going back at least to St Bernard. But there is no reason to assume from this that tombs of this type were essentially like sermons: their didacticism was much more class-specific. However, though their literary order was closed in virtue of its language, their visual order was much more fully open, and this order made itself felt, and was to my mind conceived both for and against the pre-existing conditions of burial and tomb design in the grave-cluttered late-medieval church.

Chichele's tomb in Canterbury Cathedral is a good instance: such tombs are never understood as isolated monuments, but are apprehended by the church-goer as contributors to a collective order of the dead. They are variations on a theme. Canterbury Cathedral was, and is, crammed with tombs, many extremely distinguished, and the designers of the transi tomb knew and felt the repercussions of this. At Canterbury the royal tomb of Edward the Black Prince (d. 1376) in the Trinity Chapel next to the shrine of St Thomas has a French epitaph, specially selected by the Prince in his will to be 'on our tomb, in a place where it may be most clearly read and seen', whose contents play exactly on the textual themes of the transi tomb, though only in contemplating the loss of the Prince's station in death as a 'poor caitiff, laid deep in the earth'. In death Edward is robbed of his achievements says the epitaph, and it is exactly these 'achievements' – his armour, shield and so on – that were hung over his otherwise conventional effigial tomb in knightly fashion. In its organization of themes by means of *painture* and *parole*, then, the tomb adumbrates, if only informally, the structural play on 'before and after' that so marks out the rhetoric of the double tomb of Chichele's type, with the perfect 'social' body above – the man in life – and the imperfect 'natural' body below.

By the same token, it will be intuitively obvious to anyone who has pondered Chichele's tomb with its modestly-posed cadaver secreted in an open-work chest beneath a pompous effigy, that there is another form of context-dependent allusion here: not to earlier prototypes of the Black Prince's sort, but rather

sideways in genre, to the form of shrines like that of Becket himself. Shrines, which by their design permitted the ingress of limbs or whole bodies to their relics, had impacted quite early on tomb design, as is shown by the splendid arcaded metalwork tomb of Henry I, Count of Champagne, formerly at Troyes, and the tomb-shrine of St Thomas Cantilupe at Hereford. In such examples effigies, not relics, are enclosed by a screen. At Canterbury, no special claim is being made by this tomb for its incumbent's sanctity. This is not a proto-shrine. The similarity lies rather in the form of attention such displays, open above, part concealed below, were premised upon, since their fundamental character is similar to that of the usual English shrine-base type. What in the shrine base had

Tomb of Edward the Black Prince (d. 1376), Canterbury Cathedral. His will ordered that his war armour should be processed at his funeral; the achievements suspended over the tomb may be the same pieces. The will also specifies the appearance of his tomb in detail.

been a form of attention promoted by the old-established need for physical proximity to relics has, in the transi tomb, been converted and revealed as a characteristically late-medieval form of visual display: just as late-medieval English shrines were now being cut off from general view by screens and enclosures, the cadaver is glimpsed, sensed, revealed to the touch of the curious, but also partially cut off from the spectator, whose principal form of access is now by sight. We are teased by what ordinarily we should not be seeing. Where Lagrange's cadaver is an open vulnerable spectacle, Chichele's is enclosed yet open: the effigies are no less a spectacle, but one enhanced by partial concealment. This cedes to the transi tomb immense power – the power of fascination with the dead. Aristotle says, 'Though the objects themselves may be painful to see, we delight to view the most realistic representations of them in art, the forms for example of the lowest animals and of dead bodies.' But the fascination here is ambivalent: it is with a corpse, but a represented corpse.

This point can be broadened by suggesting that transi tombs owe their real character not to their 'textuality' but rather to their role as commentaries on pre-existing funerary genres, almost as anti-representations. Historically this makes sense. By about 1400 the art of the effigial tomb in north-western Europe had established a certain decorum of display: the body natural is represented by the body artful. The medieval effigy is a simulacrum, a substitute, but one which not only replaced but powerfully erased the thing, the natural body, whose form it suggests. In the same way the limb-shaped precious reliquary erased the reality of the shrivelled body-relics it enclosed, and instead sanctified those body parts as signs. Transi tombs acted as representations which overcame this erasure of the body by the effigy; they performed a kind of unmasking of that which had hitherto been concealed. Viewed in context and in time, the transi tomb was a sophisticated anti-tomb, disclosing and glossing that which had been closed and denied for over two centuries. The transi tomb now revealed the skeleton in the cupboard of medieval funerary art, namely its denial of the facts of decomposition.

As such, of course, it played havoc with the calm atemporal order and decorum of the conventional tomb with its reassuringly idealized prospective imagery. By its means, time is reinserted into the order of the dead, but with numerous ambivalences which had already marked what we might call the temporal and existential character of the effigial tomb. The usual trope of the medieval tomb is that the body is bereft of its better part, the soul, which is commended to Heaven: the tomb, in engendering memory and prayer, is thus in the first instance 'about' the soul and its future, and it addresses the viewer with that in mind. But the transi tomb is 'about' the body and not, in the first instance, the soul: these tombs are designed not to engender memory in the narrow sense, nor prayer, but to provoke, as with the Three Living and the Three Dead, a

certain type of response, the pondering of self. The representation of the body is implicated ultimately in salvation, but by a process of deferral. Their switch between the display of wordly station and its denial, their theme of nakedness, of stripping and of restoration, challenges our selfhood as well as that of the dead. We mourn ourselves.

The transi tomb seems at first sight especially relevant to structural oppositions between the 'social' and the 'natural' body, oppositions whose origins lie in anthropological distinctions between societies which stress cultural transform-ations and those which stress natural transformations (what Lévi-Strauss thought of as the distinction between cooked and raw food, for example). But the falsity of the nature–culture dichotomy is that it pretends that the natural body is not itself historically and culturally situated: all bodies, once represented, are social bodies. Nudity is an especially important theme of the transi tomb, indicating both the exposure of the private to the public, and the separation from the sphere of culture embodied in the exterior signs of wordly station, dress, orna-ment and regalia that could be buried with the corpse in the hope of the Resur-rection – we are reminded of the expression 'bad and bare' on the tomb of John the Smith cited earlier. Just as nudity can be a sign of exile and the disordering of the natural, so it is also a form of disguise: the naked person is (paradoxically) desexed and desocialized. The nude body is informed culturally by its acting as a natural sign of the sinful and the penitent, as a site of suffering and decay, and by becoming an artwork. In this sense transi tombs, like portrait tombs, were the outcome of a long-evolving Gothic 'naturalism' which, since the twelfth century, had promoted the body as a living thing, or with the capacity to seem alive: but it is a measure of the transi tomb that it deploys an extraordinary artfulness to convey the idea of something which *has* lived. In this sense the transi corpse is an object of aestheticized interest.

The standard medieval effigy, like the statue, acts as a metaphor of perma-nence, strong and immobile in its seeming resistance to mutability, or incapacity for change. For this reason transis were only very slowly assimilated into the visual culture of power and specifically royal power, notwithstanding their seem-ing aptness in illustrating that theme of the divided character of royal power – of the king's two bodies, one natural and mortal, though God-made, the other cultural, man-made and permanent, the official body. Though the royal court of France during the Renaissance developed a vogue for the display of the royal body as a stitched-up, eviscerated, yet beautiful thing, tombs of this type were conspicuously avoided earlier. There are two exceptions. One was planned for Edward IV of England, whose will specified that he should have a tomb covered with a stone 'wrought with the figure of death', and a chantry above with a silver gilt effigy. Another was executed *c*.1450 in Angers Cathedral for René d'Anjou, titular king of Naples and Sicily, including a decidedly odd representation on its

back wall of the monarch crowned in death, enthroned but collapsing under the weight of his own decomposition, like the image of Death crowned with René's arms in a Book of Hours. (An image of Death crowned had already appeared *c.*1320 in the lower church of S. Francesco at Assisi.) The reasons for this paucity of royal transi tombs are clear: the transi tomb's unmasking of decay threatened the ideological integrity of the body politic, better exemplified by the tough ineluctable gilt bronze or marble effigy of the monarch as office holder. René's brittle and faintly absurd images of the mortal monarch amount on the other hand to a crack in the Mirror of Princes.

Transi tombs acted, then, to challenge and expose the myths and silences of the decorous medieval effigial tomb. They embodied an anti-decorum which could only evolve with reference to pre-existing norms of display. By the fifteenth century western Europe had generated an unprecedentedly elaborate visual culture of death and the cult of memory which, paradoxically, had served

A mid-15th-century crowned king-cadaver holds a scroll alluding to Genesis 3:19 and stands behind the tripartite arms of René d'Anjou accompanying the Office of the Dead.

increasingly to deny the realities of death. Against this mythologizing, death, and with it necromania, appeared in the later Middle Ages as a veritable organizing principle, a central allegory of understanding the world at large. That this new form of tomb, never very common, but symbolic even in its relative rarity, should be culturally specific to the north is significant. Panofsky noted that the northern European effigy was generally shown in life, eyes open, alert, while those of the Mediterranean sphere were shown in death, but never in decay. This locates the transi very effectively as the outcome of a specifically northern European culture of extremes, which itself became thematized in the fifteenth century in a visual order of the grotesque, the bizarre and the morbid. The macabre is, in its treatment of the body, precisely about extremes, the moments of passage from intactness to decay, and from decay to annihilation. Imaginative extremes were in this period related explicitly to images. In his treatise on memory of *c*.1335, Thomas Bradwardine wrote of memory images:

Their quality truly should be wondrous and intense, because such things are impressed in the memory more deeply and are better retained. However such things are for the most part not average but extremes, as the most beautiful or ugly, joyous or sad, worthy of respect or something ridiculous for mocking, a thing of great dignity or vileness, or wounded with greatly opened wounds with a remarkably lively flowing of blood, or in another way made extremely ugly . . .

We can see in this type of visualization a strong sense of the somatic character of late-medieval religious and penitential imagery, precisely akin to images of Christ's suffering, or to the bodily devotional language of mystics like Richard Rolle.

From this perspective, the macabre stands in antithesis to the balance sought in the fifteenth-century Italian classical body, coolly distanced and sheltered by art from the thresholds of birth and death. The earlier medieval tomb had, too, projected the body in a state of perfection, embalmed by an aesthetic of the ideal. By the high point of the fashion for transi tombs in the fifteenth century, such memorials were in a sense reacting against two things, conceivably from a self-consciously 'Gothic' perspective: against both an earlier idealizing Gothic decorum and a new, neo-antique idealization which repressed the facts of death. Their perspective was still fully Christian: the body was essential to personhood, and Christian prohibitions still ceded to the body immense importance and power as a site of anxiety and control. The medieval quest for moral truth was accompanied by excess, and in this the transi's responsiveness as art, against art, was central.

Right The 15th-century city charnel-house, Rouen. The timber frames are adorned with grisly carved motifs.

The Dance of Death

Similar points can be made about the Dance of Death, the third genre of the macabre in chronological order of appearance. This subject, again primarily popular in northern Europe though known in Italy too, occurs in about eighty surviving representations dating from after about 1425. Its theme is simple: the living, regardless of their temporal or spiritual station in life as popes, emperors or kings down to the very humblest, even children, are compelled by dancing cadavers to cavort with them as a *memento mori*. The earliest image of the Dance appears to have been a mural, accompanied by hortatory inscriptions, in the

cemetery and charnel of the Innocents in Paris, executed according to a chronicle in 1424–5. It had been to the portal of its church that Jean, Duc de Berry, had added images of the Three Living and the Three Dead a generation earlier. At the Innocents about thirty characters skipped and tottered gingerly with death, and their image inspired part of Villon's *Testament*. By about 1450 the subject occurred more widely. The north cloister of Old St Paul's Cathedral possessed a set of panel paintings of *c.*1430 with texts by John Lydgate, who knew the series at the Innocents and who had discussed their meaning with French clerks. Here there were thirty-six dancers; the 'daunce of Powles' became English short-hand for the subject itself. Magnificent extant examples of the Dance include murals at La Chaise-Dieu and the woodcuts of the subject by Holbein. These were based on an exemplar at Basle, and followed also the example of Guyot Marchant's *Danse Macabré* woodcut prints of 1485–6, which reached their third edition by 1490 and included the legend of the Three Living and Three Dead. At Kermaria in Brittany, and at Paris, the Dance was accompanied by the legend itself, and at Kermaria, with pagan conceit, some of the dancers bear animal heads.

The theme of the Dance, known throughout western Europe, plays on several conventions. At a primitive level it challenges the sacred notion of the dead at rest validated by the Requiem Mass of the funeral service. The villagers of Mon-taillou attributed to the dead doubles an endless energy and restiveness, appeased only by suffrages. Since the earliest examples of the tableau of the Dance accompanied cemeteries or charnels, the image too offered a subversive com-ment on the Church's frequent prohibitions on dancing in churchyards, enacted at Rouen in 1231 and again at Basle in 1435; a reminder that consecrated ground tended to attract vulgar activities which vigorously asserted the principle of life. The tradition of the so-called dancers of Kölbigk in the diocese of Magdeburg, which dates to the eleventh century, concerns a gathering of folk who defied Church authorities by dancing in a cemetery and were cursed to continue dancing for a year, whereupon they dropped dead. The cemetery was not an empty place, but throbbed with noise of betrothals, meetings, commerce, bread-baking, and judicial processes in and around the church porch. The Innocents confronted

one of the largest markets of medieval Paris. The Dance was a vigorous piece of taboo-breaking, connecting ritually purified spaces to the signs of fallen human nature in the world in all its worldliness.

Dancing was itself also potentially problematic. In Robert Mannyng's homiletic text *Handlyng Synne*, dance is viewed with disapproval. The activity was sensual and was tied in closely with music associated with seduction; in one longstanding Christian moral view, dance and music possess an erotic undertone. Dancing was a vehicle for the vices, and in the Dance of Death music and dance act as forms of seduction and so deceit. In the York Mystery plays, the tormentors of Christ are to dance around the foot of the Cross in mockery, dancing being a caper or game motif reminding us of the casting of dice for Christ's clothes on Golgotha. In one sense, then, the Dance is a penitential theme; in the fifteenth century Jean Gerson connected the Dance of Death with confession, and the great late fifteenth-century paintings of the Dance once in the Totentanzkapelle in the Marienkirke at Lübeck overlooked confession benches. Clerical patronage, as with the transi tomb, seems to have been important in its development and distribution. The dead and the living are pressed together by the Dance in the same way that life and death meet crucially, at the last minute, in the *Ars moriendi*. But the power of the Dance derived from the dialectical relationship it established between conventional Christian penitential thinking and worldliness. As a theme it appropriated visually what was becoming, in the fifteenth century, an important metaphor for social order, namely highly organized social dance itself. By this time courtly convention was producing dance forms like the *bassedance* which acted to display and discipline the courtly body: dance was becoming a sign not just of festivity but of controlled habits and bodily dispositions. On

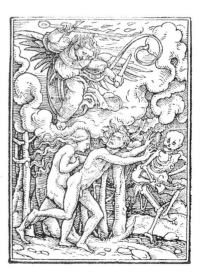

Left Dance of Death, 15th-century wall-painting, La Chaise-Dieu.

Right Adam and Eve expelled from Paradise with Death, from the *Dance of Death* (*c.* 1526) by Hans Holbein the Younger.

this basis it was possible to construct positive and negative views of the dance, comprehended both socially and morally: restrained courtly stepping on the one hand, and plebeian ring dancing, branles or *morescas* (i.e. Morris or Moorish dancing) on the other. Social dancing was thus usually clockwise in arrangement; low, or immoral, dancing, widdershins. The Dance of Death is thus at one level a tableau of class norms. The living step cautiously, the dead with uncannily enthusiastic high kicks: the dead by virtue of their movement are another order, another class.

Dance, like death, was itself becoming an allegorical form in the fifteenth century, a way of explaining and categorizing things. Again, as with the transi tomb, the order of death admits a kind of anti-representation: the Dance of Death is a theatrical piece of vaudeville whose strength derives from its parodic acknowledgement of emerging social norms and conventions and its picaresque inversion of those norms, of decorous rest and disciplined display. At first sight its import is carnivalesque in the Bakhtinian sense (the critic Bakhtin regarded the pre-modern carnival as a means of discharging social tensions): it involves a suspension of hierarchical social precedence, and the consecration of social equality as a kind of popular utopian ideal, a turning of the tables. In this sense the Dance might be regarded as an 'anticipative representation' by means of which hierarchy was not subtly reaffirmed, but rather subverted in the interest of social liberation and some future hope for a social utopia. The Dance represents both present categories and future aspirations, the utopia of death. This does not mean that the Dance as employed as a homiletic and visual motif in this period was exclusively a 'popular' form (whatever that may mean): it enjoyed the same relationship to formal thought as Latinate parodies of other genres, like the drunkard's liturgy, the *Testamentum porcelli*, or Pig's Will — a mock-legal spoof on the high literary testament of the type promoted by Villon in which the pig leaves his bones to the dicemaker and his pizzle to the priest (!). It was in no sense marginal, and its allegorical force could be open to several types of audience. Many of the recorded cycles included the figure of a preacher, and the subject seems to have been popular in Mendicant, and specifically Franciscan, contexts. One friar delivered apocalyptic sermons from a pulpit hard by the Dance of Death at the Innocents in Paris. The subject had a respectable textual and performative basis in fourteenth-century culture, as in the Catalan *Dansa de la Mort* and Jean le Fèvre's poem of the late 1370s *Le Respit de Mort*, in which is apparently the first occurrence of the term 'macabre': 'Je fis de Macabré la danse'. Its theatrical character as spectacle could prompt performances of it in the highest circles; a Dance of Death was enacted significantly enough by a painter in Bruges in 1449 before the Duke of Burgundy; and on the occasion of a Provincial Chapter of the Franciscans in 1453 another was performed in a church in Besançon. Perhaps the tableau had been acted out in the previous century, to judge

by its consonance with later mystery and morality plays, and there seems to be some evidence for a related type of performance in Normandy, at Caudebec, in 1393. Its carnivalesque nature flourished within high culture as a form of reflexive critique: society as a body is punished by death. It is also commented on in its own terms. In the texts and images by Lydgate and Holbein, the lawyer is addressed litigiously by his cadaver, while from the rich man the dead take silver. This echoes the theme of the particularized Judgement that had emerged by the fourteenth century. Death here represents Everyman, rather than Death itself personified. In the comedy of manners of the Dance, the human faculty of choice is denied; whereas the Three Living and the Three Dead, in some ways visually adumbrating this theme, are permitted to choose to amend their lives, in the Dance of Death the living are stripped of choice and are compelled into submission. The theme is a grave one, but at another level possesses a certain bathetic comedy, revealing social dance itself to be a hell of submission to the unwanted partner. But its message is no less serious: Hades is a democracy and Death is the supreme leveller.

In this sense the Dance, as a comedy of manners with a penitential subtext, also takes its place as a manifestation of forms of social comment increasingly common from the mid-fourteenth century. The Dance came equally to all, and was an allegorical means of both reinforcing and subverting the late-medieval hierarchy of estates or classes, depending on its audience. Its 'leverage' as a theme of social comment was thus ambivalent. The fact of its early occurrence at the Innocents, a charnel, is significant: structurally, the Dance shuffled the dead and living regardless of station, just as the charnel shuffled the bones of the greatest with those of the least. It is ironic that this most trenchant expression of promiscuity between the living and the dead should have occurred at a famous haunt of prostitutes. Villon remarked in his *Testament* that it would take a strong pair of glasses at the Innocents 'to tell the decent people from the uncouth'. Death is now the allegorical means of expressing that idea of postlapsarian equality first expressed by Richard Rolle, and later appropriated by Wat Tyler during the Peasant's Revolt in 1381: 'When Adam delved and Eve span ... where was then the pride of man?' Anticipating Villon, Langland's *Piers Plowman* remarks that knights and knaves are indistinguishable after death; for Death smites down 'Kings and knights, caesars and popes'. Death redistributes the true wealth of salvation, and it is the poor who have least to fear from it. According to the reading of late medieval society which stems ultimately from Huizinga, the period in which the Dance appeared was one of massive demographic change and social transformation. Wealth redistribution, and with it the redistribution of the power of consumption, threatened the old social order, which in turn was reinforced by new controls on labour and attempts, in sumptuary legislation, to separate the accumulation of wealth from its display by means of what Huizinga's contem-

porary Veblen called 'conspicuous consumption'. Erwin Panofsky's analysis of the International Gothic Style as a style of conspicuous display, pushed to hitherto unknown formal extremes by a parasitic aristocratic class intent on bolstering an ageing but threatened social order, helps to contextualize the Dance and the sense in which it allegorized a new anxiety of social control and order in a visual culture of excess.

Themes like the legend of the Three Living and the Three Dead, the transi tomb and the Dance of Death, all thematically related yet functionally separate, and offering different visions of the human dilemma of choice, all point up this new means of allegorical understanding of the self and of society. Death was itself a new order, a new class of representation and meaning. Arguably the history of the macabre represents a means by which the gaps in medieval culture's articulate meanings were to be filled. Death was itself personified. Beginning in the late twelfth and early thirteenth centuries with such texts as Hélinant de Froidment's *Les Vers de la Mort* and Robert Grosseteste's *Chateau d'Amour*, Death was ushered in as a literary figure of Everyman's fall, to vie with Life. The roots of the theme of course extend back to the opening of the seals in the Book of Revelation, and the appearance of the rider Death (Revelation 6:8) on a pale horse, with Hell following him. Usually we think of Death as male, but at the Camposanto in Pisa Death triumphs in feminine state with bat's wings and flying hair, bearing a scythe. Death is never inert: it rides, it hunts, it dances, pounces and (eventually) rapes, entering the life of mortals with an energy and timeless transformative power once the possession of the saints. It possesses the power of surprise of the ambush. Its bedside manner is increasingly represented. The corpse as *memento mori* can raise its heart up in the Mass at the *Sursum Corda*. Sometimes Death rises from the tomb in a grotesque parody of the Man of Sorrows, as in a French Book of Hours of *c.*1470 illuminated by Jean Colombe (PL. XI), again as a Christian anti-representation. Death is possessed of the faculties of sense. It is personified yet lacks personhood; its form is the form of the cadaverous body, and not the soul, and this lends to it its uncanny robotic quality and its automaton's attribute of irresistible yet terrible inexpressive power. Giovanni Fontana understood this quality in the animated skeleton precisely, when he included in his early fifteenth-century sketchbook the design for a machine powered by clockwork which, clicking, worked resurrecting skeletons. Death personified, the heir of the Greek *Thanatos*, illustrates through its universality of form the terrible blankness of death itself, for it is important to this representation that Death should be sensible yet unresponsive, that it should perceive yet be merciless, and that its look should spell the cancellation of the self; that it should embody anonymity. This of course reminds us again of the intimate relationship between images of mortality and the contemporary religious consciousness which invested holy images precisely with the fiction of respon-

siveness, especially the holy icon of the Veronica, the merciful Saviour Christ returning our gaze. Death personified requires and utilizes the same ideas of expressivity generated by contemporary artists, embodied in the sympathetic visage of the Redeemer; and in doing so it cancels them. In contrast, Death is the ultimate gargoyle. Yet unlike the gargoyle, trapped and subjected by the Church triumphant, it roams free.

Death and the Fall

As we have seen, the medieval view of human flesh is a divided one: flesh, since the Fall of Man, is fallen and naturally subject to decay, yet in medieval art is always perceived simultaneously with its intact character. In one sense, as I have suggested here, macabre imagery is in effect a form of deconstruction of what went before: the macabre is premised upon, and preys upon, certain norms. At the same time, of course, the macabre theme of the exposure of fallen flesh ties in with conventional Christian thinking validated by St Paul and St Augustine (*City of God*, XIII). Through the Gospels, and by means of the writings of St Paul and his medieval followers, the death of Christ on the Cross represented the final redemption of our fallen and knowing nature. In Pauline theology, mankind is in a state of spiritual perdition due to original sin (Romans 5–6:23); he cannot be saved by good works alone but requires the sacrificial victim to complete his atonement. For Paul the essence of salvation is sacramental. We are reborn in Christ, in baptism, a ritual purging of Old Adam, and so are reincorporated into the divine Saviour. As I noted earlier, it is the Pauline notion of the pre-baptismal body, naked and vulnerable, that informs perhaps the most telling late-medieval image of the solitude of death, that of the naked man commending his soul to God the King in the Office of the Dead in the Rohan Hours: here we have an anticipation of Martin Luther's sentiment that at death 'I will not be with you, nor you with me'. But, as Holbein's Dead Christ shows us, Christ too could be subjected to this aesthetic of solitude. In our unsharable mortality all we face is ourselves; and macabre themes are essentially mirrors of mortality which lie at the heart of what the critic Walter Benjamin called 'the allegorical way of seeing'. Mirk's *Festial* begins a sermon for funerals with the sentiment, 'Here is a mirror to us all: a corpse brought to the church.' Guyot Marchant's *Danse Macabré* of

Dead Christ, by Hans Holbein the Younger, 1521–2.

the 1480s calls itself a 'miroer salutaire'. Lydgate also ends his Dance of Death on a specular note:

> Ye folk that look upon this portraiture
> Beholding here all the estates dance
> See what you have been and what is your nature
> Meat unto worms, not else in substance
> And have this mirror ever in rememberance.

But the mirror, an important bearer of meaning in fourteenth- and fifteenth-century art and imagery, is not simply the thing which reminds us of the traditions of *vanitas* iconography, though it exploits them. An early fourteenth-century manual of religious instruction relates the story of a lady who sent her chambermaid to purchase a mirror, which turned out not to be to her liking. Sent out to buy another, the maid returned with a skull, saying 'Look at this: in all the world there is no mirror in which you can see yourself better'. The Mirror of Conscience is an important motif in the fourteenth-century *Pèlerinage de Vie Humaine* of Guillaume de Diguileville. Following St Paul's famous sentiment in I Corinthians 13:12, 'For now we see through a glass darkly; but then face to face', the lens or glass was an access-point for truth, and implicit in it was access not only to our present state, but to our future condition. The mirror was a means of divination, or catoptromancy, and it is for this reason that the breaking of a glass brings bad luck and even death. The mirror is that which, according to some psychoanalytical theory (represented by Jacques Lacan), enables the child to construct and integrate its ego from the uncoordinated childish body; the mirror, as any neurotic knows, is central to the reassurance of selfhood, to the production and so transformation of ego itself. Mirrors are thus related to unfragmentation, and introduce the idea of temporality, the passage of time. The subject encounters in the mirror its future state, something which it is in the process of becoming: death is already implicit in life, and the mirror lures us into self-understanding through auto-surveillance. From this encounter with the subject in an unfamiliar (dead or dying) form, as with the Three Living and the Three Dead, comes self-knowledge, recognition based on misrecognition. The all-seeing surveillant eye of God is at first hidden, then uncannily apparent, in Hieronymus Bosch's mirror-like Tabletop of the Seven Deadly Sins in Madrid, which has at its centre the Man of Sorrows framed by a monstrous iris, together with the seven mortal sins, the Fall, the good death and the Last Judgement. But when what we see in the Mirror of Conscience is our own death's head, representing not our integration but our disintegration, it is our own ego that is threatened, our very being, with its desire for pleasure and wholeness. The reflection of death is a kind of reversed narcissism: self-examination is now a form of self-rebuke rather than self-love, and life is to be understood and sustained through its revelation in death, and so in absence.

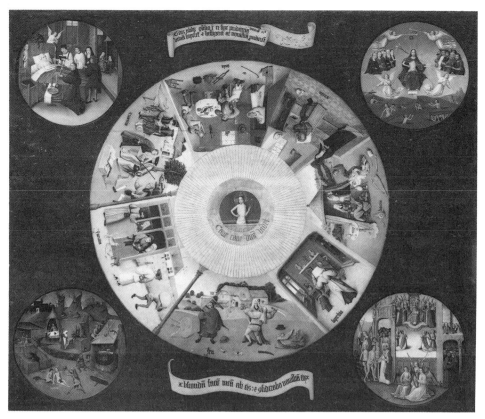

Tabletop of the Seven Deadly Sins, by Hieronymus Bosch, early 16th century. In this striking image of surveillance we slowly recognize a combination of the Mirror of Conscience, reflecting the sinfulness of the World, and the monstrous all-seeing eyeball of God: 'Beware, beware! The Lord seeth!' reads the text around the central image of Christ the Man of Sorrows. Four additional roundels show the good death, the Last Judgement, Heaven and Hell.

This is of course a theme of the Fall, that by sin and disobedience death and the knowledge of good and evil came into the world. In one telling image in Canto 23 of Dante's *Purgatorio*, we read of the gluttonous whose faces have shrunk to bone, the eyes and bridge of the nose spelling out the Italian vernacular for 'man', and who are punished by the aroma of fruit which cannot be eaten:

> The sockets of their eyes were like rings without stones:
> Those who read 'omo' in the human face
> Would certainly have recognized the 'm' there.
>
> Who would believe that the smell of an apple
> Had done all that . . . ?

In Holbein's Dance of Death woodcuts, Death leaves Paradise with Adam and Eve at their expulsion. The shame of Adam and Eve's nakedness is in the first

instance shame at self, and so is self-knowledge. By this means death, knowledge and sexuality, *Eros* and *Thanatos*, are linked in the Christian tradition. Modesty and desire both have a metaphysical significance. But Adam, the first man, knew nothing of death. In a homily on relics, St John Chrysostom said that it is important to understand the nature of death in one's lifetime; God allowed Abel, Adam's son, to die in order that Adam, who otherwise would have seen no death, might himself understand its nature. His punishment is both to die and to understand the consequences of death as the final punishment for his and Eve's disobedience. In Abel's corpse, Adam recognized himself. In the first days

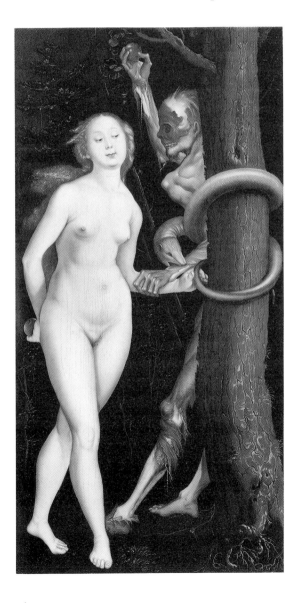

Eve, the Serpent and Adam as Death, by Hans Baldung, *c.*1530. Eve, a coy but knowing figure, seductively grasps the serpent which simultaneously bites Adam as Death.

of creation, the notion of the body as a sender of signs to others, as in the culture of the macabre, is already established.

I have already noted that the culture of the macabre had roots which were both ancient, conventional and universal: the penitential world of the late Middle Ages is in a sense no more than a magnificent footnote to St Augustine and the Fathers of the Church. But, by the same token, the Gothic north developed a strikingly distinct vision of the body as a sign of this penitential thinking. Whereas the body of man in the Italian Renaissance was essentially an image of integration, of balance, whereby the best was selected from the diversity and accidental character of ordinary fallen humanity, so redeeming the body by art, in the north the most powerful and characteristic images are of disintegration, the exploration precisely of the accidents of death. Yet the net result was in each case the production of a type, a universal: on the one hand a universality of beauty, on the other a universality of Everyman's death, in which individuality is stripped away by the banal facts of decomposition. It is perhaps characteristic that it should have been German images of the late fifteenth and early sixteenth centuries, on the eve of the Reformation, that draw these two universalizing strands of the north and south together. As Joe Leo Koerner has shown, it was especially the work of Dürer's pupil Hans Baldung Grien, in the first quarter of the sixteenth century, which collapsed these two themes together in an extremely distinguished set of images of the Fall. Baldung's representations of Death make play with Dürer's classically-inspired vision of perfect Adam. It is in these images that death as a vehicle of understanding of life emerges because of a new, and essentially modern, form of interaction and collusion: that between the viewer of the image and the image, as a means of understanding in itself. As we have seen, the roots of this relationship lie deep in the macabre itself.

In the art of Baldung, the impulse to voyeurism in the establishment of death as a spectacle is turned back on ourselves; as in the mirror, the image looks at us. Baldung's images of Adam and Eve at the Fall implicate us by their eye contact with us, and by their erotic impulse which we acknowledge as a symptom of our own fallen nature in our own erotic response. Death appears either in the guise of Adam or as a cadaver which pounces on and molests Eve. In such representations the conventional Christian discourse of gender is exposed: the feminine is aligned with death as the dangerous Other. Since the thirteenth century the serpent was frequently shown with a female head. But more important is how this image works. It engages us in a kind of aversion therapy: we shock ourselves into feeling Adam's own fallen sexual impulses, and comprehend through that feeling the consequence of it for Everyman, namely death itself. Death is revealed as itself an allegory of understanding: death, in Freud's words 'the aim of all life', becomes a criterion of the authenticity of human experience.

CHAPTER FOUR
DEATH AND THE AFTERLIFE

Many people claim to know what it is like to die, but today no-one on the right side of sanity claims to know what it's like to be dead. In the pre-modern world things were different. Lazarus, who lurched back from death at the start of this book, was dead for three days, and was in a position to report authoritatively on the afterlife. The English instructional manual published by Wynkyn de Worde in 1505, *The Arte or Crafte to Lyve well and Dye well*, includes a series of woodcuts whose subjects had been related by Lazarus after his resurrection at Christ's command; a sorry saga of tailor-made punishments fitting the crimes of sinners. Here was the most basic purpose of the plot of the afterlife; that it should be didactic, and should offer an incentive system to the living who, unlike the dead, were still in a position to reform themselves. Perhaps what Lazarus really experienced in dying bore more relationship to the stunning images of the Edenic Paradise and the Ascent to Heaven painted by Hieronymus Bosch, a contemporary of Wynkyn de Worde. In the Ascent to Heaven the naked souls of the dead are borne by angels to the mouth of a huge ribbed tunnel, through which they travel to a distant source of brilliant light in which is a far-off mysterious figure. Bosch's surprising image adumbrates what in recent years have become known as 'near death' experiences, a product not of metaphysical, but medical, miracles. Those having been resuscitated in the process of dying report a sensation of being outside their body, then floating down a tunnel towards a distant point of light, and being greeted at the other end by God, dead relations or some generalized sense of serenity.

Experiences of this type (which demonstrate a modern form of eschatology) are culturally relative. Death, like birth, is of course universal, but the state of death can only be represented or written about from the perspective of the cultural expectations of the living. To a contemporary of Bosch, his image would illustrate the first stage in the so-called Beatific Vision, the admission of the soul face-to-face with God either at death or after Purgatory. Modern 'near death' accounts act as incentives in a different way: in describing a fundamentally pleasurable and non-judgemental process, they answer to the hopes, fears and expectations of a truly hedonistic secular society. Augustine had long ago noted

Right The Edenic Paradise and the Ascent of Souls to Heaven, by Hieronymus Bosch, late 15th century.

that death was as much about the living as the dead, and it was in the construction of the afterlife – that space that could only be written about or represented – that cultural norms, and their complexity, were most readily exposed. Because this issue was of central importance to the Middle Ages, the representation of the afterlife was an issue not only for thinking and teaching, in other words doctrine, but also for the codification of faith itself, dogma. Issues of the importance to the dead of the body and soul and what form these took, the geography of the afterlife and the exact order of events were of formal as well as imaginative significance. But Christianity in all its forms still left much to be defined; and it was into the imaginative gaps that religious doctrine could not satisfactorily fill that the poetic imagination rushed. For this reason, medieval accounts of the

state of death, like Dante's *Divine Comedy* – in its way an equivalent to the modern near-death experience, though with pre-Christian roots – are supreme in a way that the literary and doctrinal literature of how-to-die are not.

'A Great Gulf Fixed': Heaven and Hell

The medieval Christian form of the afterlife was dominated by first two, then three, master notions: Heaven, Hell and eventually Purgatory. For the first thirteen centuries of Christianity, the doctrinal and dogmatic framework of death was basically binary or dualistic. This reflected the religion's Judaic and pagan heritage. In their various forms, Heaven and Hell were pre-Christian. Judaism seems for example to have had a binary view of the afterlife, with Paradise and a divided underworld: *sheol*, the pit or place of darkness, and *gehenna*, a place of punishment. The Psalms make clear a recognizable view: 'If I ascend up into Heaven, thou art there: if I make my bed in Hell, behold thou art there' (Psalm 139:8). Isaiah and Job both see the dead cut off from God in the pit of Sheol. The Greco-Roman afterlife was also dualistic, comprising Hades and the Elysian Fields. Both systems were premised upon the ideas that Heaven and Hell were places, and not simply states, arranged in a spatial dyad, Heaven up and Hell down. The descent into the underworld of Orpheus and Aeneas, and the arrangements described in Plato's *Phaedo*, recur in Dante's *Divine Comedy*. Paradise, a word originally from Persian and Hebrew, means a walled garden, and by it Christianity meant two separate but frequently confused ideas: the earthly Paradise of Eden, in the east, and the celestial 'Edenic' Paradise of Heaven. It is to the latter that Christ referred when he said to the good thief crucified with him: 'Verily I say unto thee, Today shalt thou be with me in Paradise' (Luke 23:43).

This spatial hierarchy was basically cosmological; the Greco-Roman cosmos was divided vertically into 'cthonic' (earthly) and 'uranian' (celestial) parts. The Greek word *ouranos* used in the Gospels for Heaven also means sky, and hence when Christ left the world for Heaven, He ascended, and a cloud received Him out of the sight of the Apostles (Acts 1). By the same token the rebellious angels, including Lucifer (the 'bearer of light'), were cast for their pride out of Heaven and down to Hell at the start of time (Isaiah 14:12; 2 Peter 2:4). The great Christian message of the redemption of the Fall of Man thus reflected even in its elementary metaphors a spatialization of thought; the material was beneath the spiritual, and the material world was thus an object of contempt both to Judaic and sophisticated pagan, especially Platonic, thinking, as in Job, the Pauline Epistles and the works of St Augustine. Bakhtin writes of a medieval picture of the world in which 'all metaphors of movement in medieval art and thought have this sharply defined, surprisingly consistent vertical character'. It was left to the great Neoplatonic Christian thinkers of late antiquity, such as the Pseudo-

Dionysius, to construct a hierarchical and intellectual ontology (or order of 'being') of the cosmos which provides the medieval conception of the Nine Orders of Angels. Ontologies of this type are of course also aesthetic in character, and so the dualistic hierarchy of Christian thought yielded a vertical spatial matrix not only for celestial and terrestrial power but also for image-formation. This was enriched by the possibilities of using the left–right axis (another dualistic organization of space on horizontal terms). One of the Christian creeds says that Christ shall judge the quick and dead from God's right hand, echoing the opening of the great Trinitarian Psalm 109, and the imagery of the Last Judgement in Matthew 25 deploys the same orientation. We will return to these in examining images of the Last Judgement.

To have a set of ordering principles and a sense of place and state is one thing; to flesh out or hypostatize the reality of the afterlife in terms which would suit the underlying purpose of all medieval images of the afterlife – to act as an incentive system – quite another. Images of Heaven thus assimilated other, complex ideas whose nature was metaphorical as well as ontological. Heaven was thus frequently depicted throughout the late Middle Ages – as in the images by Bosch or his precursor Jan van Eyck – in Edenic terms, as a garden. The notion of the city provided another metaphor, as in Augustine's *City of God*. The master-image of this urban paradise was of course the Heavenly Jerusalem, presented to us as a type for the ultimate arrangement of human spiritual affairs in the Old Testament Books of Enoch, Esdras and Baruch, and in the Revelation of St John, chapter 21:

And he carried me away in the spirit to a great and high mountain, and shewed me that great city, the holy Jerusalem, descending out of Heaven from God, having the glory of God: and her light was like unto a stone most precious, even like a jasper stone, clear as crystal; and had a wall great and high, and had twelve gates, and at the gates twelve angels, and names written thereon, which are the names of the twelve tribes of the children of Israel: on the east three gates; on the north three gates; on the south three gates; and on the west three gates ... and the city lieth foursquare, and the length is as large as the breadth ... And he measured the wall thereof, an hundred and forty and four cubits ... And the building of the wall of it was of jasper: and the city was pure gold, like unto clear glass. And the foundations of the wall of the city were garnished with all manner of precious stones.

As represented in great medieval illuminated Apocalypse manuscripts produced in Spain and England, the Heavenly Jerusalem brings to mind a great thirteenth-century cathedral like that at Chartres, with its many-portalled facades and stupendous displays of stained glass and interior vastness. When this system of building reached its apogee in the construction of the cathedral at Beauvais, the interior height and planning of the church were based upon a measurement of 144 French royal feet, perhaps a conscious evocation of the number of cubits in

the Heavenly Jerusalem. Such grandiose statements of modernity accorded with the Apocalyptic notion that the tabernacle of God is with men, and the former things are swept away (Rev. 21). Notwithstanding the collapse of Beauvais' vaults in 1284, these New Jerusalems were the most obviously impressive statements of the medieval incentive system at its highest and most palpably splendid. And unlike the Edenic vision of Paradise, they observed a certain unanswerable systematic rigour, the rigour of the many mansions of Christ's Paradise.

Another way of accomplishing this kind of systematic rigour was to envisage the afterlife in terms of a cosmological order, one ordered concentrically rather than architectonically. This was based on the old (ultimately Aristotelian) Ptolomaic system which exerted a profound influence upon medieval mathematics, astronomy and cartography for fourteen centuries. According to this model the earth lay at the centre of a series of rotating spheres which contained the heavens, with an outer static sphere, the Empyrean or ultimate Heaven, God's sphere, the sphere of the Beatific Vision. This model, which yielded the idea that the soul

The mid-13th-century choir of Beauvais Cathedral.

Left The Heavenly Jerusalem with the Tree of Life, as represented in the 13th-century English Trinity College Apocalypse.

ascends through the various heavens to God, was validated by texts in the pagan and Judaic traditions, and culminates in Dante's early fourteenth-century *Divine Comedy*. Its synthesis of pagan and Christian themes was refined as part of the medieval incentive system in the thirteenth century in work by figures like John Peckham (d. 1292), the Franciscan Archbishop of Canterbury. His treatise on the sphere finds a visual counterpart amongst a series of early fourteenth-century diagrams and illustrations concerning the structure of medieval sin and life, including the Three Living and the Three Dead, in the Psalter of the Franciscan-influenced Robert de Lisle, which we noted earlier on. This illumination, which emphasizes the importance of diagrammatic formulations to medieval memory and learning, shows Hell (*Infernus*) at its centre in the form of giant jaws and flames, with the sphere of the earth around it, then the various spheres of the heavens culminating in the outer *celum empireum fixum* where is to be found the seat of God and the final realm of light. This giant cosmos was of course validated by Aristotle (whose authority Peckham cites, like Aquinas) and by the Pseudo-Dionysius, whose heavenly hierarchy was illustrated in a colossal mosaic on the dome of the Baptistery in Florence a few years earlier, as brilliant a matching of form and content as the great northern Gothic cathedrals.

The concentric model, as opposed to the Edenic and the civic models, at least grappled directly with the relationship of Heaven to Hell and the underworld. This was seldom tackled head-on in the major texts of revealed truth in Christianity, as in the spatially unfocused but hugely influential parable of justice concerning the rich man Dives and the poor leper, Lazarus, in Luke 16.

And it came to pass that the beggar died, and was carried by the angels into Abraham's bosom: the rich man also died and was buried; and in Hell he lift up his eyes, being in torments, and seeth Abraham afar off, and Lazarus in his bosom, and he cried and said, Father Abraham, have mercy upon me and send Lazarus, that he may dip the tip of his finger in water and cool my tongue; for I am tormented in this flame. But Abraham said, Son, remember that thou in thy lifetime receivedst thy good things, and likewise Lazarus evil things, but now he is comforted and thou art tormented. And beside all this, between us and you there is a great gulf fixed: so that they which would pass from hence to you cannot; neither can they pass to us, that would come from thence.

This is one of the master narratives of the 'great gulf fixed', with its image of Dives trapped and tormented by flame and thirst, and by the vision of Abraham and the nestling Lazarus far off. Hell (from the Old Norse *hel* meaning 'death' or 'burial mound') is the final irreversible and hopeless deprivation of God's love, and is in the first instance a state as much as a place, a state of utter egotism. It is everything Heaven is not. Dives can see but cannot attain Heaven, and his sight is not of God but of Abraham, the receptacle of the blessed before the Last Judgement: he is deprived of the Beatific Vision.

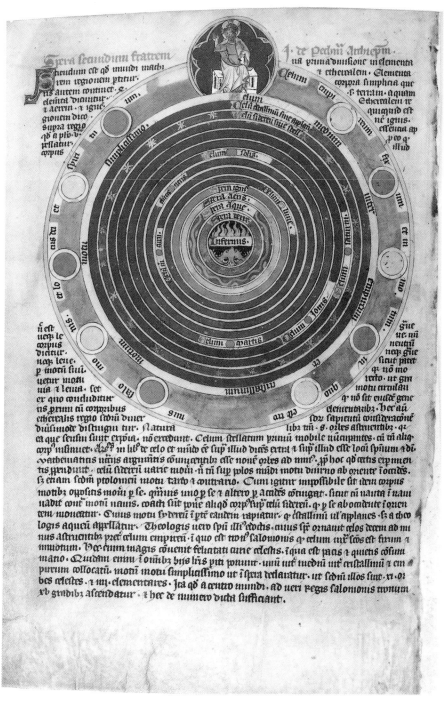

The Sphere of John Peckham, from the Psalter of Robert de Lisle, *c.*1310, with Hell at the centre and God in the empyrean.

Hell is also other people. Here it is that the rebel angels fell in tandem with the Fall of Man at the Creation, as illustrated by the thirteenth-century Oxford illuminator William de Brailes. Where Heaven represents order and harmony, Hell represents disorder; again, it is an anti-representation, premised upon a binary opposition of order and disorder that constitutes yet another aesthetic principle in medieval art, whose metaphysical roots lay in Neoplatonism. And in some ways it is a representational sphere that offered to medieval writers and artists vastly greater scope than the calm aesthetic numbness of Heaven. Hell as the sphere of ego was the ideal sphere of artistic egotism; it was wrong, but it was also romantic. Demons are, like gargoyles, amongst the most romantic creations of medieval art, and the myriad form of their legions represented their protean power, which included the capacity to escape Hell and enter the world of the living to corrupt mankind, as Tertullian put it, with their 'subtle spiritual properties'. On about eighteen occasions Christ had to cast demons out in all their forms. Hell is thus inevitably the realm of variety and fantasy, and it is usually the case, in the art and literature of the later Middle Ages, that the pangs of Hell are described more fully and richly than the corresponding rewards of Heaven.

The roots of this realm of spectacular visual fantasy were of course older, and they lay especially in the vigorous world of monasticism, with its fundamental idea of the warfare between good and evil, and triumph over temptation. Evil should be a force to reckon with, and it is to the art of the early Middle Ages that we owe some of the basic and most powerful images of Hell. One such is the Hell Mouth, the giant maw which figures somewhat tamely at the centre of the spheres of John Peckham. The ultimate model for this huge all-devouring mouth was the monster Leviathan, in Job 41, as understood and passed down to the Latin Middle Ages by texts like Gregory the Great's *Moralia in Job*. Hence it passed into the great Carolingian and Anglo-Saxon traditions of Psalm illustration where it blended, in works like the ninth-century Carolingian Utrecht Psalter, with pagan ideas of Hades and medieval ideas of the Grendel-like monster in the epic *Beowulf*. Epic battles between men and monsters form a natural part of contemporary poems and sagas: the Old English poem *Christ and Satan* includes the laments of the fallen angels, 'Where has gone the glory of angels which we were wont to possess in Heaven?' – like the Three Dead of later legend. This pagano-Christian imagery of triumph, eschewed for the most part in the earliest Christian art, can be seen in representations of the Temptations of Christ like that in the eighth-century Book of Kells, and flourished in works of monastic scriptoria like the eleventh-century Tiberius Psalter and the twelfth-century Winchester Psalter, perhaps the greatest of all such visions of Hell and its claustrophobic finality. The angel who locks up Hell in the Winchester Psalter (PL. IX) of course answers to the figure of Peter bashing a demon on the snout

with his keys, in the slightly earlier New Minster *Liber Vitae*: here is the power of the church triumphant, its power of binding and loosing, the key to sin itself. When combined with the hierarchical spatial metaphors of medieval art, based on Psalms 91 and 109, this power, attested throughout the Acts of the Apostles, could produce the triumphalist imagery of the great sculpted cathedral portals which depict the saints of the church trampling and neutralizing, literally subjecting, evil in all its diversity.

The mutant but powerful world of Hell represented a perversion of the divine order; its polymorphous perversity constituted what one critic has called a *monde renversé*, its almost carnivalesque character creating endless scope for medieval artists for *inventio* and visual promiscuity. The imagery of triumph was manifest in the grotesque punishments of the damned, devoured or, very commonly, boiled in a huge cauldron heated by a fire fanned by bellows-wielding demons. The visual construction of demons themselves between at least the twelfth and the sixteenth centuries was based upon the accumulation of individually innocuous elements, subjected to weird organizational principles. Medieval artistic invention preyed upon the protean forms of demons in a way which revealed a deep understanding of the metaphysical lack in evil. While the truest good was stable and unchanging, the material world was by its nature transient and unstable. Ordinary matter is thus shown to be blind and yearning for shape, yearning to be informed by the good. Demons are reduced by the art of fantasy to a hell of arbitrary material forms, which signify their abject separation from the source of all order; demons are repulsive, but also pitiable. Dante's depiction of Satan as a tearful furry inverted monster with bat's wings and three heads is only one instance. This promiscuity of forms, answering to the lust of the eye, or *curiositas*, described by St Augustine, was what St Bernard objected to in denouncing Romanesque artistic fantasies in the cloister in one of the most celebrated anti-art polemics of the twelfth century, his *Apologia* to William of St-Thierry. In its section *De picturis et sculpturis . . . in monasteriis* (On pictures and sculptures in monasteries) Bernard expostulated:

But apart from this, in the cloisters, before the eyes of the brothers while they read – what is that ridiculous monstrosity doing, an amazing kind of deformed beauty and yet a beautiful deformity? What are the filthy apes doing there? The fierce lions? The monstrous centaurs? . . . You may see many bodies under one head, and conversely many heads on one body . . . Good God! If one is not ashamed of the absurdity, why is one at least not troubled at the expense?

Bernard's refreshing attack is to be understood within the norms and expectations of monastic reform of the period which, from his point of view, should purge the sanctuary and cloister, types for Paradise, of anything obscene or pagan, hellish, or frankly popular. Behind it lies that idea of order apparent in the most influential aesthetic treatise of the Middle Ages, Augustine's *De Musica*:

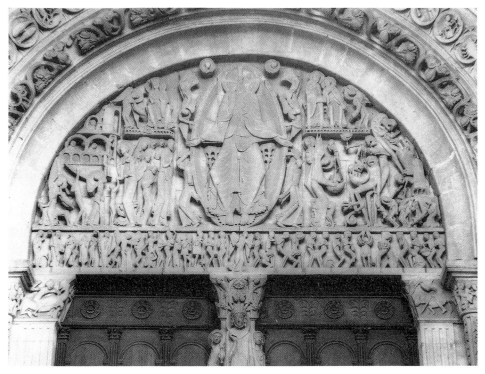

The Last Judgement, Saint-Lazare, Autun, *c*.1130. The torments of the damned are especially notable in this most celebrated example of Burgundian Romanesque sculpture: note for example the figure (lintel, right-hand side) whose head is grabbed by an enormous pair of hands. The fillet beneath Christ's feet bears the name 'GISLEBERTUS', probably the sculptor; here the artist inscribes himself into the narrative of salvation. Patrons like Abbot Suger of Saint-Denis (compare illustration on p. 209) could also place themselves in this position.

the ultimate basis of harmony and meaning was not visual, nor even acoustic, but numerical. Hell is by any standards damnably disordered. And it is also noisy; noise is visually implicit in the way demons were rendered by Bernard's artistic contemporaries, as on the great Last Judgement portal at Autun in Burgundy, whose spectacular demons gape and shriek. Their din inverts the calm quasi-acoustic order of Heaven; their aversion to harmony is an aversion from meaning itself. The demon Tutivillus, responsible for writing down in a book all our vile sins, disliked the acoustic incense of church bells, used to ward off evil. But demons could if necessary feign harmony in the form of the siren-call to sin, like the woman-headed serpent with the apple in Eden, which yowled seductively to Eve with its minstrelsy of deceit. Aversion from meaning is represented too by the lewd Devils who speak garbled Latin and emit stentorian sulphurous farts, apparently a standard reaction for stressed-out demons: 'For fear of fire a fart I crack', cries Lucifer on being ejected from Heaven in the Coventry Mystery play.

Hell, not surprisingly, also smells: it presents a fantasia of effects to the senses of sight, hearing and smell. In keeping with biblical accounts like that of the destruction of the Cities on the Plain in Genesis 19:24 it reeks of fire and brimstone, and one of its principal torments is flame.

But Hell is supremely the place where the egotism of mortal sin – its character of voluntary separation from God – comes to define its inhabitants. In Heaven the blessed or cleansed soul rises to God in such a way that its ego is absorbed in the Godhead; this too was one of the aims of late-medieval mysticism. In Hell, in contrast, we are reduced corporeally to our sins; torments become the signs, the emblems, of what we have done wrong, in such a way that sin robs us of our true selfhood. To the thirteenth-century mind this was a by-product of justice; Aquinas in his *Summa Theologiae* said that one of the pleasures of the blessed was to regard the suffering of the damned, not for its own sake, but in order to rejoice at the spectacle of God's justice. Hell is thus a form of judicial theatre, many of the props of which were biblically-derived and later enriched by subsequent apocryphal accounts of the specificities of torment in texts like the first- or second-century *Apocalypse of Peter*. Matthew's Gospel is rich in such allusions. In Matthew 13:49 we read that at the end of the world the angels shall sever the wicked from the just 'And shall cast them into the furnace of fire: there shall be wailing and gnashing of teeth', and in Christ's account of the Last Judgement in Matthew 25 the sheep are separated from the goats, and those who have not performed the Works of Mercy shall depart 'into everlasting fire, prepared for the devil and his angels'. James 5:1–7 is even more specific in linking the character of sin and torment: 'Go to now, ye rich men, weep and howl for your miseries that shall come upon you . . . Your gold and silver is cankered; and the rust of them shall be a witness against you, and shall eat your flesh as it were fire. Ye have heaped treasure together for the last days.' Not surprisingly the parable of Dives and Lazarus was chosen for some of the most splendid twelfth-century sculpted church facades showing the Last Judgement or Apocalypse, as at Moissac in western France, or Lincoln. At Moissac are representations of the parable together with the vices *Avaritia* and *Luxuria; Luxuria* is pursued by a demon and gnawed at by revolting snake-like reptiles, in allusion to Isaiah 66:24 and Mark 9:44 where Hell is that place 'where their worm dieth not, and the fire is not quenched'. A tremendous drawing of the magician Mamres standing at the mouth of Hell in an Anglo-Saxon manuscript of the *Marvels of the East* of *c*.1025 shows the souls of the wicked wound around with snakes, much in the spirit of the image at Moissac.

By the thirteenth century it was becoming more common for artists and writers to tie the character of specific punishments down to specific sins. This form of correspondence was engendered, as we have seen, by the widespread efforts of the thirteenth-century church to codify belief and disseminate the basic tenets

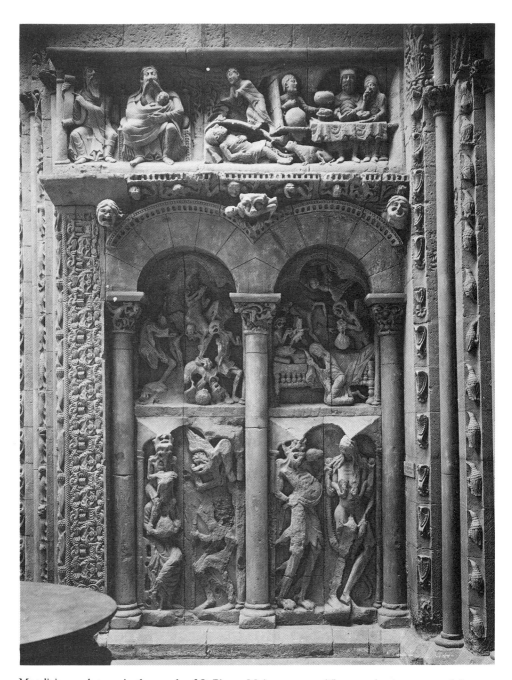

Moralizing sculptures in the porch of St-Pierre, Moissac, c.1125. The apocalyptic content of the main tympanum is glossed by these scenes alluding to the bodily torment of sinners: above, Lazarus dies at the gate of Dives' feast and goes to the Bosom of Abraham; below, Dives and figures of *Avaritia* and *Luxuria* are punished in Hell.

of the faith amongst the clergy and laity. Of these the classification of sin in theological and legal terms was part. This classification had begun early, with the compilation of so-called 'penitentials', or rule-books, which listed sins and their remedies. In a tradition going back to Cassian, the canons of the Fourth Lateran Council of 1215 required that priests, doctors to the soul, 'must be diligent and cautious, inquiring about both the sin and the circumstances of the sin, so that with prudence he might understand what advice and remedy to offer'. Robert Grosseteste, Bishop of Lincoln, published a reform programme in 1238 aimed at clerics: at its heart were the Ten Commandments, the Seven Deadly Sins and the Seven Sacraments. They should especially exhort the people to 'flee' from the Seven Deadly Sins (Gluttony, Pride, Luxury, Avarice, Envy, Accidie, Anger). This structuring of sin is precisely that found in late-medieval manuals of sin and confession, and in the mnemonic diagrams based on convenient number-symbolism in the de Lisle Psalter mentioned earlier.

Images of the Last Judgement could also map the mortal sins, so providing a part of that incentive system to flight and self-improvement. This was done by means of the secular legal idea of the *contrapasso*, wherein the punishment was seen to fit the crime. Many of the punishments singled out by Dante had wordly counterparts, like those dragged to Hell tied to the tail of an animal (*Purgatorio* 24), a standard Florentine punishment for treachery. Correspondences of this type also reflected the habits of mind of the ancient penitentials, and the more recent manuals of confession, which proliferated with the practice of personal confession in the thirteenth century. These systematically aligned sin and penance. It was becoming much more important not only to identify sins but also to ask about the circumstances of their commission and of the individuals in question; as Alan of Lille put it in considering confession in his twelfth-century *Liber Penitentialis* 'Be careless in nothing, but always determine what, where, for how long, and when'. This is the language of the lawyer as much as of the doctor of the soul: spirituality and jurisprudence seem to coincide increasingly from now on. But notwithstanding this new circumstantial attention to the commission of sins, certain offences were outstanding in the popular consciousness. Two were specially notable in representations of the Last Judgement and Hell: usury (the lending of money at interest) and sodomy. Usury and sodomy were increasingly disapproved of or persecuted by the thirteenth century, especially in Italy. Though usurers could find their way into Purgatory their fear of the *contrapasso* was still substantial. Dante, for example, places a family notorious for usury, the Scrovegni, in the Seventh Circle of Hell not far from the sodomites, and it was in part to expiate this sin — one of mortal character nearly as vile as Pride — that Enrico Scrovegni commissioned Giotto's frescos of the Life of the Virgin Mary and Christ, the Virtues and Vices, and the Last Judgement in the first decade of the fourteenth century at the Arena Chapel at Padua. The representation of Hell

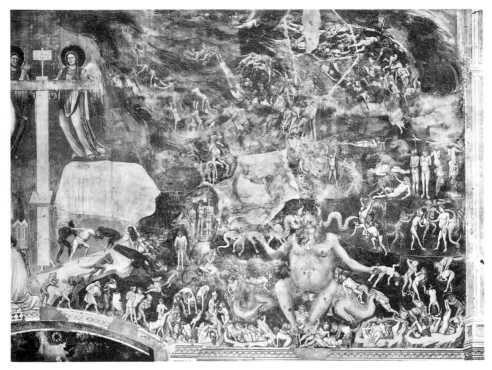

Part of the Last Judgement, by Giotto, Arena Chapel, Padua, *c.*1305, showing Hell and, among other sins, the punishment of usury (right, centre).

includes standard imagery of the money-bagged usurer amongst its torments. Sodomy is even more graphically punished amongst the damned in Taddeo di Bartolo's celebrated Last Judgement mural of the 1390s at the Collegiata at San Gimignano, showing a naked man labelled in the vernacular SOTOMITTO being skewered from his arse to his mouth by a demon; nearby a usurer is forced to swallow hot coins.

Images of this type are hardly subtle, nor were they meant to be. Though in part a way of structuring information about sin, they acted primarily as agents of terror, and so as incentives. Hell's image naturally exemplified a culture in which retributive notions of justice expressed the community's outrage at, and denunciation of, crime. A thirteenth-century Lay Folk's Mass Book, directing the laity as to what to do and think during Mass, advises the reader to ponder the image of the Hell Mouth. The *Life of St Hugh of Lincoln*, whose exploits at Fécamp we noted at the start of this book (p. 15), relates an exchange between the saint and King John before the great Romanesque Last Judgement sculptures formerly at Fontevrault:

Then the bishop pointed to the left hand of the Judge, where kings in their regalia were being consigned to damnation ... The bishop turned to his companion and said, 'A

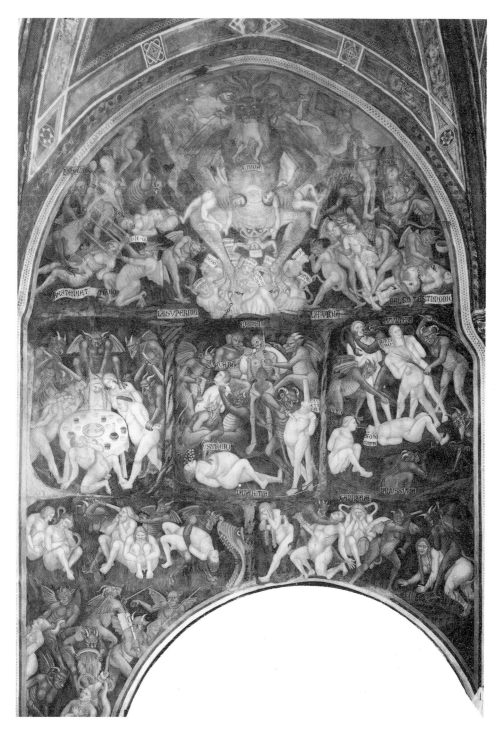

Torments of Hell, including the punishment of sodomy, by Taddeo di Bartolo, Collegiata, San
Gimignano, 1390s.

man's conscience ought continually to remind him of the lamentations and interminable torments of these wretches. One should keep the thought of these eternal pains before one's mind at all times . . . Let the memory of these pains remind you how severe will be the charge against those who are set up for a short time to rule others in this world, but fail to govern themselves. . . .' He said that images like this were very rightly placed at the entrance of churches. For thus the people going inside to pray for their needs were reminded of this greatest need of all . . .

The imagery here is akin to that of the great northern French Last Judgement portals which show the various estates of society either being received into bliss or consigned to Hell in the trappings of their station, a dramatization of the universality of sin and death premonitory of the Dance of Death. Here, in the

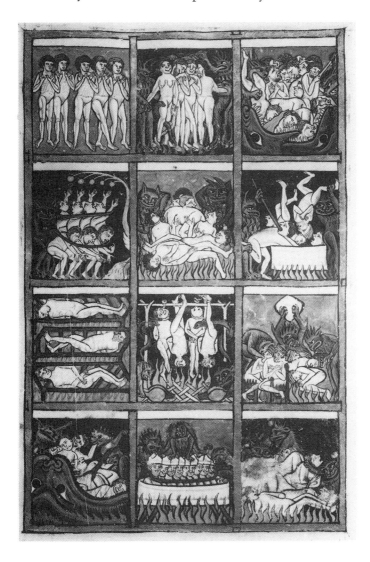

Torments of Hell, from the Munich Psalter, *c.*1200.

early thirteenth century, there was still no question of portraying notions of the particularity of sin and punishment, or of the idea of the individual or 'particular' Judgement which became fashionable in the later Middle Ages in tandem with new thinking about the soul's individual experience of the Godhead in the Beatific Vision. The tendency, as in the splendid page showing the torments of Hell in an early thirteenth-century English Psalter now in Munich, was rather to depict the meting out of punishments to the different estates: naughty bishops boiled in a cauldron as a weird parody of baptismal rites – a real baptism of fire – for example. But in so conceptualizing the social estates, the way was open to renegotiate the mortal character of some sins typical of those estates – usury and the urban middle classes for example – in such a way that Purgatory, the third place, could help them upwards. By the fifteenth century urban capitalists and tradespeople were sponsoring dramatizations, the Mystery Plays, in ways appropriate to their calling: in York, the glaziers supported the play of the Harrowing of Hell because of its light symbolism, while the mercers put on the play Doomsday because of their use of weights and measures, echoed in the *psychostasia*, or weighing of the souls, at the Last Judgement. The city became, perhaps appropriately, the ultimate theatre of Hell: a York mercer's indenture of 1433 mentions props for plays, including a Hell Mouth. A draper's account from Coventry mentions payments for keeping a fire going, representing the flames of Hell. Records of a Passion play performed in Metz in 1437 note 'The gateway and mouth of Hell in this play was very well made, for by a device (*engin*) it opened and closed of its own accord when the devils wanted to go in or come out of it. And this great head had two great steel eyes which glittered wonderfully.' And sometimes the paraphernalia could act up in a way farcically reminiscent of the pangs of Hell. A 1496 production of the *Mystery of St Martin* play at Seurre degenerated when:

Lucifer began to speak, and during his speech the man who played Satan prepared to enter through his trapdoor underground; but his costume caught fire round his bum so that he was badly scorched . . . [and had to] retire to his house.

The Third Place: Purgatory

This brief and necessarily partial excursus into the phenomenal wealth of medieval imagery of the afterlife shows that while its various models provided a remarkably open forum, their basic conceptual, and hence visual, character was based upon a binary opposition. Here at least most theologians and thinkers were in agreement. But Christianity, as I noted at the start of this book, was a religion less of system than of systems. This arose principally because doctrinally the faith was founded upon more than one type of truth: first, the revealed truth divulged in scripture; and second, the truth of authoritative commentary and

interpretation, which we mostly identify with the early patristic writing of the Church Fathers and their medieval followers. A third element was the legacy of pagan natural philosophy, first Neoplatonism, predominant throughout the Middle Ages, and second Aristotelianism, recovered in the thirteenth century. It was only by the thirteenth century, a century of reason and system, that all three forms of thinking, revelation, commentary and natural philosophy, were brought together with varying degrees of success. Thought about the afterlife was dominated by these various attempts, and it is for this reason that medieval notions of the afterlife were based on a plurality of sometimes irreconcilable authorities, that they were intertextual. Nevertheless, medieval Christianity, though synthetic, was still governed morally and historically by an incentive system: it was a religion of example, of goal-orientation, the goal being the final reckoning. As its organism of thought became more complex, the character of this goal-oriented, or eschatological, view of spiritual destiny was qualified, perhaps most significantly, by the emergence of a third category of the afterlife (either a state or a place), namely Purgatory. The doctrine of Purgatory was a truly medieval creation, a synthesis, which came, as we have seen in this book, to have a profound effect upon medieval institutions and art, and which also by its nature disturbed the symmetrical, binary aesthetic foundations of the afterlife. But here we face a paradox: why is it that so fundamental a renegotiation of the state after death had relatively little direct effect on the medieval system of representing the afterlife?

In order to understand the ways in which the doctrine of Purgatory as it developed in the first thirteen centuries of Christianity seems not to have tallied rigorously with the visual arts, we must first outline the formation of the doctrine itself. As we saw earlier (pp. 24–5), Christ, in his prophecy of the Last Things in Matthew 24, made the early church a hostage to fortune by promising the parousia within a generation. In its absence the problem of the state of the dead between death and the Last Things became more pressing, and this existential hole was plugged either by elaborating on the scheme of the afterlife, as in the apocryphal Apocalypses of Peter and Paul, or by gradually ceding to the church a sacramental role in the care for souls, with Christ as the supreme priest and mediator. This was the basis of the medieval ecclesiastical systems of hierarchy, clericy, sacramental theology and the formalized disciplines of penance and absolution, which served to prepare and control the faithful, given the postponement of the *telos*, or final point, of the religion. In sum, the existential character of the period between death and judgement became negotiable, and the central sign of this was the emergence of the doctrine of Purgatory, a grey area of joint jurisdiction between God and the Church, which presided over sinners who were neither especially good nor especially bad, and who could eventually, with the help of the living, escape.

Purgatory was usually thought of doctrinally as a state, though, as Jacques Le Goff has argued, its imaginative character progressively took on the qualities of a place as well, especially by the thirteenth century. Debate thus focused on the nature of this intermediary state – who belonged to it, and what it was like – and on its spatial relationship as a place to the binary system of Heaven and Hell: was Purgatory a form of lower Heaven, or upper Hell? Dante's vision of the geography of all three places in the *Divine Comedy* was merely the most eloquent and coherent statement of an idea which had taxed theologians, poets and visionaries for several centuries, and it is perhaps a reflection of the theological quandary of Purgatory that its most imaginative exponent should not have been a theologian at all, but a poet.

Normally, medieval Purgatory as a state or a place was thought of in terms which lay somewhere between Dante's grand and haunting landscape of the *Comedy*, and the ancient Greco-Roman and early Christian notion of the afterlife as a place of various uncoordinated receptacles for the souls of the dead. The oldest Christian ideas of the *refrigerium* were based on the idea of receptacles, the anthropomorphic equivalent to them being Abraham's Bosom, the resting-place of the soul of Lazarus mentioned earlier (p. 170). To Tertullian, writing in the third century, this state was an interim one before the soul was admitted to the final joys of Heaven. In considering the vocabulary of burial and tombs we noted the early adoption of metaphors of containment and domesticity; tombs were in themselves receptacles of the dead and it was natural to think of the soul occupying the same kind of space in the hereafter. Abraham's Bosom was thus an ante-chamber, or atrium, of Paradise. But the loose character of the receptacle theory of the afterlife – which existed independently of the doctrine of Purgatory – was persistent and can lead to confusions. Thus, it is not clear whether an early fourteenth-century mural in Salamanca Cathedral showing the Last Judgement with a series of small naked figures being taken out of receptacles in the ground, shows Limbo or Purgatory (as suggested by Le Goff), or just the Resurrection of the Dead: the receptacles and small naked forms could indicate either. Here then was a weakness in the system, to which we will return in looking at the representation of Purgatory in art: how persuasively to tie a new ternary, or three-part, notion of the afterlife to a representational system conventionally founded upon binary oppositions and fragmented spatial units.

The genealogy of medieval thinking on Purgatory can be traced to a source which stood on the cusp of revealed truth and interpretation: St Paul, in 1 Corinthians 3:13.

For other foundation can no man lay than that is laid, which is Jesus Christ. Now if any man build upon this foundation gold, silver, precious stones, wood, hay, stubble; every man's work shall be made manifest: for the day shall declare it, because it shall be revealed by fire; and the fire shall try every man's work of what sort it is. If any man's

work abide which he hath built thereupon, he shall receive a reward. If any man's work shall be burned, he shall suffer loss: but he himself shall be saved; yet so as by fire.

Here was the most elementary description of the idea of trial and purgation by fire without its leading to eternal damnation, and it was as it were upon this foundation that the elaborate edifice of Purgatory itself was erected, with the addition of the further and equally fundamental idea that those in this state of trial could be assisted by the living, by suffrages – prayers, Masses and alms. This idea of mercy is itself already apparent in the third-century apocryphal *Apocalypse of Paul* in which Hell is divided into upper and lower compartments, the upper part admitting the mercy of God, and so hope. That the living could be implicated in this state of hope is also suggested by another early 'pre-Purgatory' text, the third-century *Passion of Perpetua* set in Africa, in which Tertullian's idea of the *refrigerium* provided the context for a vision of Perpetua in which she saw her dead brother trying to gain cooling water to assuage the thirst of the dead (from which Dives suffered in Hell), and tried to help him by prayer.

Nevertheless, the notion of suffrages and of the exact character of this truly interim state remained conceptually vague. Little or no hard evidence for it was preserved in the revealed texts of Christianity, and there was a conflict between it and conventional eschatology, because the idea of a redeemable state of progressive punishment and cleansing seemed to vitiate the idea of a final single event of catharsis at the Last Judgement; it was not so much eschatology as escapology. Furthermore, it encouraged the idea that purgation was a matter for individual souls and categories of sin, rather than a single collective act. Some Christians remained quite unable to accept the idea of such a state, most conspicuously the Greek Orthodox church, which finally split from its Western Latin counterpart in the eleventh century for a variety of reasons. So it was left to the great patristic writers, principally St Augustine, to begin the process of sharpening the idea into a more coherent doctrine. Augustine is often cited as one of the fathers of Purgatory less because he defined its character as a state, though this was important, but rather because he validated the idea that the living could assist the dead through suffrages, in his *Confessions* (397) and in the *City of God* (written from 413).

The formation of the later medieval idea of Purgatory owes much to the intersection of what we might call 'supply side' theology – the high cultural thinking of intellectuals – and 'demand side' popular belief, though how relatively important these two strands were, just as what people really believed at the 'popular' level, is a matter of debate. In the end distinctions of this type may not be terribly helpful, and the distinction between popular and high belief positively misleading because it cannot provide any true criterion of 'normality'. We can usually expect to excavate at best behaviour and words of contemporaries; beliefs or *mentalités* are more problematic. Study of the detailed inquisition registers

drawn up in 1318–25 during an examination of the ordinary folk of Montaillou in southern France, and discussed by the author Le Roy Ladurie, reveals what appear to be the heterodox belief systems of communities tainted with Cathar heresy. Here the ordinary folk showed little evidence of absolute faith in the doctrines of Purgatory or the Resurrection, subscribing instead to the idea of metempsychosis or reincarnation, derived ultimately from Plato, Pythagoras and the Orphics. But even when, in cases like this, we can point to a coherent body of opinion, we are still left without absolutely firm evidence for what people really thought in a well-documented context, let alone for how representative such ideas might have been of society at large.

The classic supply side view of this state was essentially that of Pope Gregory the Great (d. 604), whose *Moralia in Job* envisaged a subdivided Hell with an upper part, Limbo, reserved for the unbaptized; whereas in the realm of monastic visionary literature the so-called visions of Drycthelm (related in Bede's eighth-century *Ecclesiastical History*) and Wetti, a ninth-century German, represent absolutely convincing early statements of the imaginative construction or spatialization of the third state, 'popular' or not. A Northumbrian, Drycthelm, died, but Lazarus-like returned from the dead with an account of the landscaped afterlife which he had visited with an angelic guide. The guide interpreted what Drycthelm had seen thus:

The valley that you saw, with its horrible burning flames and icy cold, is the place where souls are tried and punished who have delayed to confess and amend their wicked ways, and who at last had recourse to penitence at the hour of death, and so depart this life. Because they confessed and were penitent, although only at death, they will all be admitted into the Kingdom of Heaven on the Day of Judgement. But many are helped by the prayers, alms, and fasting of the living, and especially by the offering of Masses, and are therefore set free before the Day of Judgement. The fiery, noisome pit that you saw is the mouth of Hell, and whosoever falls into it will never be delivered throughout eternity. This flowery place, where you see these fair young people so happy and resplendent, is where souls are received who die having done good, but are not so perfect as to merit immediate entry into the Kingdom of Heaven. But at the Day of Judgement they shall all see Christ . . . And whoever are perfect in word, deed, and thought, enter the Kingdom of Heaven as soon as they leave the body.

Though not exactly tripartite in construction (there appear to be two interim states, with and without punishment), this is as clear an idea of the notion of purgatorial punishment and the Augustinian notion of the value of suffrages as any high theological statement.

The transition from doctrine to dogma, from teaching to decree, really underwent its most critical period in the twelfth and thirteenth centuries, when the sophisticated clerical cultures of northern France and Rome conspired, with varying degrees of success, to produce an absolutely coherent single system of

reformed belief. Almost all important scholastic debates in the northern French cathedral schools, and in Paris, focused upon Book Four of Peter Lombard's *Sentences* (1155–57), the central text of contemporary theology which summarized much of what had been said before. And it is to the circle of a Parisian successor of the Lombard, Petrus Comestor, writing in the period around 1170, that Le Goff attributes the use of the noun *purgatorium* to designate a formal place of punishment: by this reading, Purgatory in the full doctrinal sense, was a product of the school of Notre Dame in the late twelfth century. But the importance of this usage was essentially nominal, because at most levels of thought the third state, as a state, was still an object of debate. In the early thirteenth century the extremely influential Pope Innocent III, in a sermon on All Saints, could think in terms of a five-tiered notion of the cosmos, consisting of Heaven, Eden, the World, Purgatory and Hell, not unlike Dante's. The teachings promulgated at the Lateran Council of 1215 make no mention of Purgatory, yet the reaction of contemporary heretics in France to the idea of Purgatory, and to the idea of its being controlled by the clergy, indicated widespread popular acceptance of the potential, if not the validity, of the idea. These can only have been reinforced by the most important visionary texts on the theme of the period, the vision of Tundal and St Patrick's Purgatory from the 'Celtic fringe', and the notion that the entrance to Purgatory was located near Sicily. Just as Purgatory was tugged around conceptually between Heaven and Hell, so it was torn between the various geographical margins of Latin Christendom.

The production of dogma really required the consolidation of teaching in such a way that it could be promulgated from within the legal and institutional framework of the church by means of the interaction of the law of the Church, Canon Law and civil law. The first important dogmatic statement about Purgatory in the Latin church was made at the second Council of Lyons in 1274:

The Holy Roman Church ... teaches that those who after baptism fall into sin are not to be rebaptized; instead, they will obtain forgiveness of such sins by doing penance for them. If, however, thus truly repentant and in the love of God, they should die before making satisfaction for these their sins ... by bringing forth fruits befitting penance, then their souls are purified after death by purgatorial or cleansing punishment; which punishment can be lightened by the prayers of the living.

Here nothing is said about the place, nor even the state or condition of Purgatory. What mattered now was that the character of sin and the quantifiable (and so demonstrable and enforceable) value of punishment and suffrage had to be established. The system always tended to think in worldly, not other-worldly, terms. Purgatorial punishment was thus marked not only by its *quality* or intensity (typically by fire), but by its *quantity* and duration. Hence by the thirteenth century there was a new and somewhat literal concern with the ratio of time's passage on earth and in Purgatory, such that the internal coherence and validity of the

idea of punishment and suffrage could be coordinated. This was one important basis of what has been called the 'quantitative piety' of the later Middle Ages, its obsessive concern with the notion that the repetition of an action (like a prayer) ensures its validity. I have already discussed this issue in examining images of the macabre in Chapter Three. A logical system had to be seen to work. In the English *Speculum laicorum* we read of a Cistercian monk who, when he died, twitched so violently that for a moment he seemed to rise four feet above his bed. The next night, he appeared as a ghost, peacefully surrounded by light. And when asked what had happened to make him jump, he said that in the instant of death his soul had passed through Purgatory for a period that seemed to last a thousand years, even if on earth it had only been an instant. Kings were not immune to this slow passage of time. In 1232 the St Albans' historian, Roger of Wendover, recorded a vision in which Richard I of England (d. 1199) was released from Purgatory after over thirty terrestrial years. By 1300 at the latest, as we have seen in looking at 'pardon' brasses, the notion of a fixed quantifiable return for suffrages was a normal component of tomb inscriptions; sometimes forty days, sometimes, as on the tomb of John de Warenne, Earl of Surrey (d. 1304), three thousand. The grateful dead, including the elite of the Church, were now in practice enforcing a system over which the greatest minds were still oddly prone to dither in theory.

This bookkeeping of salvation, sanctified by that bond of charity which Aquinas said linked the living and the dead, was of course widely sanctioned. But above all the system was enforced by the papacy. In 1300 Pope Boniface VIII declared a jubilee year and a plenary indulgence – complete remission of sins, and so direct access to Heaven – for those going on pilgrimage to Rome in a state of repentance and confession. Perhaps two million people benefited by visiting Rome in 1300. The first such plenary indulgence had been issued in 1095 by Pope Urban II for participants in the first crusade, long before any formalized dogmatic statements about Purgatory. And here was a critical issue: concrete doctrine about states and places in the afterlife counted for little in comparison with the notion of the indulgence as an expression of the papal plenitude of power. The church's power of binding and loosing of sin, ceded by Christ directly to St Peter, had now become a means of offering immunity from sin with impunity. It was to this system of paper immmunity that energy was now devoted. By the thirteenth century popes could offer partial remissions for all kinds of good works: thus by a Bull in 1245 Pope Innocent IV offered twenty days' relaxation of penance to those contributing financially to the rebuilding of Westminster Abbey, at the behest of Henry III. Innocent IV in fact granted rather large indulgences sometimes without any conditions of service.

From the perspective of Protestant (and much Catholic) thought, the introduction of the cash nexus into this bookkeeping of the afterlife was the final straw.

This began in the fourteenth century with the extension of a privilege to buy a plenary indulgence from a confessor at the moment of death, an economy of salvation obscured, and perhaps mystified, by the culture of the *Ars moriendi*. In 1344 the Avignonese Pope Clement VI granted this right to two hundred people in England alone, in return for a fee. Rather than plough through the trials of *Moriens*, the dying sinner had merely to hear a spell cast by a layman: 'May the Lord absolve you from your guilt and punishment according to the privilege which you say you have received from the supreme pontiff.' And since Rome could plumb bottomless resources of spiritual capital, inflation 'beyond useful computation' (as R. W. Southern put it) ensued. Irony was the only conceivable intelligent response, as Chaucer's cutting thumbnail sketch of the Pardoner in the prologue to the *Canterbury Tales* famously demonstrates. Here was an official charged with the conveying of indulgences at a price; swanning onto the stage with an image of the Veronica (a Roman image-relic) sown to his cap, a wallet stuffed with pardons hot from Rome, a bit of the Virgin Mary's veil and a bottle of pig's bones for relics, the Pardoner

> . . . whan that he fond
> A povre person dwellynge upon lond,
> Upon a day he gat hym moore moneye
> Than that the person gat in monthes tweye.

Images and Incentives: The Non-Representation of Purgatory

To return to a question posed earlier: why is it that so central a doctrine as that of Purgatory should not have been accompanied by a fundamental rethinking of the way the afterlife was itself represented in medieval art? The issue here is one both of quantity and quality; with the exception of the canon of illuminated manuscripts and frescos illustrating Dante's *Divine Comedy*, it is singularly difficult to identify a widespread visual culture of Purgatory-illustration. Such illustrations do exist, but they do not carry the force and conviction of the received tradition in medieval art of representing the binary opposition of Heaven and Hell, especially as grandiose monumental conceptions.

Most commonly, illustrations of Purgatory occur in illuminated manuscripts, usually Breviaries or Books of Hours, containing the Office of the Dead. In the great Parisian Breviary of Philip le Bel of *c.*1295, the Psalm used to open Vespers in the Office of the Dead is headed with an initial D for *Dilexi* (Psalm 114) and shows Christ in Majesty with cherubim, and beneath, in truncated form, souls being lifted up from flames by angels. This illustrates conventionally enough the content of the Psalm, whose subject is the delivery of the soul from torment:

I love the Lord, because he hath heard my voice and my supplications ... The sorrows of death compassed me, and the pains of Hell gat hold upon me ... Return unto thy rest, O my soul; for the Lord hath dealt bountifully with thee. For thou hast delivered my soul from death.

Similar subject-matter reappears, minus Christ, in an initial illustrating the text for All Souls in the mid-fourteenth-century Parisian Breviary of Charles v (d. 1380). Variants on this theme are also found in Offices of the Dead in fifteenth-century Netherlandish and French Books of Hours. An example from Holland of *c.*1435 confronts a performance of a Requiem Mass with an initial on the page opposite showing naked souls in flames, again in the D of *Dilexi*, a more or less classic illustration of the idea of Mass as a suffrage. Even more gorgeous is a representation of a Requiem Mass in a French Hours of *c.*1460 in which souls are released by angels from Purgatory, set miraculously in the crypt of the church, at the moment of the elevation of the Host; at the door a rich man hands out doles or alms to a pauper by way of mercy and charity. So here a joint suffrage is being performed, to which of course the reader's prayer, again that in Psalm 114, adds yet a third.

Another celebrated example is provided by panel painting: the Avignonese painting executed in 1453 by Enguerrand Quarton showing the Trinity crowning the Virgin Mary. Here the contract for the image explicitly required the inclusion of images of Purgatory and Hell beneath the Coronation. The image is remark-

Purgatory, in the late 13th-century Breviary of Philippe le Bel.

Souls released from the fire of Purgatory during the celebration of a Requiem Mass; at the church door, the suffrage of charity. Office of the Dead, from a French Book of Hours, *c.*1460.

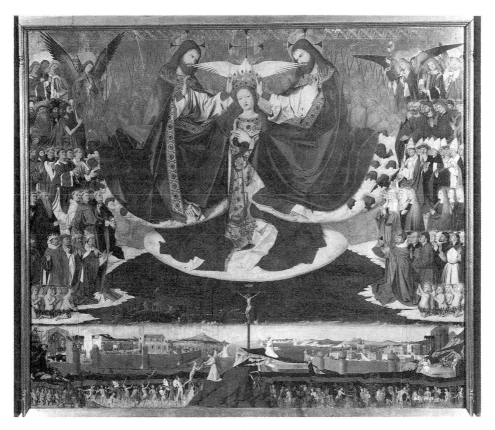

Coronation of the Virgin by the Holy Trinity, by Enguerrand Quarton, 1453–4. In this image made for Carthusian patrons, Purgatory is situated under Rome (bottom left) and Hell under Jerusalem (bottom right).

able for its landscape format. Beneath the Coronation is a Crucifixion, with Hell and Purgatory to either side, Hell being on the image's left or less honoured side. As in the *Dilexi* illustrations, souls, including those of popes and cardinals, are being freed by angelic agency from purgatorial torments. Above Purgatory is a representation of Rome. Opposite, beneath an image of Jerusalem, is Hell, eternally closed off. So here is a properly topographical commitment which, in a tradition going back to ancient Rabbinic literature, places *gehenna* or Hell under Jerusalem.

The absolutely concrete visualization of the afterlife in the vernacular verse *Divine Comedy* of Dante (d. 1321) represents a similar but fundamentally separate and specialized issue, which we can only approach briefly here. As in the later Avignonese panel, Dante conceives of the afterlife in absolutely coherent topographical terms which, though related to previous purgatorial visions, have their own logic. The earth, Hell and Purgatory are all terrestrial, and are all understood

within the basically Ptolomaic concentric model of the cosmos we examined earlier. Our world is in the northern hemisphere; Satan's abode is exactly at the centre of the world, where he fell with the rebel angels, and Purgatory is a nine-terraced mountain at the southern antipode, opposite Jerusalem (not Rome), shoved outwards like a vast cosmic molehill by the force of Satan's impact in falling. The earthly Paradise, located in the south and not, as on early *Mappae Mundi*, in the east, is on top of the Purgatorial mountain, and the celestial Paradise is above in the spheres. It is through this formidable landscape, which Dante vividly populates with the contemporary and long dead in one of the most devastating political and moral critiques in Christian literature, that Dante himself is led by guides – Vergil (who, being unbaptized, cannot mount above Purgatory) and later his beloved Beatrice, who takes him up to the Beatific Vision of the Empyrean. Now the beauty of this concept is that Dante presents it in such a way that it could be illustrated, and in fact about thirty illustrated manuscripts

Left Topography of Hell and Purgatory, after Dante. The centre of the earth is marked by Satan's hip (compare illustration on p. 171).

Right Dante, the Mountain of Purgatory with the earthly paradise on top, and the entry to Hell, with a portrait of Florence, in a fresco by Domenico di Michelino, Florence Cathedral, 1465.

of the *Comedy* survive from the fourteenth and fifteenth centuries which present not only his various specific and telling images of the torments and pleasures of the dead, but also diagrams illustrating the *Comedy*'s mapping of the afterlife. A large fresco commemorating Dante by Domenico di Michelino of about 1465 in Florence Cathedral demonstrates its scenic potential. But the matter of Dante was specialized in this sense: though illustrated Dante manuscripts account for a significant proportion of medieval Purgatory representations, their character is so precisely that of the poem that their representative value is doubtful. It is certainly a mistake to judge the progressive 'spatialization' of Purgatory in Dante's terms, and to see his text as the fulfilment of a long process towards the definition of a geographically coherent afterlife. Dante remains Dante, and the art he inspired is so cramped by his text, and so prone to imprisoning it in return, that it stands to one side of the fundamentally open system of purgatorial representation based upon orthodox doctrine.

Why, then, this more general late-medieval representational silence? We can attempt to answer this difficult question in broadly formal and functional terms. In the first place there was a fundamental problem with the idea itself: the doctrinal and dogmatic notion of Purgatory remained essentially nebulous, and

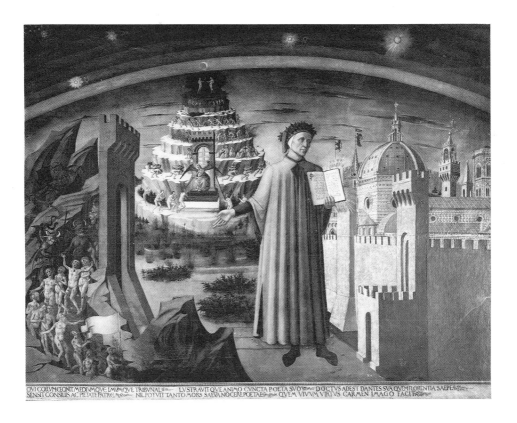

remained (the tendency to 'spatialize' Purgatory notwithstanding) essentially a state of being and not a place. As a dogmatic subject, Purgatory was never codified in terms that could be translated visually, and since medieval art was premised upon ideas of authority and tradition, the possibility of a distinct convention for its representation could not come into being except in very limited terms, typically the terms of small paired illustrations in the Office of the Dead illustrating the value of suffrages. Heaven and Hell also occurred frequently as part of eventful narrative illustrations of the Last Judgement, a context to which Purgatory, as a process, was unsuited, notwithstanding the fact that Purgatory was the most heavily populated space.

But though this lack of doctrinal clarity might have been a necessary condition for the lack of representation of Purgatory as a physical counterpart to Heaven and Hell, it was not a sufficient condition. Many late-medieval images have no prior textual or doctrinal validation, and there was a rich heritage of visionary literature concerning Purgatory which might have been useful, its apocryphal character notwithstanding. And this directs us to a deeper structural issue, over which the dialectic of medieval texts and medieval images reached an impasse: namely that many medieval images had their own rhetorical order and their own sense of place. As we have seen, the ancient eschatological binary pairing of Heaven and Hell – a received truth of medieval image-making – was, in theory, disturbed by the imposition upon this model of a third category, place or state. For some models of history and culture, like those advanced by Lévi-Strauss, Duby and Le Goff, the transition from binary to ternary models of thinking, whether about the three orders of medieval society, or the three orders of medieval death, marked a transition of fundamental cultural importance. We have already seen (p. 138) that some medieval images of the macabre, in implicating the third-party viewer in their basically binary thematic structure, mark a transition of this type, one characteristic of the viewer-responsiveness of late-medieval art.

Nevertheless, at heart, medieval picture-making itself tended to resolve into binary oppositions or pairs. This binary or dualistic system was fundamental to the expressive repertory of Gothic art, which emerged at the same time as the doctrinal formulation of Purgatory in the twelfth and thirteenth centuries. We can see this tendency in several spheres, notably the 'psychologizing' of the features of Gothic portal statuary from around 1250 into pairs of happy/good and sad/bad, as in the Wise and Foolish Virgins from the Judgement portal at Magdeburg Cathedral. Medieval art, in other words, was based upon a binary rhetorical order of absolute distinctions, in which the bodily form stood as a metaphor for the soul: expressive dualities were moral dualities. As we saw in

Right St Michael weighs the souls, west portal, Bourges Cathedral, mid-13th century.

considering the macabre, Thomas Bradwardine thought in terms of visual extremes in considering the nature of memory and the way images could impact upon it. The notion of intermediary expressive (or moral) states required by a ternary model was thus hard to reconcile with this rhetorical order. On the great west facade Last Judgement at Bourges Cathedral, this binary opposition of the saved, smiling complacently with satisfaction, and the grimacing damned represented a perfectly integrated aesthetic, rhetorical and theological order quite capable of dealing, as in the early thirteenth-century Psalter of St Louis, with a binary afterlife of Hell and Abraham's Bosom, and the elementary distinctions of left and right derived from the Psalms. Even macabre mirror-images follow suit. This rhetorical problem of a 'centred' ternary system was in

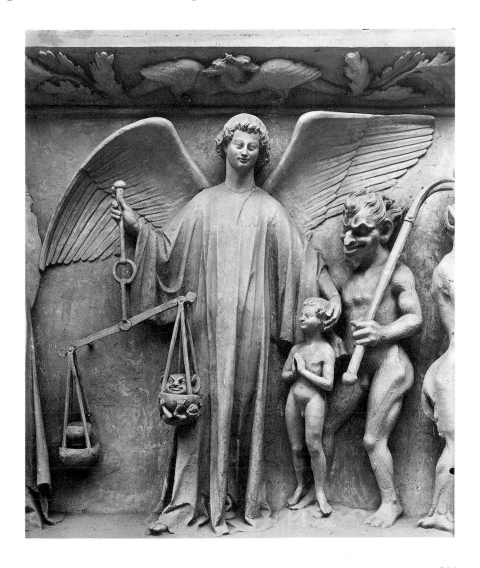

a sense implicit in thought about Purgatory between the time of Gregory the Great and Aquinas, even Dante: was it an upper Hell, was it infernalized; or was it a lower Heaven, was it celestialized? – the question itself reveals the quandary of two ideas colliding with three. How, in short, was Purgatory to be distanced usefully from the opposition of Heaven and Hell, such that its representation as part of the incentive system of medieval images could be plain and unambiguous?

One solution to this structural problem was to focus ideas of the afterlife onto isolated motifs. A means of illustrating intermediate conditions was through colour: Aquinas noted that sin resulted in a stain, or *macula*, on the soul, and so the state of a soul could be judged by its brightness, or proximity to God. The idea that ghosts are grey or black may descend from this basically purgatorial notion of the cleansing of the moderately bad soul. But this idea was never really represented, and the most common motifs used instead illustrated the tendency in medieval art – the Italian development of landscape painting notwithstanding – to deploy non-continuous spaces, consisting of receptacles or isolated attributes. In Purgatory's case this involved motifs like the bridge, the ladder and so on, many of which are liminal or linking images which carried into high medieval art ideas of ascent and ordeal: these were metaphors of system, of process and

Bridge of Hell, from the early 14th-century *Vision of St Paul.*

The Last Judgement with the ladder and bridge, early 13th-century wall-painting, Chaldon, Surrey.

transition, but not of place. The motif of the bridge crossed by souls from Hell to Heaven occurs in the Apocalypse of Paul and the *Dialogues* of Gregory the Great, in *St Patrick's Purgatory* and Dante. In some instances the souls fall off the bridge into a flaming river and so are cleansed, assimilating the motif to the progess of Purgatory; and so the bridge becomes an attribute of purgation, as in the vision of Thurkill as recorded by Roger of Wendover at early thirteenth-century Saint Albans. Another linking motif of precariousness was the ladder, derived from Jacob's dream in Genesis 28. This could stand both for the ordeal and for a Neoplatonic notion of intellectual ascent and worldy renunciation. It occurs in the early *Passion of Perpetua* and in the thoroughly monastic *Scala celestis* of John Climacus, the seventh-century abbot of Mount Sinai, itself a metaphor of spiritual ascent for the Greek Church. Numerous medieval illustrations of souls clambering up to Heaven on the ladder, and dragged down to Hell by their vices, followed. A fine early thirteenth-century representation of the Last Judgement in a wall-painting at Chaldon in Surrey combines both the bridge and the ladder motifs. Above are the weighing of souls by St Michael and the Har-rowing of Hell, the emptying-out of Limbo by Christ. Beneath are Hell and the bridge of souls, and the two stages are linked by the ladder with souls falling and ascending. Chaldon, painted probably before the formal exposition of the doc-

trine of Purgatory, illustrates the spatial incoherence which arose from the syn-thesis of these diverse and basically independent metaphors which implied no overall spatial or topographical context: it cannot be described as a diagram of the ternary afterlife. This conceptual patchwork should be separated from iso-lated visions like that granted in the twelfth century to St Bernard while in Rome, of souls ascending a ladder to Heaven assisted by prayer, the basis of a later indulgence called the *Scala Coeli*.

But more deeply, the representational silence about Purgatory touches most upon the very function, purpose and character of medieval image-making. At heart the question was one of the ends and means of images themselves. The old binary eschatological system promoted a rhetorical, exhortatory vision of the afterlife as an incentive; it was an art of ends, of goal-orientation, best rep-resented by the monumental sculptures of the Last Things on the portals of great churches. But Purgatory was not an end; rather it was a means of obtaining something else, namely the goal of Paradise. Purgatory was instrumental in character. It was a supplement to the pre-existing incentive system of represen-tations. And this led to an important area of indistinctness which characterizes much late-medieval image-making. For this image-making was itself premised upon an instrumental idea of the role of art; the function of art, whether images or tombs, was increasingly geared from the thirteenth century towards providing a means by which salvation might be gained. A typical instance of this new instrumentality of images was the practice of indulgencing certain texts and rep-resentations, in such a way that their use by the viewer might actively contribute to their passage through Purgatory. The indulgenced prayer which Innocent III composed for the Veronica, the Roman image-relic of the face of Christ, is a standard instance of this practice: that is why Chaucer's Pardoner had the 'ver-nicle' or Veronica attached to his cap. Innocent IV yielded an indulgence of three years to those saying the prayer *Ave facies preclara*. Many later-medieval devotional images of this type, which focus upon the somatic character of Christ's human nature, perform this function. Images like this acted as a form of displacement, whereby their end, the spiritual education of the soul, was hidden or rendered only implicit in the means of their use. Purgatory too, as we have seen, was itself a form of further education, education by cleansing and 'knowing' fire. The macabre was in a sense part of this development as well, since it displaced the incentive of the final ends of salvation onto the image of Death itself.

This reveals why a stress on the notion of Purgatory as a place, as argued by Le Goff, is in some ways unhelpful. The doctrine of Purgatory had instead helped to bring about a far more ambitious and brilliant manoeuvre than its mere spatialization or representation: it had insinuated itself into the very process of image-making itself, and into the very fabric of its use and understanding. As an instrumental doctrine, Purgatory implicated all institutions, mobilized all images:

to commission, make and use an image was to participate in the education of the soul. Purgatory was at one level nowhere, and yet, in the realm of medieval art, it was everywhere.

One authority has written as follows:

Punishment, then, will tend to become the most hidden part of the penal process. This has several consequences: it leaves the domain of more or less everyday perception and enters that of abstract consciousness; its effectiveness is seen as resulting from its inevitability, not from its visible intensity; it is the certainty of being punished and not the horrifying spectacle of public punishment that must discourage crime . . . it is the conviction itself that marks the offender with the unequivocally negative sign: the publicity has shifted to the trial, and to the sentence; the execution itself is like an additional shame. Justice is relieved of responsibility for it by bureaucratic concealment of the penalty itself . . . And beyond this distribution of roles operates a theoretical disavowal: do not imagine that the sentences that we judges pass are activated by a desire to punish; they are intended to correct, reclaim, 'cure'.

The writer is not a medievalist at all, but Michel Foucault, writing about crime and punishment, and the disappearance of public executions, in the modern period. But his text well (if inadvertently) expresses the quandary and the dynamics of Purgatory as a collective representation. For here was a means of reclaiming those tainted by sin or crime, which at the same time involved a near-total suppression of any dramatization of the outcome of those sins or crimes; instead of Purgatory being illustrated, its nature as a state or place, and in a sense its true horror, was hidden and internalized. Its real force lay in the subjective religious imagination rather than the external visualization of artists. Purgatory left the field of everday perception and entered the realm of abstract, interiorized, consciousness: it was the final pilgrimage of the mind. And related to this was an act of disavowal on the part of the institution which governed the mechanisms of sin, the Church, whereby a massive relativization of sin was offered by the Church, in return for the laity's acceptance of its power of binding and loosing. Spiritual mediocrity was now tolerated and negotiated by the Church in exchange for its control over the rights of the soul, for: 'From being an art of unbearable sensations punishment has become an economy of suspended rights' (Foucault) – a suspension of the right to experience the Beatific Vision before the Resurrection, which only the Church could undo.

The Last Things: Resurrection

The notion that at the end of time the dead would undergo bodily resurrection and would see God is deeply rooted in the Judeo-Christian tradition. Christ himself of course resurrected physically after His death. In the Office of the Dead we read from Job 19:26: 'For I know that my redeemer liveth, and that he

shall stand at the latter day upon the earth: and though after my skin worms destroy this body, yet in my flesh shall I see God.' In Ezekiel 37 we read of the valley of dry bones to which the Lord says: 'Behold, I will cause breath to enter into you, and ye shall live.' Isaiah 40:5 says: 'And the glory of the Lord shall be revealed, and all flesh shall see it together.' The Gospels affirm this message, in Matthew 22, Luke 14:14 and John 5:28: the hour is coming when all those in their graves shall hear God's voice and shall come forth to the Resurrection of life, or the Resurrection of damnation. Christ's account of the final Judgement in Matthew 25 is not explicit on the importance of the Resurrection, since the Judgement is envisaged as the gathering of the nations before Christ as the Son of Man. But the Book of Revelation, Chapter 20, is clear: there will be two resurrections, that of the blessed and that of mankind in general:

And I saw the dead, small and great, stand before God; and the books were opened: and another book was opened, which is the book of life: and the dead were judged out of those things which were written in the books according to their works. And the sea gave up the dead which were in it; and death and Hell delivered up the dead which were in them ... And whosoever was not found written in the book of life was cast into the lake of fire.

Though, as we shall see, representations of the Apocalypse and Last Judgement were technically distinct, the character of the Resurrection and Last Judgement was based upon all these texts. St Paul, in 1 Corinthians 15, stresses the absolute centrality of the Resurrection:

But if there be no resurrection of the dead, then is Christ not risen: And if Christ be not risen, then is our preaching vain, and your faith is also vain ... For since by man came death, by man came also the resurrection of the dead. For as in Adam all die, even so in Christ shall all be made alive.

And so the belief was incorporated in the Apostle's Creed and restated regularly, as in the canons of the Fourth Lateran Council of 1215.

But to the medieval mind, prone to concrete belief, this doctrine required clarification. Book Four of Peter Lombard's mid-twelfth-century *Sentences* is, and was, a standard reference-point for the difficulties the idea raised. Book Four is devoted to eschatological issues: to the sound of the last trump, to the reassuringly practical question of whether those who are alive at the moment of its sounding have to die in order to be resurrected, to the age and gender of the resurrected body, to the state of the bodies of the damned, and also to the exact circumstances, the when and where, of the events narrated in Matthew 25 and in Revelation. The concerns here are absolutely material, even scientific, in their minutiae. What happened to cannibals, whose bodies were made up of other people; what, asks Aquinas, of the state of a man who ate only human embryos, who generated a child who only ate human embryos?

These debates were in no sense pin-headed; they were as practically important

as the definition of Purgatory as a state or a place, and they touched such day-to-day matters as the status of relics or the nature of the body and blood of Christ at the Mass. At heart they touched the issue of what human identity really is, what we are, and whether we can ever stop being ourselves. The modern secular answer is unequivocal; we are our bodies and we have no soul. Perhaps surprisingly, the medieval Christian answer, in so far as there was a single answer, was much the same, except that the existence of the soul was unquestioned. In arriving at this, medieval thought had brought about a sophisticated concoction of pagan natural philosophy and Christian doctrine. In the twelfth and thirteenth centuries especially, the medieval mind found itself grappling with the phenomenal complexity of theories of matter and form derived primarily from Plato and Aristotle, theories we call 'hylomorphism'. Platonic theory, which, in its impure late guise of Neoplatonism had provided the foundation of medieval philosophy, was basically dualistic: physical matter was in a state of endless protean transformation but it was shaped or 'informed' by transcendant and entirely stable universal forms, God's Ideas. Aristotelian theory, which was recovered in the thirteenth century, though also dualistic, linked form and matter much more closely; in fact the two were inextricable. So here were two interrelated models of the material world whose importance could readily be transferred to the concerns of a body-centred religion, to relics, to the Host, and to the body and soul, the matter and form of the person. Notwithstanding their subtle differences of emphasis, both were assimilable to Christian doctrine. A thirteenth-century Franciscan intellectual like St Bonaventure, acquainted with both Neoplatonism and Aristotelianism, could say that the soul was itself material, but made of spiritual matter: soul and body were both essential to the person because the material body satisfied the natural appetites of the soul. His Dominican contemporary Aquinas could shift the emphasis away from appetite towards intellect: though the soul is immortal and does not need the body for its existence, the body is required because its senses are vital to the soul's understanding or intellect. The disembodied soul between death and resurrection is thus in a profoundly unnatural state. The beauty of these deliberations is that, notwithstanding their immense sophistication, they could yield a rationale, a scientific validation, for the Christian revealed truth of the Resurrection.

And of course they affected ideas of selfhood. The person amounted to a union, albeit a hierarchical one, of body and soul; if the body alone did not define the person, neither did the soul. As Aquinas said, 'I am not my soul, and if only souls are saved, I am not saved, nor is any man.' Herein was a principle of justice: that the soul alone should not be punished for the sins of the flesh, and that the full effect of judicial retribution, or indeed of bliss, required both at the Last Judgement. St Bernard remarked that 'The sick, dead and resurrected body is a help to the soul that loves God'; their union was the consummation

of what it meant to love God fully. Bodily resurrection was thus a matter of moral necessity, in demonstrating not only the course of divine justice, but also the power of divine will to 'inform' all things. St Bonaventure extended this perfectly logically to account for the new doctrine of the bodily Assumption of the Virgin Mary into Heaven, already depicted in twelfth-century art:

Her happiness would not be complete unless she [Mary] were there personally . . . the person is not the soul, it is a composite . . . the minds of the saints are hindered, because of their natural inclination for their bodies, from being totally borne into God.

The consequences of this for other practices were widespread. If the body was naturally required by the soul to ensure its bliss, it made sense for the saints to pray for us and so speed up the completion of the elect in Heaven which pre-saged the Last Things; Resurrection thus aided intercession, because the saints needed and wanted their bodies. The belief that part of a body stood for the whole, which affected relics and the Mass, was also implicated. Did the resurrected body have to be identical to the original body? Were all transformations of matter, like God's creation of Eve from a rib of Adam, essentially miraculous? What 'informed' the dead body once the soul had left it? If nothing but the form of the body itself, what were the implications for Christ's own Resurrection? If Christ's body was not his 'real' body, then he could not have lain in the tomb for three days, and the relics of the saints were not actually the saints at all. The relationship of the body and soul also concerned anxieties about bodily division which I considered in the first chapter. Boniface VIII seems to have made no explicit theoretical claim as to the threat post-mortem division entailed for the person, but clearly if the body was necessary to the soul, then anything which hindered its coherent physical resurrection was undesirable. As we saw in looking at the politics of the body in the critical period towards 1300 in the first chapter, the metaphysical character of relics posed problems: could one have bodily relics of Christ like the Holy Blood which seemed to subvert the idea of His perfect and total Resurrection? Were relics, following Augustine, simply empty signs which recalled the memory of their original owners, to be revered not for what they were, but for what they represented?

The implications for images were also important, since these too represented the working of matter by form. What was an image? How did images relate to conventional doctrine? The issue of whether beasts which had devoured men would have to be resurrected in order to vomit up the human matter for the sake of its own resurrection, condemned even by Tertullian, was vigorously addressed in the twelfth-century Byzantine-influenced mosaic on the west wall of the cathedral of Torcello near Venice, where the Last Judgement issues in a vast cosmic regurgitation, and in similar vein in the *Hortus Deliciarum* of Herrad of Hohenbourg. More fundamentally, such questions affected the rhetoric and

doctrine of images. French twelfth-century sculpted portals, like those at Senlis and Mantes Cathedrals, present entirely material illustrations of the Assumption of the Virgin Mary's body prior to her Coronation by Christ in Heaven. The stupendous naturalism of some thirteenth-century French Gothic art seems to answer to the debate about the unicity of the body and soul in its expressive language: the body is the seat of the senses and the basis of selfhood, and in order to lend Christianity force and coherence, it could lend to art, and to the senses of the viewer, a new persuasiveness: that of the somatic character of late-medieval devotion and imagery we have mentioned before. The thirteenth-century Last Judgement on the west facade at Bourges, which I mentioned earlier in connection with the binary rhetorical language of Gothic images, incarnates poetically the notion of the bliss of the soul reunited with its body in the smiles of the saved, and the correspondingly vivid pangs of the damned. Thirteenth-century edifying literature like *La Lumière as Lais* emphasized the importance of sense-possession to the blessed. Dante's approach in the *Divine Comedy* (notably Canto 25 of *Purgatorio*) is similar. Following Aristotle and Aquinas on the soul and intellect, Dante saw in the unicity of body and soul the key to his idea of retributive justice as well as eternal bliss; before their reunion each was exiled from the other (and the *Comedy* is a text on exile). Canto 20 of *Purgatorio* stresses that the spiritual Heaven before the Last Judgement is provisional. In Canto 14 of *Paradiso* Dante accordingly remarks:

> When our flesh, then glorified and Holy
> Is put on us once more, our persons will be
> In greater perfection as being complete at last.

Beasts regurgitate the dead at the Last Judgement, mosaic, west wall, Torcello Cathedral, 12th century.

The Assumption of the Virgin, west portal, Senlis Cathedral, *c.*1170.

Face to Face with God

And so, with the body imprisoning the soul, and the soul imprisoning the body, we come to the Last Things. The notion of a cataclysmic final Judgement was not unique to Christianity; in fact the theme of post-mortem Judgement had wide currency. Some of the best examples were produced in ancient Egypt from the third millenium BC onwards, such as the *Middle Kingdom Coffin Texts* and the *New Kingdom Book of the Dead*. Egypt developed the idea of the weighing of souls on a set of scales by an entity called Thoth, the equivalent of St Michael who weighed the souls at the Last Judgement in the so-called *psychostasia*. In Christianity, the key texts were St Matthew's Gospel and the Book of Revelation. In Matthew 24, Christ answers his disciples' question about the end of the world, answering that the quick and the dead will be separated with devastating speed:

Then shall appear the sign of the Son of Man in Heaven . . . and they shall see the Son of Man coming in the clouds of Heaven with power and great glory. And he shall send his angels with a great sound of a trumpet and they shall gather together his elect from the four winds . . . verily I say unto you, This generation shall not pass till all these things have been fulfilled.

Matthew 25 starts with Christ's parable of the Wise and Foolish Virgins: the wise ones have oil in their lamps and are prepared for the arrival of the bridegroom (i.e. Christ) at the wedding, while the foolish ones have no oil and so have the door of the celebration shut in their faces. The designers of medieval portals

readily picked up this liminal theme in alluding to the image of Christ as the Way, the Truth and the Life, or as the Door (John 7). St Matthew continues:

When the Son of Man shall come in his glory, and all the holy angels with him, then shall he sit upon the throne of his glory: and before him shall be gathered all nations: and he shall separate them from one another, as a shepherd divideth his sheep from the goats. And he shall set the sheep on his right hand, but the goats on the left ... then he shall say also unto them on the left hand, Depart from me ye cursed into everlasting fire, prepared for the devil and his angels ... and these shall go away into everlasting punishment: but the righteous into life eternal.

We have already cited a text from Revelation 20, the other major source, concerning the two resurrections. Revelation 21 proceeds to list those who will be condemned:

But the fearful, and unbelieving, and the abominable, and murderers, and whoremongers, and sorcerers, and idolaters, and all liars, shall have their part in the lake which burneth with fire and brimstone: which is the second death.

It was on the basis of such texts that the Christian faith founded its creeds. The so-called *Quincunque vult* or Athanasian creed, which echoes the left–right imagery of the Psalms, states:

[Christ] suffered for our salvation, descended into Hell and rose again on the third day from the dead. He ascended into Heaven, He sitteth on the right hand of the Father, God Almighty: from whence He shall come to judge the quick and the dead. At whose coming all men shall rise with their bodies: and shall give account for their own works. And they that have done good shall go into life everlasting: and they that have done evil into everlasting fire.

As a subject-matter for monumental art, the imagery of Matthew and Revelation, in various combinations, was stunningly successful. But its emergence as one of the characteristic topics of medieval public art was gradual. Christianity had inherited from Judaism an apocalyptic inflection which derived from texts like those of Ezekiel and Daniel, and its early reference to Matthew's text was limited. The Last Judgement, however, was at first treated metaphorically, or through a kind of pictorial compression; thus in the catacomb of St Cyriaca the parable of the Wise and Foolish Virgins stands for the whole narrative, stressing its central message of preparedness and uncertainty. By the sixth century, as in the mosaics of S Apollinare Nuovo at Ravenna, the subject occurred in monumental form with Christ dressed in imperial purple separating the sheep and the goats. But the essential character of the Last Judgement as a court-room drama also required the emergence of a more fully organized penitential culture, which could explore its spiritual implications more comprehensively. This idea was already apparent in sixth-century texts like the sermons of Caesarius of Arles. But what we recognize as the medieval type of Last Judgement only appeared in the ninth century, in the art of the Carolingian Franks. By then the intertextual character of the

Last Judgement, drawing on both Matthew and the Apocalypse for its ideas, was becoming apparent. A ninth-century Anglo-Saxon ivory of the scene produced under Carolingian influence already includes the text *Venite benedicti patris mei* (Come ye blessed of my father) later found on the fine Last Judgement sculpture of the west facade of the Abbey of Saint-Denis, near Paris. Other elements, like the mouth of Hell, were already current in Carolingian Psalm illustration, as we saw earlier. Again, liturgical performances of plays like the eleventh-century *Sponsus*, based on the Wise and Foolish Virgins, contributed gradually to the formalization of the Last Things.

By the late eleventh and twelfth centuries the object of this formalization, namely the appeal to the Last Judgement as the final incentive for self-improvement, appears regularly, as in St Anselm's *Meditation to stir up fear* – 'Alas, wrath of the Almighty, do not fall upon me . . . there is the terror of judgement. Below the horrible chaos of Hell lies open, above is the wrath of the judge' – and in St Hugh's words to King John before the portals of Fontevrault. Here the late medieval practice of deploying images as imaginative resources for developing the higher faculties of moral, spiritual and social reasoning was already appearing. St Hugh used the Last Judgement as a moral *exemplum* on the theme of bad rule, in the fashion of narratives of the bad death I examined earlier in this book (pp. 47–50). Aelred of Rievaulx recommended imagining the Last Judgement in the same way as the slightly later Lay Folk's Mass Books. For this reason many parish churches adorned the wall over the rood screen, at the division of the nave from the chancel, with the Doom: the central messages of Redemption and Judgement were thus ever before their eyes in an imagery of means and ends.

Church portals, as the metaphorical entries to Paradise, were the most telling positions for this subject, and the Carolingian heritage of formalized Last Judgements found grand counterparts in the imagery of French Romanesque and Gothic churches erected during the building boom of the twelfth and thirteenth centuries. As we might expect, the potential of architecture to attract symbolic readings was developed by Carolingian intellectuals like Hrabanus Maurus, author of *De universo*, the first Christian encyclopedia, whose preface, dating to the 840s, is addressed to Charlemagne's son Louis the Pious. Here Hrabanus offered remarks on the symbolic nature of things and on their 'mystic signification'. Columns in Christian buildings could be mystically understood in anthropomorphic terms:

They stand for the apostles and all the spiritual doctors, raised up towards the heavens and strong in faith and works and meditation . . . For the door of the Temple is the Lord: because no-one comes to the father except through Him (John 14) . . . Because the columns clearly stand at either side of the door, with the help of the text they show the entry of the Kingdom of Heaven.

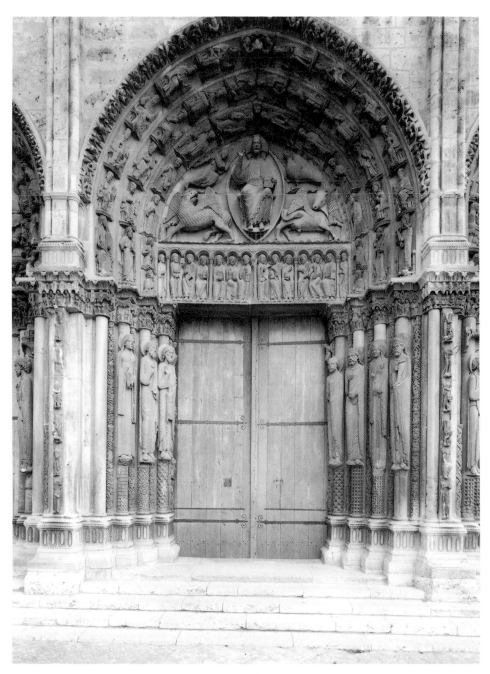

The apocalyptic vision, west portal, Chartres Cathedral, *c.*1150.

When juxtaposed with the imagery of Revelation 4, in which occurs the great vision of God seated on a throne with the twenty-four elders and the four beasts, Hrabanus' style of commentary brings to mind nothing so much as the great entrances on the west facade of Chartres Cathedral of *c.*1150 with their throng of royal and saintly witnesses framing the portals, strong in faith and works and meditation, and the Revelation of God in the guise of Christ with the beasts, above. Chartres' great west front is explicitly Apocalyptic in its grandiose tranquillity, and stands as one of the last representatives of purely Apocalyptic material in such a context; Moissac, whose imagery of Dives and Lazarus I have already mentioned, is a slightly earlier representative of this outlook.

As the imagery of Gothic portals reached its greatest elaboration in the early thirteenth century, the Apocalypse as a source was displaced by the more textually complex Last Judgement. This process was already beginning in Romanesque portal displays like those at Conques, Beaulieu, Autun and Lincoln, but it attained its first truly systematic form on the west facade erected by Abbot Suger at Saint-Denis, in the 1130s, just prior to Chartres. Suger's facade was in some respects even more self-consciously triumphalist than that of Chartres. Its three portals were adorned with bronze inscriptions, bringing to mind nothing so much as Roman triumphal arches, examples of which were found throughout Gaul. Like Chartres, they had a modern-looking complement of jamb statues framing the doorways. But at Saint-Denis the imagery, though influenced by some elements from Revelation, was drawn much more directly from Matthew: the Wise and Foolish Virgins frame the central doorway beneath Christ's appearance separating the blessed and the damned, who pass respectively to Abraham's Bosom and to Hell on the round archivolts of the doorway. St Peter presides with the Apostles as a celestial bouncer, and Suger's own image is to be found just beneath that of the judging Christ, overlapping his mandorla; nearby was an inscription with Suger's supplication, 'Grant that I be mercifully numbered among Thy own sheep.' In its dispassionate orderliness, Saint-Denis represented a paradigm of modernity. Like the Last Judgement portals at Conques and Autun, it makes free play with Latin inscriptions, sealing off its inner mysteries from the unlearned; but unlike the ornate expressivity of the Romanesque examples, the art at Saint-Denis is more that of the metalworker in its smooth surfaces, integration of ideas, and suppression of gratuitous horror. The transition to Gospel-derived imagery of this type was complete by about 1200: at Chartres, the new south transept of the cathedral erected after 1194 was given a full programme of Last Judgement imagery in the Saint-Denis manner, and doorways of this type were designed at Reims, Amiens and Bourges.

Here, then, was a clear adjustment in the eschatological character of medieval public imagery which corresponded closely to the choice of the Last Judgement for massive interior decorations, like those of the mosaics at Torcello, Cavallini's

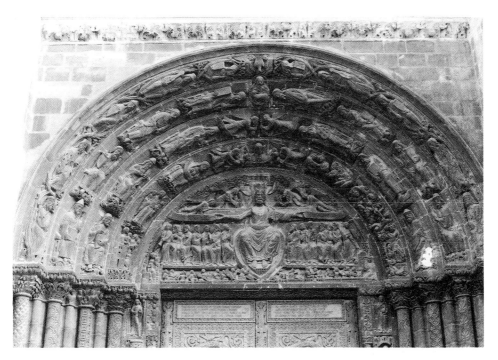

The Last Judgement, west portal, Saint-Denis, *c.*1140. Souls are brought 'face to face' with God in the archivolts above the tympanum.

late thirteenth-century frescos at Sta Cecilia in Rome and Giotto's Last Judgement at the Arena Chapel at Padua of *c.*1305. Suger's presence as patron and donor on the west front of Saint-Denis, as in the stained glass windows within, exemplifies the new trend of eschatological thinking towards stressing the particularity of judgement, and hence its negotiable and merciful potential. Enrico Scrovegni appears in a similar position as donor at the Arena Chapel, and the inclusion of the name of the sculptor Gislebertus beneath the Last Judgement at Autun represents the way in which artists too could inscribe themselves into the army of the saved, like William de Brailes, who depicts himself on the side of the blessed in a mid-thirteenth-century miniature of the Last Judgement. Gestures of this type by patrons and artists illustrate the role that the doctrine of intercession (which had been marginalized by more communal and transcendent Apocalyptic material) could play in Last Judgement images. It was this doctrine, based on the legalistic idea that the elect could intercede for the souls of the worthy on their behalf before God, that lent absolute coherence to the portal as an ensemble of mystical images and representations of the elect. Here the cult of the very special dead, the cult of the saints, increasingly represented in narrative and symbolic form on the portals of Gothic churches, attained its demotic and triumphalist climax. Portals like those on the transepts of Chartres, with their arrays of

apostles, martyrs and scholars headed by St Peter with the keys to these same doors, represent the historical victory of the church as richly as contemporary episcopal tombs: here the power of binding and loosing from sin is made flesh. The Virgin Mary's role as *mediatrix*, having direct access to the ear of the God she suckled, was celebrated in Byzantine art and in contemporary Latin devotional literature written by St Anselm and St Bernard. She occurs in this role at Autun and at Saint-Denis. And her presence, either as a specific subject of devotion on the facades of those great cathedrals dedicated to her, or, with St John the Baptist or St John the Evangelist, as an intercessor before Christ the Judge, is felt throughout Gothic art.

But the doctrine of intercession was still presented in these schemes within a basically binary eschatology, and it would be rash to see in those instances where specific privileged individuals include themselves in the Last Things, any suggestion that art of this type was the product of a new sense of the individual. We could equally well argue that images of this type were actually constructing a new notion of individuality. Nor, despite their conceptual coherence, do these images register the range of opinion about the tripartite afterlife current in contemporary thought. The continuing presence of Abraham's Bosom as the resting place or receptacle for souls after Judgement is a sign of this conceptual inertia. The problem with Abraham's Bosom was really twofold. According to commentators like Petrus Comestor, Abraham's Bosom was in the upper reaches of Hell. It formed the so-called Limbo of the Patriarchs where the worthy unbaptized resided after death – Adam and Eve, the patriarchs and prophets of the Old Testament, Lazarus, and so on – which had been emptied and closed by Christ when he descended into Hell. The idea that Christ visited Hell between His Death and Resurrection was affirmed in a variety of texts – the creeds of the Western Church, the Acts of Pilate and the so-called Gospel of Nicodemus – and from the seventh century was visualized in the so-called *anastasis*, or Harrowing of Hell (PL. x), a solution both to the issue of what happened to the worthies of the Old Testament, and to the representation of Christ's own Resurrection. Christ's barging down the doors of Hades was in a sense his first significant judgement of the dead. But the emptying of the Limbo of the Patriarchs in theory left open only the Limbo of children, namely unbaptized infants. How then could Abraham's Bosom be occupied by the baptized Christian in the state between death and judgement?

Second, in what sense could this supposedly interim state be said to represent the outcome of the Last Judgement as a symbol of Heaven, as indicated on the portals? It was only slowly, by the fourteenth century, that the redundancy and inconsistency of Abraham's Bosom as a metaphor was felt, and not uncommonly, as on the brass of Lawrence Seymour at Higham Ferrers, Christ's own figure was eventually substituted for that of Abraham. But this only exposed a further

problem: how could the soul of the ordinary sinner be commended directly to Christ and experience his presence? Was this experience not reserved for the elect after the Last Judgement, or was there some prior judgement of a provisional sort which decided who was to be allocated to the new tripartite afterlife – and if so, when did this judgement occur? These questions became a matter of serious speculation only by the fourteenth century, and answers to them were implicit in many images of the period.

Representations of the *Commendatio animae* on contemporary tombs seemed to imply some direct experience of what was known as the Beatific Vision, as Abraham was replaced by Christ. So much is suggested by the image of the dying man in the Rohan Hours whose soul comes 'face to face' with the Godhead. Last Judgement representations could be individualized. The effigy of Bishop Walter Stapledon at Exeter looks up to a painted image of the judging Christ,

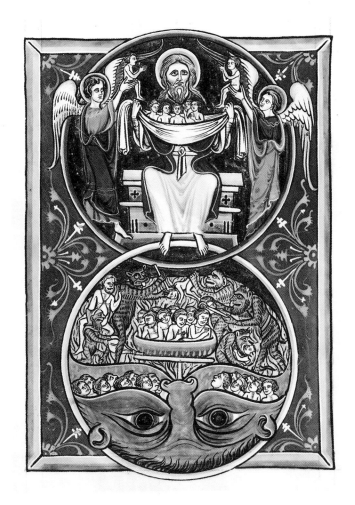

The Bosom of Abraham, from the Psalter of St Louis and Blanche of Castile, early 13th century.

and a similar representation was painted by Maso di Banco on the back wall of a tomb of a member of the Bardi family in Sta Croce in Florence, who is shown resurrecting by himself. The *Ars moriendi* texts implied some direct preliminary judgement at death. Here then were two concurrent ideas of eschatology: the universal one of the Last Judgement, and the personal one of the initial process of selection.

But images were surprisingly fluid and lacking in rigour, partly because the issue of post-mortem judgement was itself a fluid doctrinal issue. In principle the issue was clear: the direct experience of the face of God was reserved only for baptized and blessed Christians. Augustine makes this clear in his exposition of Exodus 33 in which God forbids Moses to see His face with the words, 'Thou canst not see my face: for there shall no man see me, and live': the true nature of God was only revealed under the Christian dispensation. But the nature of this revelation was still complex. St John's Gospel 1:18 says that, even though the New Law had replaced the Old, 'No man hath seen God at any time; the only begotten Son, which is in the bosom of the Father, he hath declared him.' This statement had implications for the metaphysics of the Holy Trinity, since the first person, the Father, could only be attained by means of the second, the Son. On the Last Judgement tympanum at Saint-Denis, a centre of notable visual speculation on the nature of the Trinity, this doctrine is clarified by God being personified holding His son before Him in the guise of the Lamb above the Last Judgement, and receiving two souls borne up by angels from the scene below. This follows Augustine's essentially Neoplatonic thinking on the Trinity, in which the Beatific Vision of God appears only after the Last Judgement. But as to the exact sequence of events the Fathers of the Church were divided. Augustine followed the Book of Job and St Paul in asserting that the final vision followed the Last Judgement, and was available only to the resurrected and blessed. To him, as to Suger at Saint-Denis, the intellect ascended to its final understanding of God. But other thinkers like St Ambrose and St Gregory stated that the Beatific Vision was directly accessible to the blessed, that is the saints, immediately upon death. In 1241 the Bishop of Paris and the faculty of theology at the university of Paris stated that the Beatific Vision was reserved for glorified souls and not bodies: in other words, it was accessible after the cleansing of Purgatory, but before the Last Judgement. St Bonaventure agreed. So by 1300 there were three possible solutions to this quandary: the Beatific Vision occurred to the blessed after death, after Purgatory or after the Last Judgement.

In arriving at a logical final statement on this issue, the Church also had to balance these authorities against the bulk of medieval belief about the doctrine of intercession and the role of Purgatory, which was now growing rapidly in importance. How were all these beliefs to be coordinated? The issue came to a head in a series of sermons in 1331–2 by Pope John XXII, based at Avignon.

John went against the authority of Paris by stating that nobody, not even the blessed, obtained the Beatific Vision until after the Last Judgement. Christ was accessible before, but only in His human rather than His divine form. John's position was related to that of St Augustine, who stated that at the Last Judgement the blessed could see Christ's divine nature, the damned only His human nature; the essence remained the same, only the perception differed. But here the 'Catch 22' of medieval theology made itself felt; postpone the Beatific Vision in this way even for the saints, and you undermine the power of the saints to intercede, and so cancel out not only the doctrine of intercession but also the host of images based upon it. Split Christ's humanity from His divinity, and you

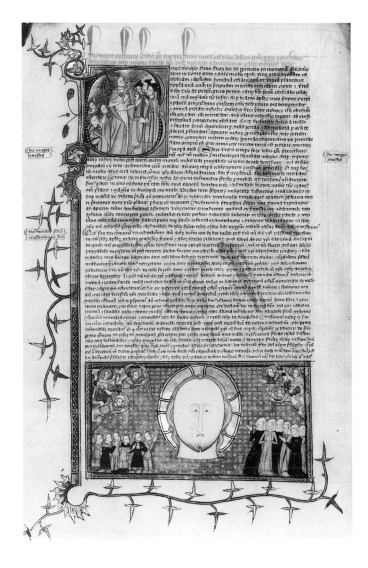

The Bull of Pope Benedict XII on the Beatific Vision, from the mid-14th-century *Omne bonum* encyclopedia.

restate the heretical belief of the Cathars that Christ had two separate natures. John's sermons, understandably enough, were quickly challenged. The King of France held a conference on the issue at Vincennes which restated the doctrine of the Bishop of Paris advanced in 1241: the Beatific Vision was indeed available to the souls of the cleansed after Purgatory, or directly to the saints, but before the Last Judgement. The intercessory power of the French royal saints was thus restored. Pope John recanted, and in 1336 Pope Benedict XII, who had earlier led an inquisition against the Cathars in France, issued a Bull, *Benedictus Deus*, which enshrined this belief in dogma. The Beatific Vision occurred to the just before the Last Judgement.

Benedict's Bull thus happily reinforced the doctrines of intercession and Purgatory. But inevitably it subverted the point of the Last Judgement. If the blessed had already been chosen and admitted to God before even the Resurrection, the Last Judgement could offer no more than a stamp of approval; it became a formality. In this decision lay the seeds of the final decline of Christian eschatological art into an art of instrumentality, an art premised upon sophisticated means rather than upon the necessity of final judgement. And this process is perfectly demonstrated by a series of illustrations of the Beatific Vision in the earliest alphabetical encyclopedia, the *Omne Bonum*, drawn up and illustrated by an English exchequer clerk, James le Palmer, in the mid-fourteenth century. Answering to the new fashion for indulgenced relics of the Holy Face or Veronica, the Beatific Vision is illustrated by a gigantic moon-like face of Christ appearing in separate visions to the mass of the faithful, and, in response to patristic thinking, to St Benedict and St Paul, rapt in their final intellectual ascent to God. The saints required no suffrages. But the mass of the people, the ordinary sinners, did. *Omne Bonum* makes it clear that by contemplating those most somatic images of Christ's Passion – the *Arma Christi*, including the Holy Face and the Instruments of the Passion – indulgence for sin, and so the Beatific Vision, could be attained. One could have no better illustration of the protean character of medieval thought on the outcome of death, and of the endless ingenuity of medieval artists in responding to the complexity and subtlety of its ideas.

Bibliography

This bibliography is full but by no means comprehensive. I have listed titles, including important primary sources, under the chapters where they have been cited in the preparation of this book, or where their reference seems most appropriate. Books marked with an asterisk are of particular importance.

Books of general interest

Ariès, P., *Western Attitudes Towards Death: From the Middle Ages to the Present*, trans.
Ranum, P. M. (Baltimore and London, 1974)

* Ariès, P., *The Hour of Our Death*, trans. Weaver, H. (New York, 1981) – standard reference work for theories of death culture and individuality

Baudrillard, J., *L'Échange symbolique de la mort* (Paris, 1976)

Bloch, M., and Parry, J., eds., *Death and the Regeneration of Life* (Cambridge, 1982)

* Boase, T. S. R., *Death in the Middle Ages: mortality, judgment and remembrance* (London, 1972) – still useful account, with numerous images

Braet, H., and Verbeke, W., eds., *Death in the Middle Ages*, Mediaevalia Lovaniensia, ser. I/IX (Leuven, 1983)

Cederroth, S., Corlin, C., Lindstrom, J., eds., *On the Meaning of Death: essays on mortuary rituals and eschatalogical beliefs* (Uppsala, 1988)

Chapman, R., Kinnes, I., and Randsborg, K., eds., *The Archaeology of Death* (Cambridge, 1981)

Chidester, D., *Patterns of Transcendance: religion, death and dying* (Belmont CA, 1990)

* Colvin, H. M., *Architecture and the After-Life* (New Haven and London, 1991) – comprehensive account from antiquity to the nineteenth century, with excellent bibliography

Curl, J. S., *A Celebration of Death: An Introduction* (London, 1980)

Duby, G., *The Three Orders: Feudal Society Imagined*, trans. Goldhammer, A. (Chicago, 1980)

Duby, G., ed., *A History of Private Life, II. Revelations of the Medieval World* (Cambridge and London, 1988)

Enright, D. J., ed., *The Oxford Book of Death* (Oxford, 1983)

Gatch, M. McC., *Death: meaning and mortality in Christian thought and contemporary culture* (New York, 1964)

Gittings, C., *Death, Burial and the Individual in Early Modern England* (London, 1984)

Goodwin, S. W., and Bronfen, E., eds., *Death and Representation* (Baltimore, 1993) – stimulating accounts of death and representational theory, including filmic analysis

* Huizinga, J., *The Waning of the Middle Ages* (1924) (Harmondsworth, 1976)

Humphries, S. C., and King, H., eds., *Mortality and Immortality: the anthropology and archaeology of death* (London, 1981)

Kay, S., and Rubin, M., eds., *Framing Medieval Bodies* (Manchester and New York, 1994)

La Mort au moyen âge, Colloque des médiévistes françaises, Soc. Savante, vol. 25 (Strasbourg, 1977)

* Le Goff, J., *The Birth of Purgatory*, trans. Goldhammer, A. (Chicago, 1984) – central text on the 'spatialization' of Purgatory

Llewellyn, N., *The Art of Death: visual culture in the English death ritual c.1500–1800* (London, 1991)

* Metcalf, P., and Huntington, R., *Celebrations of Death: the anthropology of mortuary ritual*, rev. 2nd edn (Cambridge, 1991) – compare Bloch and Parry 1982, useful theoretical introduction

Miller, A., and Acri, M., *Death: A Bibliographical Guide* (London 1972)

Morris, C., *The Discovery of the Individual 1050–1200*, Medieval Academy Reprints for Teaching, 19 (Toronto, 1991)

Ohler, N., *Dying and Death in the Middle Ages* (Munich, 1990)

Pelikan, J., *The Shape of Death* (New York, 1962)

Scarisbrick, J. J., *The Reformation and the English People* (Oxford, 1984)

* Southern, R. W., *Western Society and the Church in the Middle Ages* (Harmondsworth, 1970)

Taylor, J. H. M., ed., *Dies Illa: Death in the Middle Ages*, Vinaver Studies in French, I (Liverpool, 1984) – useful essays by Taylor on mirror-motifs, and Burke on death and the Renaissance

Thomas, K., *Religion and the Decline of Magic* (London, 1971)

Turner, V., *The Forest of Symbols* (Ithaca, 1967)

* Vovelle M., *La Mort et l'occident, de 1300 à nos jours* (Paris, 1983)

Ward, B., *Miracles and the Medieval Mind: theory, record and event 1000–1215* (London, 1987)

* Whaley, J., ed., *Mirrors of Mortality: studies in the social history of death* (London, 1981) – stimulating collection of essays: see Finucane, below

Introduction: The Roots of Medieval Death Culture

In addition to Ariès 1981, Colvin 1991, Le Goff 1984, see:

* Augustine, Saint, *The City of God*, trans. Bettenson, H., Penguin Classics (Harmondsworth, 1984)

Augustine, Saint, *Confessions*, trans. Pine-Coffin, R. S., Penguin Classics (Harmondsworth, 1961)

Brown, P., *Relics and Social Status in the Age of Gregory of Tours* (Reading, 1977)

* Brown, P., *The Cult of the Saints: its rise and function in Latin Christianity* (Chicago, 1981) – fundamental account of the cult of saints and early Christian culture

Brown, P., *The Body and Society: Men, Women and Sexual Renunciation in Early Christianity* (London, 1989)

Douie, D. L., and Farmer, H., eds., *The Life of St Hugh of Lincoln*, 2 vols (Nelson's Medieval Texts, 1961–2)

Finucane, R., C., *Miracles and Pilgrims: popular beliefs in Medieval England* (Totowa, N.J., 1977)

* Geary P. J., *Furta Sacra: Thefts of Relics in the Central Middle Ages* (Princeton, 1990)

Geary, P. J., *Living with the Dead in the Middle Ages* (Cornell, 1994)

Kemp, E. W., *Canonization and Authority in the Western Church* (London, 1948)

* Krautheimer, R., *Corpus Basilicarum Christianarum Romae* (Vatican City, 1937–77) – standard survey of medieval Roman architecture

Krautheimer, R., *Rome, Profile of a City, 312–1308* (Princeton, 1988)

Lucretius, *De Rerum Natura*, trans. Rouse, W. H. D., rev. Smith, M. F., Loeb Classical Library, 181, rev. edn (Cambridge, 1992)

Mancinelli, F., *Catacombs and Basilicas: The Early Christians in Rome* (Scala, Florence, 1981)

Mourant, J., *Augustine on Immortality* (Villanova, 1969)

Murray, S., *Rebirth and Afterlife* (Oxford, BAR International Series 100, 1983)

Nichols, J. H., and Segal, C., eds., *Lucretius on Death and Anxiety: poetry and philosophy in 'De Rerum Natura'* (Princeton, 1990)

* Panofsky, E., ed., *Abbot Suger on the Abbey Church of St-Denis and its Art Treasures*, 2nd edn (Princeton, 1979)

Plato, *Phaedo*, ed. Rowe, C. J. (Cambridge, 1993)

Rollason, D., *Saints and Relics in Anglo-Saxon England* (Oxford, 1981)

Rush, A. C., *Death and Burial in Christian Antiquity* (Washington, 1941)

Sumption, J., *Pilgrimage: An Image of Mediaeval Religion* (London, 1975)

Thomas, C., *Bede, Archaeology and the Cult of Relics* (Jarrow Lecture, 1973)

Wilson, S., ed., *Saints and their Cults: studies in religious sociology, folklore and history* (Cambridge, 1983)

Chapter One: Ways of Dying and Rituals of Death

In addition to Ariès 1991, see:

Alexiou, M., *The Ritual Lament in Greek Tradition* (Cambridge, 1974)

Barasch, M., *Gestures of Despair in Medieval and Early Renaissance Art* (New York, 1976)

* Beaty, N. L., *The Craft of Dying: a study in the literary tradition of the Ars Moriendi in England*, Yale Studies in English, 175 (New Haven, 1970) – strongly influenced by Huizinga 1924

Bloomfield, M. W., *The Seven Deadly Sins* (East Lansing, Mich., 1967)

Braswell, M. F., *The Medieval Sinner: characterization and confession in the literature of the English Middle Ages* (London and Toronto, 1983) – compare Delumeau 1990, Tentler 1977

Brown, E. A. R., 'Death and the human body in the later Middle Ages: the legislation of Boniface VIII on the division of the corpse', *Viator*, 12 (1981), pp. 221–70

Coulton, G. G., *Five Centuries of Religion* (Cambridge, 1923–50)

Delisle, L., *Rouleux des morts du IX^e au XV^e siècle* (Paris, 1866)

* Douglas, M., *Purity and Danger: an analyis of concepts of pollution and taboo* (London, 1966)

Douglas, M., *Natural Symbols: explorations in cosmology* (London, 1970)

Duckett, E. S., *Death and Life in the Tenth Century* (Michigan, 1988)

* Duffy, E., *The Stripping of the Altars: traditional religion in England 1400–1580* (New Haven and London, 1992) – rich and sympathetic account of late-medieval religion with special reference to East Anglia

Elias, N., *The Loneliness of the Dying* (Oxford, 1985)

* Finucane, R. C., 'Sacred corpse, profane carrion: social ideals and death rituals in the later Middle Ages', in Whaley 1981 – recommended survey of death and different social groups

Furnivall, F. J., ed., *The Fifty Earliest English Wills, 1387–1439*, Early English Text Society 78 (London, 1882)

Genet, J., *Funeral Rites* (New York, 1969)

* Giesey, R. E., *The Royal Funeral Ceremony in Renaissance France* (Geneva, 1960) – brilliant account of the development of royal funeral ritual: see also Kantorowicz 1957

Guthke, K. S., *Last Words: variations on a theme in cultural history* (Princeton, 1992)

Hallam, E., 'Royal burial and the cult of kingship in France and England, 1060–1330', *Journal of Medieval History*, viii (1982), pp. 359–80

* Kantorowicz, E. H., *The King's Two Bodies: a study in medieval political theology* (Princeton, 1957) – compare also Giesey 1960

Lea, H. C., *A History of Auricular Confession and Indulgences in the Latin Church*, I (London, 1896)

Le Goff, J., 'Head or heart? The political use of body metaphors in the Middle Ages', in Feher, M., Naddaff, R., and Tazi, N., *Fragments for a History of the Human Body*, 3 (Zone: 5, New York, 1989), pp. 13–26

McManners, J., 'Death and the French historians', in Whaley 1981

McNeill, J. T., and Gamer, H., *Medieval Handbooks of Penance* (New York, 1938)

Mirrer, L., ed., *Upon my Husband's Death* (Michigan, 1990) – valuable series of essays on the plight of medieval widows

Moore, R. I., *The Formation of a Persecuting Society: Power and Deviance in Western Europe 950–1250* (Oxford, 1987)

Morris, C. A., 'A critique of popular religion: Guibert of Nogent on the relics of the saints', in Cuming, G. J., and Baker, D., eds., *Popular Belief and Practice, Studies in Church History*, 8 (Guildford, 1972), pp. 55–60

* O'Connor, M., *The Art of Dying Well: the development of the Ars Moriendi* (New York, 1942) – standard account of textual history and manuscripts of the *Ars moriendi*

Office of the Dead (*Officium defunctorum*) – typically consult the *Breviarium Monasticum* (e.g. Use of Rome)

* Paxton, F. S., *Christianizing Death: the creation of a ritual process in early medieval Europe* (Cornell, 1990) – useful account of the development of medieval death liturgy

* Pouchelle, M-C., *The Body and Surgery in the Middle Ages*, trans. Morris, R. (Cambridge, 1990) – for Henri de Mondeville

Puckle, B. S., *Funeral Customs: their origin and development* (London, 1926)

Raine, J., and Clay, J. W., eds., *Testamenta Eboracensia: a selection of wills from the Registry of York*, Surtees Society 4, 30, 45, 53, 79, 106 (1832–1902)

Sheehan, M., *The Will in Medieval England* (Toronto, 1963)

* Van Gennep, A., *The Rites of Passage*, trans. Vizedom, M. B., and Caffee, G. L. (Chicago, 1960) – influential account of the structure of rituals

* Wieck, R. S., ed., *Time Sanctified: The Book of Hours in Medieval Art and Life* (New York and Baltimore, 1988) – essential for the Office of the Dead

Chapter Two: Death and Representation

In addition to Ariès 1991, Colvin 1991, see:

Adhémar, J., and Dordor, G., 'Les tombeaux de la collection Gaignières', *Gazette des beaux-arts*, 84 (1974), 88 (1976), 90 (1997)

Banker, J. R., *Death in the Community: memorialization and confraternities in an Italian commune in the Late Middle Ages* (Athens, Georgia, 1988)

* Bauch, K., *Das mittelalterliche Grabbild* (Berlin and New York, 1976)

Binski, P., *Westminster Abbey and the Plantagenets: Kingship and the Representation of Power 1200–1400* (New Haven and London, 1995)

Carruthers, M., *The Book of Memory: a study of memory in medieval culture* (Cambridge, 1990)

* Coales, J., ed., *The Earliest English Brasses: patronage, style and workshops 1270–1350* (London, 1987)

Cohn, S. K., *Death and Property in Siena, 1205–1800: strategies for the afterlife* (Baltimore, 1989)

Cohn, S. K., *The Cult of Remembrance and the Black Death: six Renaissance cities in Central Italy* (Baltimore, 1992)

* Cook, G. H., *Mediaeval Chantries and Chantry Chapels* (London, 1963)

Deér, J., *The Dynastic Porphyry Tombs of the Norman Period in Sicily* (Cambridge, Mass., 1959)

Durandus, Guglielmus, *Rationale Divinorum Officiorum* (Venice, 1568)

Erlande-Brandenburg, A., *Le Roi est mort* (Geneva, 1975) – for French royal tombs

Foucault, M., *Discipline and Punish: The Birth of the Prison*, trans. Sheridan, A. (Harmondsworth, 1977) – for the notion of 'disciplinary space'

* Gardner, J., *The Tomb and the Tiara: Curial Tomb Sculpture in Rome and Avignon in the Later Middle Ages* (Oxford, 1992)

Gee, L. L., ' "Ciborium" tombs in England, 1290–1330', *Journal of the British Archaeological Association*, cxxxii (1979), pp. 29–41

* Grabar, A., *Martyrium*, 2 vols (Paris, 1946)

Harding, V., 'Burial choice and burial location in later medieval London', in Bassett, S., ed., *Death in Towns: Urban Responses to the Dying and the Dead 100–1600* (Leicester, 1992), pp. 119–35

Hurtig, J., *The Armored Gisant Before 1400* (New York, 1979)

Jacob, H. S'., *Idealism and Realism: a study of sepulchral symbolism* (Leiden, 1954)

Langland, William, *The Vision of Piers Plowman*, ed. Schmidt, A. V. C. (London, 1995), esp. *passus* 6

Les Pleurants dans l'art du moyen âge en Europe, exhib. cat. (Dijon, 1971) – for weepers

McManamon, J. M., *Funeral Oratory and the Cultural Ideals of Italian Humanism* (Chapel Hill, 1989)

Mann, H. K., *Tombs and Portraits of the Popes of the Middle Ages* (London, 1928)

Molinier, A., *Les Obituaries français au Moyen Âge: Les sources de l'histoire de France, des origines aux guerres d'Italie*, III, pt. I (Paris, 1890)

Norris, M., *Monumental Brasses: The Memorials* and *The Craft*, 2 vols (London, 1977, 1978)

* Panofsky, E., *Tomb Sculpture: its changing aspects from Ancient Egypt to Bernini* (New York, 1964) – characteristically rich and clearly-structured account but with a strong humanist bias

Pierce the Ploughman's Crede, see *The Piers Plowman Tradition*, ed. Barr, H. (London, 1993), esp. pp. 67–70

Ragon, M., *The Space of Death: a study of funerary architecture, decoration and urbanism* (Charlottesville, 1983)

Rosenthal, J., *The Purchase of Paradise; Gift Giving and the Aristocracy, 1307–1485* (Toronto, 1972)

Sauerländer, W., *Gothic Sculpture in France 1120–1270* (London, 1972)

* Stone, L., *Sculpture in Britain: the Middle Ages* (Harmondsworth, 1972)

Tummers, H., *Early Secular Effigies in England: the thirteenth century* (Leiden, 1980)

Tyson, D. B., 'The Epitaph of Edward the Black Prince', *Medium Aevum*, 46 (1977), pp. 87–104

Wagner, A. R., and Mann, J. G., 'A Fifteenth-Century Description of the Brass of Sir Hugh Hastings at Elsing, Norfolk', *Antiquaries Journal*, vol. xix, 1931, p. 421

Wilson, C., *The Shrines of St William of York* (York, 1977)

* Wilson, C., 'The Medieval Monuments', in Collinson, P., Ramsay, N. L., and Sparks, M., eds., *A History of Canterbury Cathedral* (Oxford, 1995), pp. 451–510 – exemplary account of tomb design and patronage at one site

Wood-Legh, K. L., *Perpetual Chantries in Britain* (Cambridge, 1965)

Wright, G. S., 'A Royal Tomb Programme in the reign of St Louis', *Art Bulletin*, lvi (1974), pp. 224–43

Chapter Three: The Macabre

In addition to Ariès 1991, Huizinga 1924, Kay and Rubin 1994, Taylor 1984 and Vovelle 1983, see:

Barber, P., *Vampires, Burial and Death: Folklore and Reality* (New Haven, 1988)

Bataille, G., *Eroticism: death and sexuality* (San Francisco, 1986)

* Belting, H., *Likeness and Presence: a history of the image before the era of Art*, trans. Jephcott, E. (Chicago, 1994) – comprehensive account of medieval images and image-relics

Boothby, R., *Death and Desire: Psychoanalytic Theory in Lacan's Return to Freud* (New York, 1991)

Brandon, S. G. F., *The Personification of Death in some Ancient Religions* (Manchester, 1961)

Brion-Guerry, L., *Le Thème du triomphe de la Mort dans la peinture Italienne* (Paris, 1950)

Bronfen, E., *Over Her Dead Body: Death, Femininity and the Aesthetic* (Manchester, 1992)

Brunereau, S., *La Danse macabre de La Chaise-Dieu* (Paris, 1925)

* Bynum, C. W., 'Material Continuity, Personal Survival and the Resurrection of the Body: a scholastic discussion in its medieval and modern contexts', in Bynum, C. W., *Fragmentation and Redemption: Essays on Gender and the Human Body in Medieval Religion* (Zone Books, New York, 1992), pp. 239–97

Campbell, A. M., *The Black Death and Men of Learning* (New York, 1931)

Campbell, B. M. S., ed., *Before the Black Death: studies in the 'crisis' of the early fourteenth century* (Manchester and New York, 1991)

Chihaia, P., *Immortalité et décomposition dans l'art du Moyen Âge* (Madrid, 1988)

Clark, J. M., *The Dance of Death in the Middle Ages and Renaissance* (Glasgow, 1950)

* Cohen, K., *Metamorphosis of a Death Symbol: The Transi Tomb in the Late Middle Ages and the Renaissance* (Berkeley and Los Angeles, 1973) [reviewed by R. Giesey, *Speculum*, 52 (1977)]

* Delumeau, J., *Sin and Fear: The Emergence of a Western Guilt Culture 13th–18th centuries*, trans. Nicholson, E. (New York, 1990) – massive survey

Dubruck, E., *The Theme of Death in French Poetry of the Middle Ages and Renaissance* (The Hague, 1964)

Dufour, V., *La Danse macabre painte sur les charniers des SS. Innocents de Paris* (Paris, 1891)

* Freud, S., 'Beyond the Pleasure Principle' and 'Mourning and Melancholia' (1920, 1917), in various editions: see S. Freud, *On Metapsychology: the theory of psychoanalysis*, ed. Richards, A., Penguin Freud Library, 11 (Harmondsworth, 1984)

Glixelli, S., *Les cinque poèmes des trois morts et des trois vifs* (Paris, 1914)

Gottfried, R. S., *Epidemic Disease in Fifteenth-Century England* (New Brunswick, 1978)

Grabes, H., *The Mutable Glass: mirror-imagery in titles and texts of the Middle Ages and the English Renaissance* (Cambridge, 1982)

Gundesheimer, W. L., ed., *The 'Dance of Death' of Hans Holbein the Younger* (New York, 1971) – facsimile and introduction

Hertz, R., 'A contribution to the study of the collective representation of Death', in *Death and the Right Hand*, trans. Needham, C. and R. (New York, 1960)

King, P. M., 'The Cadaver tomb in England: novel manifestations of an old idea', *Church Monuments*, 5 (1990), pp. 26–38

* Koerner, J. L., 'The Mortification of the Image: Death as a Hermeneutic in Hans Baldung Grien', *Representations*, 10 (1985), pp. 52–101

Kristeva, J., 'Holbein's Dead Christ', in Feher, M., Naddaff, R., and Tazi, N., *Fragments for a History of the Human Body*, 1 (Zone: 3, New York, 1989), pp. 238–69

Kurtz, L. P., *The Dance of Death and the Macabre Spirit in European Literature* (New York, 1934)

Lacan, J., *The Four Fundamental Concepts of Psychoanalysis* (1973), ed. Miller, J-A., intro. Macey, D. (Harmondsworth, 1994)

Lawson, S., 'Cadaver effigies: the portrait as prediction', *Bulletin, Board of Celtic Studies*, 25 (1974), pp. 519–23

Lerner, R. E., 'The Black Death and Western eschatological mentalities', *American Historical Review*, 86 (1981), pp. 533–52

Levin, W. P., et al., *Images of Love and Death in Late Medieval and Renaissance Art*, exhib. cat. (Michigan, 1975)

Lévi-Strauss, C., *The Raw and the Cooked* (New York, 1969)

Mâle, E., *Religious Art at the End of the Middle Ages in France* (Paris, 1922)

* Meiss, M., *Painting in Florence and Siena after the Black Death* (Princeton, 1951)

Meyer-Baer, K., *Music of the Spheres and the Dance of Death: Studies in Musical Iconology* (Princeton, 1970)

Mirk, J., *Mirk's Festial: A Collection of Homilies*, ed. Erbe, T., Early English Text Society, extra series, 96 (London, 1905)

Montaiglon, A. de, ed., *L'Alphabet de la mort de Hans Holbein . . . suivi d'anciens poèmes français sur le sujet des trois morts et des trois vifs* (Paris, 1856)

Morganstern, A. M., 'The La Grange Tomb and Choir: a monument of the Great Schism of the West', *Speculum*, xlviii (1973), pp. 52–69

Owst, G., *Preaching in Medieval England* (Cambridge, 1926)

Owst, G., *Literature and Pulpit in Medieval England* (Cambridge, 1933)

Pagels, E., *Adam, Eve and the Serpent* (New York, 1987)

Paquette, J. M., *Poèmes de la Mort* (Paris, 1979)

* Ringbom, S., *Icon to Narrative: the rise of dramatic close-up in fifteenth-century devotional painting* (Abo, 1965)

Sheridan, R., and Ross, R., *Gargoyles and Grotesques: Paganism in the Medieval Church* (Boston, 1975)

Storck, W., 'Aspects of death in English art and poetry', *Burlington Magazine*, xxi (1912), pp. 249–56

* Tenenti, A., *La Vie et la Mort à travers l'art du XVᵉ siècle*, Cahiers des Annales, 8 (Paris, 1952)

Tentler, T. N., *Sin and Confession on the Eve of the Reformation* (Princeton, 1977)

Tristram, P., *Figures of Life and Death in Medieval English Literature* (London, 1976)

* Van Os, H. W., 'The Black Death and Sienese Painting: a problem of interpretation', *Art History* 4/3 (1981), pp. 237–49 – review of the issue since Meiss 1951

Van Os, H. W., *The Art of Devotion in the Late Middle Ages in Europe, 1300–1500* (London/ Amsterdam, 1994)

Villon, F., *The Poems of Francois Villon*, trans. Kinnell, G. (Boston, 1977)

Warren, F., and White, B., *The Dance of Death*, Early English Text Society, 181 (London, 1931)

Williams, E. C., 'Mural paintings of the Three Living and Three Dead in England', *Journal of the British Archaeological Association*, vii (1942), pp. 31–40

Williman, D., ed., *The Black Death: the impact of the fourteenth-century plague* (Binghampton, 1982)

Wirth, J., *La Jeune Fille et la Mort: Recherches sur les thèmes macabres dans l'art germanique de la Renaissance* (Geneva, 1979)

Zeigler, P., *The Black Death* (London, 1969)

Chapter Four: Death and the Afterlife

Aquinas, St Thomas, *Summa Theologiae*, Blackfriars Edn, 60 vols (London, 1964–76)

Aquinas, St Thomas, *Aristotle's De Anima with the commentary of St Thomas Aquinas*, trans.

Foster, K., and Humphries, S. (New Haven and London, 1951)

Ariès, P., 'Une conception ancienne de l'au-delà', in Braet, H., and Verbeke, W., eds, *Death in the Middle Ages*, Mediaevalia Lovaniensia, ser. I/IX (Leuven, 1983), pp. 78–87

Bernstein, A. E., *The Formation of Hell: Death and Retribution in the Ancient and Early Christian Worlds* (London, 1993)

* Bevington, D., et al., *Homo Memento Finis: The Iconography of Just Judgement*, Early Drama, Art, and Music Monograph Series, 6 (Kalamazoo, 1985)

Brandon, S. G. F., *The Judgement of the Dead* (London, 1967)

* Brieger, P., Meiss, M., and Singleton, C. S., *Illuminated Manuscripts of the Divine Comedy*, 2 vols (Princeton, 1969) – see also Morgan 1990

Broëns, M., 'The resurgence of Pre-Indoeuropean elements in the Western Medieval Cult of the Dead', *Diogenes*, xxx (1960), pp. 70–103

Bynum, C. W., *The Resurrection of the Body in Western Christianity, 200–1336* (New York, 1995) [appeared too late to be consulted for the present study; see also above, Bynum 1992]

Cahn, W., 'Ascending to and Descending from Heaven: ladder themes in early Medieval art', in *Settimane di Studio del Centro italiano di studi sull'alto medioevo*, 36 (Spoleto, 1989), pp. 697–724

Caviness, M. H., 'Images of Divine Order and the Third Mode of Seeing', *Gesta*, 22 (2) (1983), pp. 99–120

Cherry, C., 'Near-Death experiences and the problem of evidence for survival after death', *Religious Studies*, xxii (1986), pp. 397–406

* Dante Alighieri, *The Divine Comedy*, numerous editions

* Davidson, C., and Seiler, T. H., eds., *The Iconography of Hell*, Early Drama, Art, and Music Monograph Series, 17 (Kalamazoo, 1992) – very useful overview of imagery of Hell in late medieval drama

Dinzelbacher, P., *Vision und Visionsliteratur im Mittelalter* (Stuttgart, 1981)

Dykmans, M., *Les Sermons de Jean XXII sur la vision béatifique*, in *Miscellanea Historiae Pontificae*, xxxiv (1973)

Edgerton, S. Y., *Pictures and Punishment: art and criminal prosecution during the Florentine Renaissance* (Cornell, 1985)

* Finucane, R. C., *Appearances of the Dead: a cultural history of ghosts* (London, 1984)

Gurevich, A., *Medieval Popular Culture: problems of belief and perception*, trans. Bak, J. M., and Hollingsworth, P. A. (Cambridge, 1988) – responds to Le Goff 1984; see also Dinzelbacher 1981 and Patch 1950

Haren, M., *Medieval Thought: The Western Intellectual Tradition from Antiquity to the Thirteenth Century*, 2nd edn (London, 1992) – summary of medieval theories of hylomorphism

* Hughes, R., *Heaven and Hell in Western Art* (London, 1968) – broad if flippant general account

Kartsonis, A. D., *Anastasis: the making of an image* (Princeton, 1986)

Kren, T., and Wieck, R. S., eds., *The Visions of Tondal from the Library of Margaret of York* (Malibu, 1990)

* Le Goff, J., *The Birth of Purgatory*, trans. Goldhammer, A. (Chicago, 1984)

Lehner, E., *Devils, Demons, Death and Damnation* (New York, 1971)

Le Roy Ladurie, E., *Montaillou: the promised land of error*, trans. Brary, B. (London, 1978)

Lombard, Peter, *Sententiae in IV libris distinctae*, ed. Collegium S. Bonaventurae, Spicilegium Bonaventurianum, 4 and 5, 2 vols (Grottaferrata, 1971, 1981)

Morgan, A., *Dante and the Medieval Other World* (Cambridge, 1990)

Patch, H. R., *The Other World According to Descriptions in Medieval Literature* (Cambridge, Mass. 1950)

Pseudo-Dionysius, *The Complete Works*, trans. Luibheid, C. (New York, 1987) – includes the Divine Names and Celestial Hierarchy

Redle, M. J., 'Beatific Vision', *New Catholic Encyclopedia* (Washington, 1967), 2, pp. 186–93

Ring, K., and Kubler-Ross, E., *Heading Towards Omega: in search of the meaning of the near-death experience* (New York, 1985)

Sandler, L. F., 'Face to face with God: a pictorial image of the beatific vision', in *England in the Fourteenth Century*, ed. Ormrod, W. M. (Woodbridge, 1986), pp. 224–35

Index

Page numbers in *italics* refer to black-and-white illustrations and roman numerals indicate colour plate nos.